Published by **Hero Collector Books**, a division of Eaglemoss Ltd. 2021
Premier Place, 2 & A Half Devonshire Square, EC2M 4UJ, London, UK.

™ & © 2021 CBS Studios Inc.
STAR TREK and related marks and logos are trademarks of CBS Studios Inc.
All Rights Reserved.

General Editor: **Ben Robinson**
Project Manager: **Jo Bourne**
Editor: **Alice Peebles**
Designer: **Katy Everett**
Jacket Designer: **Stephen Scanlan**

With thanks to the team at CBS: John Van Citters, Marian Cordry
and Risa Kessler

Most of the contents of this book were originally published as part of
STAR TREK – The Official Starships Collection by Eaglemoss Ltd. 2013-2020

Printed in China

ISBN 978-1-85875-956-2

10 9 8 7 6 5 4 3 2 1

www.herocollector.com

STAR TREK
SHIPYARDS

THE BORG AND DELTA QUADRANT

CONTENTS

CHAPTER 1: THE BORG

- 10: **CUBE**
- 16: **SPHERE**
- 20: **QUEEN'S SHIP**
- 26: **RENEGADE SHIP**
- 32: **TACTICAL CUBE**
- 38: **PROBE**
- 44: **SIZE CHART**

CHAPTER 2: THE DELTA QUADRANT

- 48: **ABADDON'S "JUNK SHIP"**
- 50: **AKRITIRIAN FREIGHTER**
- 51: **AKRITIRIAN PATROL SHIP**
- 52: **AKSANI RACING SHUTTLE**
- 54: *ALICE*
- 60: **ANKARI SHIP**
- 62: **ANNARI WARSHIP**
- 63: **ANNARI COMBAT SHIP**
- 64: **ANTARIAN TRANS-STELLAR RALLY**
- 68: **B'OMAR PATROL SHIP**
- 74: **BA'NETH SHIP**
- 75: **BENTHAN PATROL SHIP**
- 76: **BENTHAN COAXIAL DRIVE PROTOTYPE**
- 82: **BOTHAN SHIP TYPE 1**
- 84: **BRUNALI TRANSPORT SHIP**
- 86: **CAATATI SHIP TYPE 1**
- 88: **CAATATI SHIP TYPE 2**
- 90: **CHOKUZAN SHIP**
- 94: **CRAVIC STARSHIP**
- 98: **CYTOPLASMIC LIFE-FORM SHIP**
- 102: **DAELEN'S SHIP**
- 104: *U.S.S. DAUNTLESS*
- 110: **DALA'S *"DELTA FLYER"***
- 116: **DEVORE WARSHIP**
- 122: **DEVORE SHUTTLE**
- 124: **DINAALI HOSPITAL SHIP**
- 128: **DRALIAN SHIP**
- 130: **DRAYAN STARSHIP**
- 132: **ENTHARAN SHIP**
- 134: **FLEA SHIP**
- 138: **HAZARI WARSHIP**
- 142: **HAZARI SCOUT SHIP**
- 144: **HIERARCHY SHIPS**
- 152: **HIROGEN HOLOSHIP**
- 158: **HIROGEN WARSHIP**
- 164: **HIROGEN *VENATIC* CLASS**
- 168: **ILARI SHIP**
- 170: **IMHOTEP RACING SHUTTLE**
- 174: **IRINA'S RACING SHIP**
- 180: **KAZON AND TRABE CARRIER**
- 184: **KAZON AND TRABE FIGHTER**
- 186: **KAZON RAIDER**
- 192: **KES'S SHUTTLE**
- 198: **KOBALI SHIP**
- 200: **KRAYLOR MEDICAL TRANSPORT *(NIGHTINGALE)***
- 206: **KRENIM PATROL SHIP**
- 210: **KRENIM WARSHIP**
- 216: **KRENIM TEMPORAL WEAPON SHIP**
- 222: **SHIPS A-K, WITH EPISODES**
- 224: **EPISODE INDEX**
- 226: **EPISODES, SERIES AND SEASON**

www.startrek-starships.com

ACKNOWLEDGMENTS

We'd like to acknowledge the work of all the people who made the physical and CG models of the ships that appear in this book. Tony Meininger, Greg Jein, and everyone who worked in their shops are responsible for the physical models, while Foundation Imaging and Digital Muse created the CG ones. Our own CG modelers Rob Bonchune, Fabio Passaro, and Ed Giddings rebuilt the physical models as CG for us. Rob, Fabio, Ed, and Adam "Mojo" Lebowitz, created many of the renders you will see on the pages that follow.

We'd especially like to highlight the work of the modelers at the CG companies. Sadly, we don't always know the names of all those involved, but we know that particular thanks are due to Brandon MacDougall and Koji Kuramura. We are also very grateful to Fred Pienkos, John Gross, David Lombardi, and Mojo for helping us to retrieve the CG archives that could all too easily have been lost forever.

Thanks are also due to all the concept artists responsible for designing the ships – in this case, Rick Sternbach, Dan Curry, Steve Burg, and Tim Earls. The modelmakers, VFX supervisors, and producers also deserve thanks, since their role in creating the final designs is often overlooked. The same should be said for *VOYAGER*'s creators: Rick Berman, Michael Piller, and Jeri Taylor.

We must also mention Jorg Hillebrand and Ex Astris Scientia, who have made an exhaustive study of every ship that has ever appeared on *STAR TREK* and helped us to track down reference for some of the more obscure "missing" vessels.

We wish especially to thank our friends at CBS Consumer Products: Risa Kessler, Marian Cordry, and John Van Citters, without whom none of this would be possible.

As always and finally, we'd like to thank Gene Roddenberry and Matt Jefferies who came up with the design for the original *Starship Enterprise*, which inspired everything that followed.

FOREWORD

Because the crew of the *U.S.S. Voyager* were stranded on the other side of the Galaxy, it was inevitable that they would encounter unfamiliar cultures with new ships. Until *VOYAGER*'s third season, a new ship involved a massive investment. Physical models had to be commissioned and built, then filmed in a laborious process that took hours to produce seconds of footage. The adoption of CG technology made a radical difference. Suddenly the VFX team could produce ships almost at will. As a result, the space lanes of the Delta Quadrant became more crowded – so much so that we've had to devote two volumes to the ships that were encountered there.

With the help of the original VFX team, we've been able to retrieve almost all of the files that were used to create the ships. Most of the renders on the following pages are taken directly from the original CG assets, meaning that they couldn't be more accurate. Where that wasn't possible, we've built our own CG models, filling in the handful of gaps that were left. There was one exception: we see so little of the Etanian ship in 'Rise' that we decided it was beyond us. The folders from the VFX team are empty, so this one vessel remains a mystery.

Despite the introduction of CG technology, *STAR TREK*'s VFX team didn't have infinite resources, so they reused various ships for species that could never have met each other, let alone exchanged technology. We offer those ships without comment. Whatever problems it causes, they were identified on-screen (or in the case of the Antarian Trans-stellar Rally, simply appeared) and we see it as our job to record the facts. The original series explained the appearance of several Earth-like planets by citing Hodgkin's Law of Parallel Planetary Development. We'd like to suggest that Hodgkin may have had another law that related to the development of spaceships.

For those of you who don't know, this book is part of a series, and there are other volumes that cover Starfleet, the Klingons, and the other alien races that fill the *STAR TREK* Universe. This volume and its companion, which covers the rest of the Delta Quadrant, is one of the fullest and most varied, since it includes dozens of races and radically different approaches to Starship design. We hope you enjoy reliving *Voyager*'s journey and that you will find a few unexpected gems on the pages that follow.

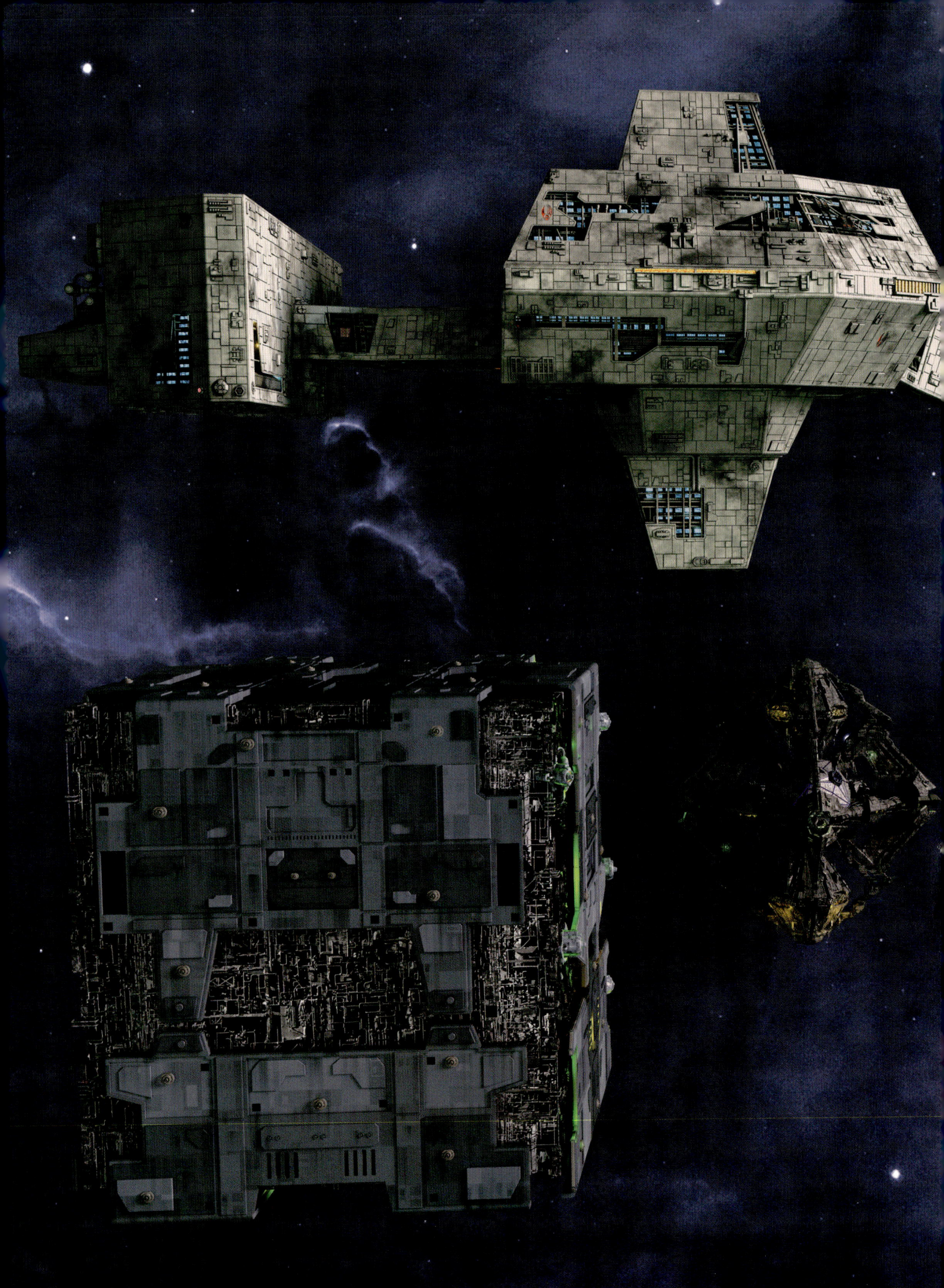

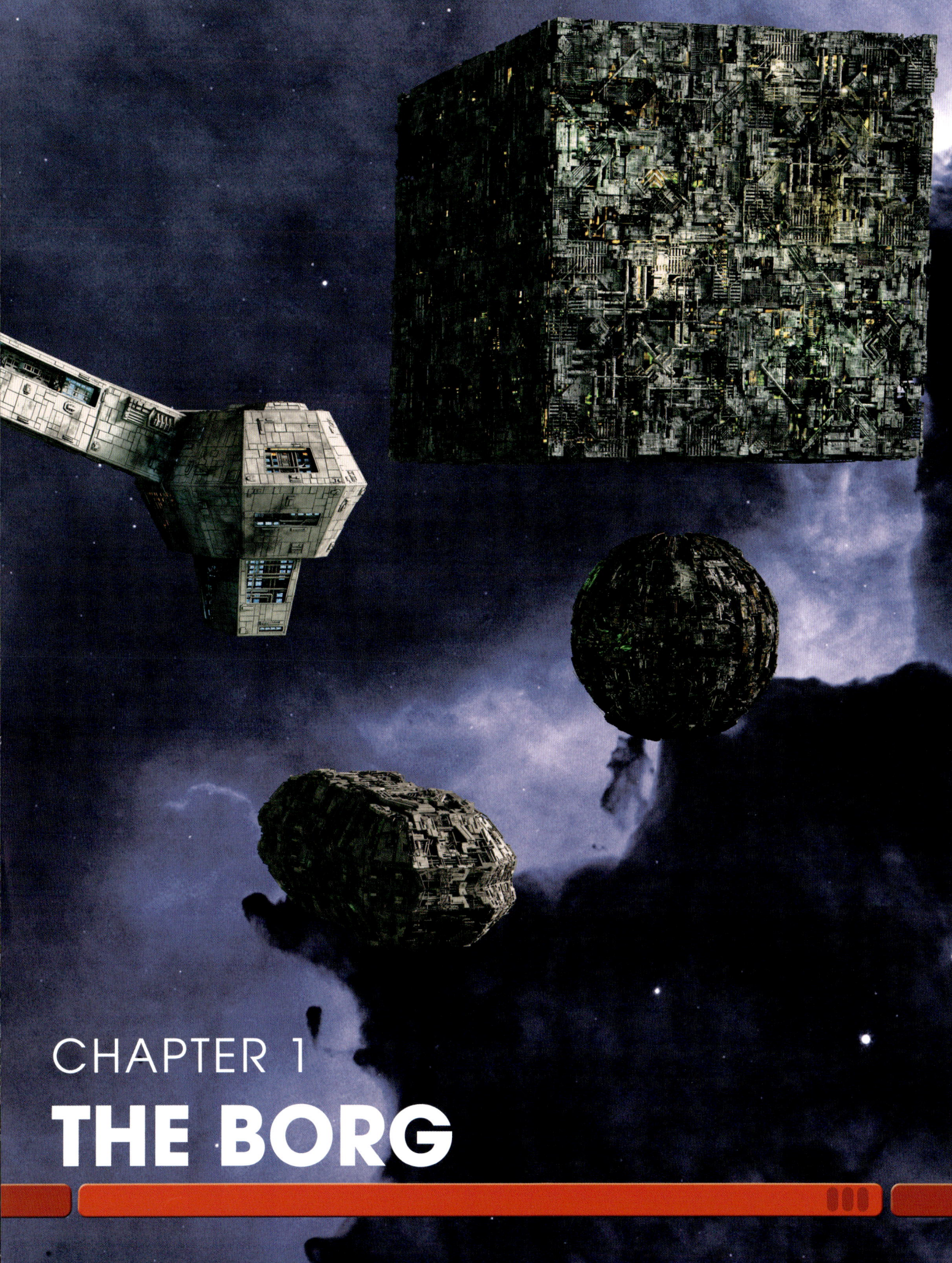

CHAPTER 1
THE BORG

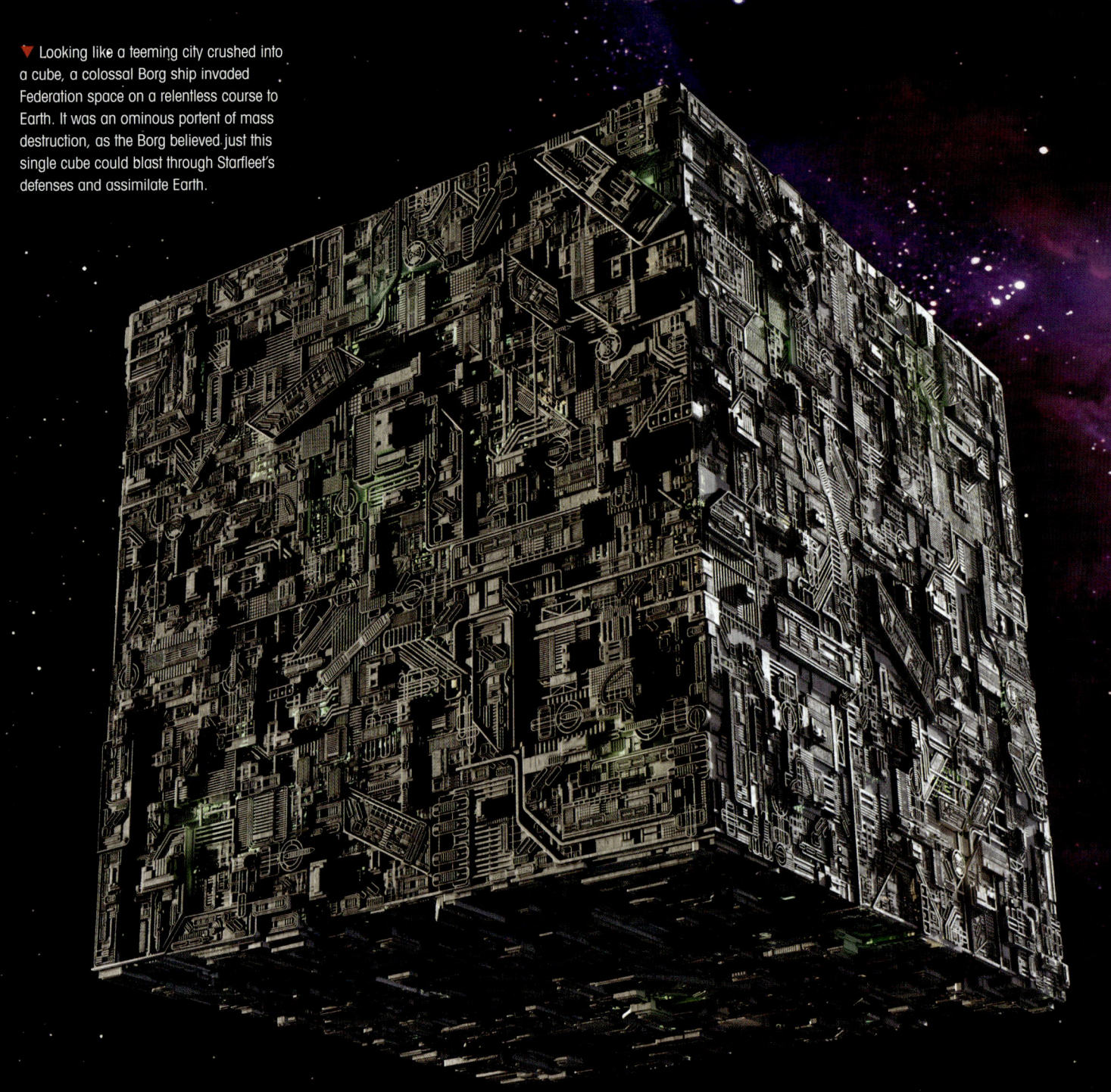

▼ Looking like a teeming city crushed into a cube, a colossal Borg ship invaded Federation space on a relentless course to Earth. It was an ominous portent of mass destruction, as the Borg believed just this single cube could blast through Starfleet's defenses and assimilate Earth.

BORG CUBE

In 2373, a Borg cube containing a Borg Queen battled a Starfleet armada on its way to assimilate Earth.

SHIP PROFILE

> **DATA FEED**
> Borg cubes were decentralized in structure, so that no specific area was responsible for a vital function. Instead, all vital systems were duplicated throughout, making them highly resistant to damage.

A Borg cube attempted to assimilate Earth and fought at least 30 Federation ships in the Battle of Sector 001 in 2373. It appeared to be the same as the two previous Borg cubes encountered by Starfleet.

The stark, brutalist-looking cube was massive and measured almost three kilometers per side, with an internal volume of around 27 cubic kilometers. It was largely made from tritanium and contained thousands of Borg drones. Normally, a cube was run by 5,000 drones, but numbers varied widely and could be as high as 179,000 drones.

As with other Borg cubes, it was equipped with an array of weaponry. This included cutting beams, high-power disruptor beams, and high-yield torpedoes. Its defensive systems included ablative hull armor and a regeneration shield matrix that could almost instantly repair damage.

The cube could achieve very high warp speeds, more than matching Starfleet's fastest ships, and attain even faster velocities through its transwarp technology. It used a network of transwarp corridors and hubs, and was able to travel safely through them without breaking apart from extreme gravimetric shear, by projecting a structural integrity field in front of it.

BORG LEADER

The Borg cube that invaded Federation space and headed to Earth in 2373 included several features that had not been seen on cubes before. Most notably, it contained a Borg Queen. Previously, the Borg had never shown signs of a hierarchical command structure on their ships, but the Queen appeared to be the focal point of the Borg collective consciousness. She seemed to have overall authority over the other drones, directing and coordinating their tasks. Whether this was true or not was not clear, but the fact that the Queen referred to herself as "we" and "I" interchangeably suggested that she was more

◀ Vice Admiral Hayes commanded the fleet that engaged the Borg cube in 2373. Before mobilizing the fleet, Hayes contacted Captain Picard and ordered him to stay away because he believed Picard would be a liability after his previous partial assimilation. In the battle, his flagship was destroyed, but Hayes survived.

SHIP PROFILE | BORG CUBE | OVERVIEW

▲ The Borg cube had no discernible features or systems on its exterior, which looked the same on all sides. Like all Borg cubes, it had green energy glowing between gaps in its hull. Its energy weapon beams were also green and appeared to come from emitters that were mainly located along each edge of the cube.

like the personification of the Borg collective's will, rather than the supreme leader of the Borg.

This cube also carried another Borg ship within it that had not been previously encountered. This smaller, spherical ship was launched through a circular hatch in one of the cube's sides. It appeared to be an escape vessel, since it was launched seconds before the cube was destroyed. The sphere was roughly 600 meters in diameter and contained the Borg Queen and hundreds of drones. It was able to form a temporal vortex by projecting chronometric particles in front of it, allowing it to travel back in time.

In 2373, the Borg made a second attempt to destroy Starfleet and assimilate Earth with just one cube. Its incursion was first reported by Deep Space 5, when the cube obliterated a Federation colony on Ivor Prime. Vice Admiral Hayes, who was in charge of Starfleet's response fleet, contacted Captain Picard and ordered him not to enter the fray. Hayes felt that Picard's previous traumatic experience with the Borg and his partial assimilation to become Locutus in 2367 would bring an "unstable element to a critical situation."

ENGAGING THE BORG
Hayes' fleet, which consisted of at least 30 ships, was mobilized in the Typhon sector and ordered to intercept the cube. Listening to a broadcast of the battle, Picard was unable to stand by passively as the fleet was suffering heavy losses, so he took the *U.S.S. Enterprise* NCC-1701-E into the battle.

When the *Enterprise* arrived, much of the fleet had already been destroyed, including Hayes'

SHIP PROFILE

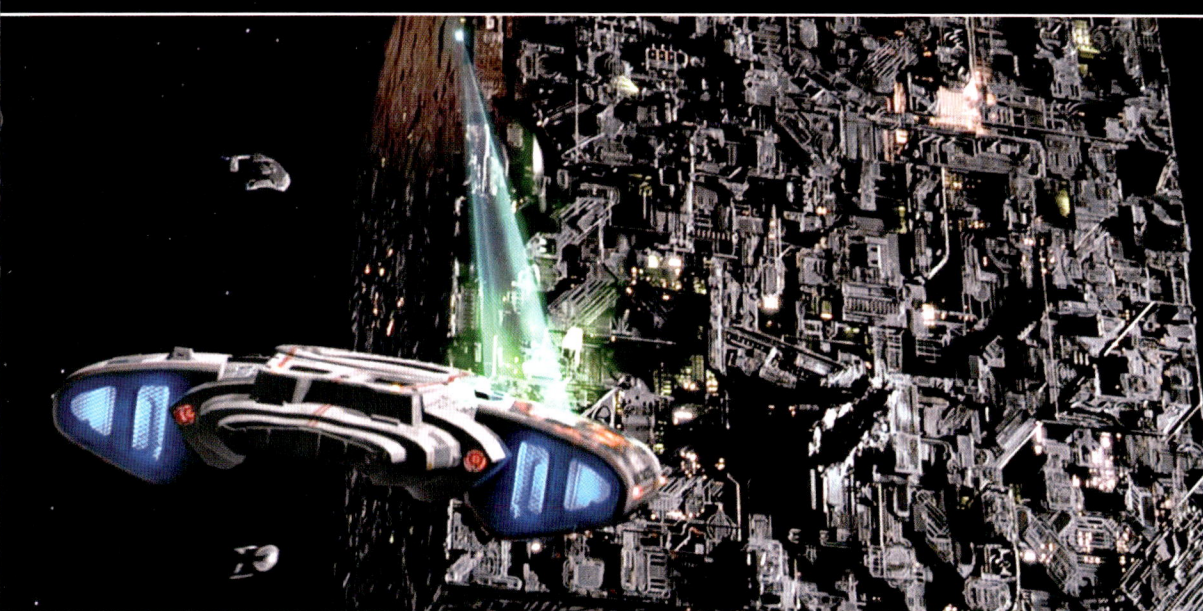

◀ In the opening exchanges of the Battle of Sector 001, the highly maneuverable *Defiant* made several fast strafing runs. It unleashed its phaser cannons and a barrage of quantum torpedoes at the cube, but without causing any significant damage. Eventually, the *Defiant* was hit and lost shields and weapons, but the crew was rescued by being beamed to the *Enterprise*-E.

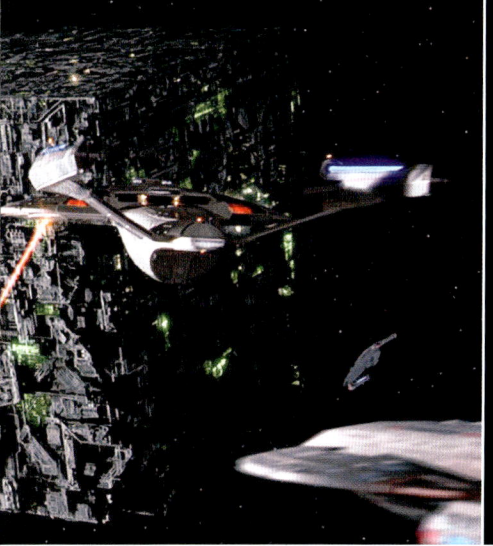

◀ Picard's residual link with the Borg enabled him to sense exactly where the cube was most vulnerable.

▶ The cube was repeatedly hit, which caused fluctuations in its power grid. Seconds before it imploded, a sphere was launched through a circular hatch in one of its sides.

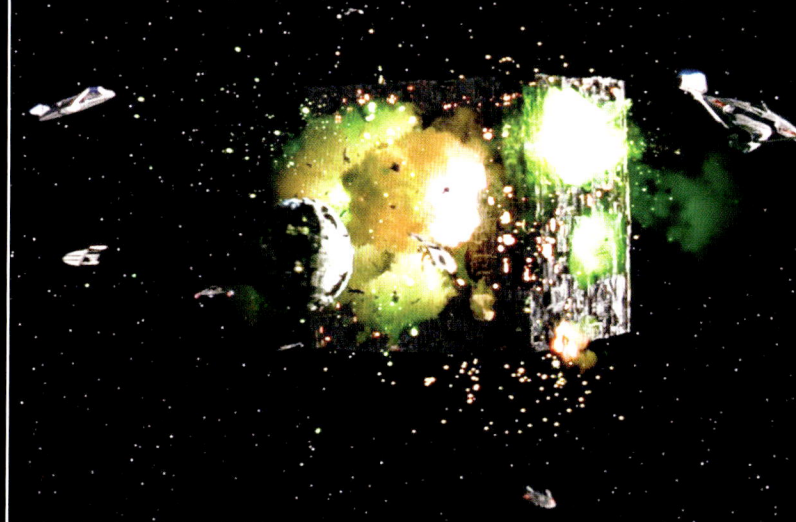

flagship, and Picard therefore took charge of the remaining ships. He used his knowledge of the Borg from his residual link with the Collective to launch an attack on the cube. Every available ship was ordered to target their weapons at a seemingly noncritical point on the cube. The sustained onslaught caused massive damage to the Borg vessel as its power grid became unstable.

Before the cube exploded, it launched the sphere, which entered a temporal vortex. The *Enterprise*-E was able to follow the sphere and destroy it. During the Battle of Sector 001, the Borg inflicted high losses on Starfleet, much as they had done previously during the Battle at Wolf 359. However, once again, through the heroic efforts of the *Enterprise* crew, Earth was saved and the population escaped assimilation.

DATA FEED

The Borg Queen was first encountered by Starfleet after the Battle of Sector 001 in 2373. Before this event, the Borg had not appeared to operate via a chain of command, but the Queen seemed to formulate their plans and coordinate their activities. She talked about bringing "order to chaos," but she did display emotions, unlike all other drones. Despite her importance, the Borg collective still endured after she was killed by Captain Picard.

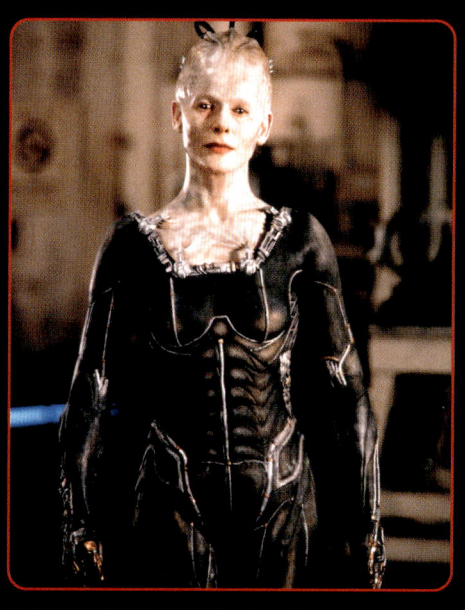

13

THWARTING THE BORG

The Borg cube that headed for Earth in 2373 was confronted in the Typhon sector by Vice Admiral Hayes' fleet. This consisted of at least 30 vessels, which were much better armed and prepared than the previous Starfleet armada that fought a Borg cube in 2367, at the Battle of Wolf 359. Despite the preparations made by Hayes' fleet, however, this cube managed to slice through it with comparative ease.

The cube mainly used its beam and projectile weapons on Hayes' fleet, rather than its cutting beam. Before long, many of the ships had been destroyed or rendered inoperative, including the *U.S.S. Defiant* NX-74205 and Hayes' flagship.

The fleet had caused damage to the cube's outer hull, but it continued on its way to Earth. Requests to Starfleet Command had called for reinforcements, but it was Captain Picard and the *U.S.S. Enterprise*-NCC1701-E that really made a difference, after he disobeyed orders and entered the battle. Thanks to Picard's lingering connection with the Borg from his horrifying time as Locutus, he could "hear" their thoughts and knew where to attack the cube. Picard was instrumental not only in destroying the Borg cube, but also in thwarting the Borg's subsequent plan to prevent the formation of the Federation by altering history.

Ablative hull armor

Disruptor beam emitter

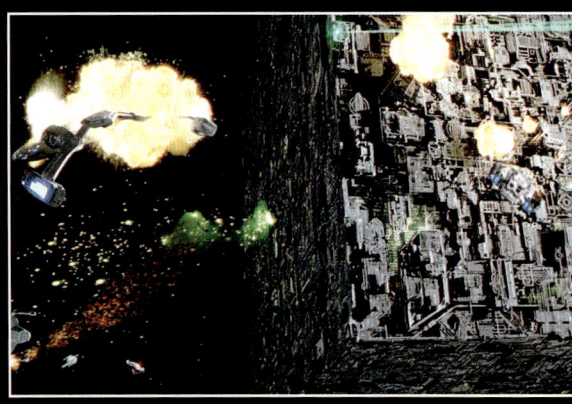

▲ The Battle of Sector 001 resulted in carnage as dozens of Starfleet ships were destroyed in seconds by the cube, until Captain Picard and the *Enterprise*-E arrived and turned the conflict in Starfleet's favor.

Projectile launcher

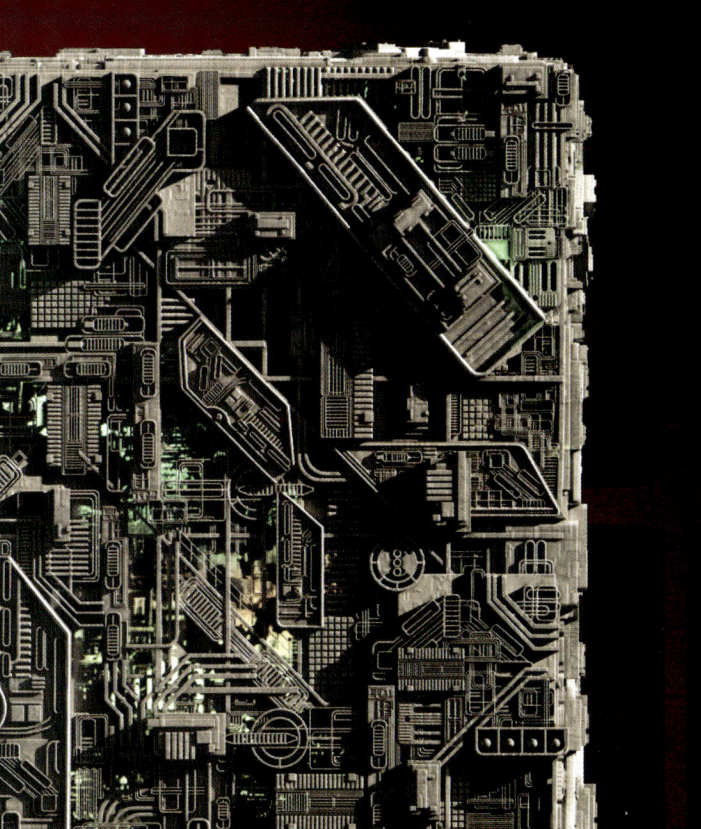

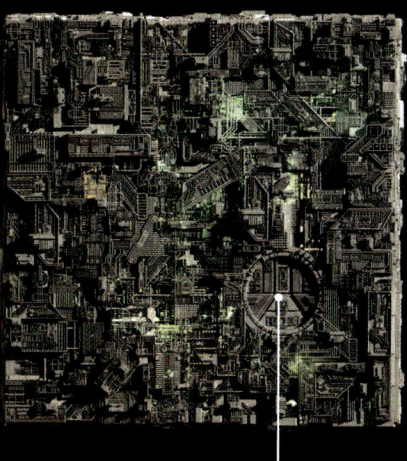
Sphere launch hatch

Transwarp conduit emitter

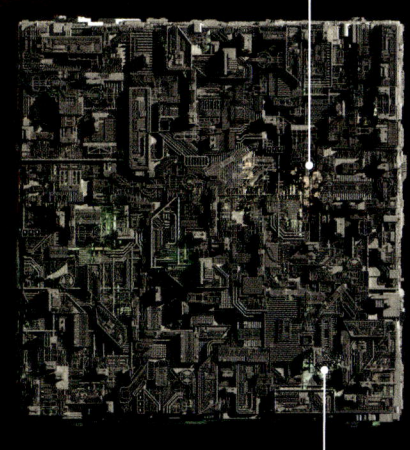
Structural integrity field emitter

Structural integrity field emitter

NEW WEAPON
Quantum torpedoes were specifically developed by Starfleet in preparation for a second Borg invasion. The *U.S.S. Defiant* NX-74205 was the first Starfleet ship to be equipped with the new torpedoes, in 2371.

CAUSALITY LOOP
Seven of Nine would later describe as a "Pogo paradox" the event in which the crew of the *Enterprise*-E intervened in the Borg's plan to change history and prevent the first warp flight.

FIGHTING FLEET
In addition to the *U.S.S. Enterprise*-E and the *U.S.S. Defiant,* the vessels that engaged the Borg cube at the Battle of Sector 001 included four *Saber*-class ships, five *Steamrunner*-class ships, three *Oberth*-class ships, two *Norway*-class ships, two *Akira*-class ships, two *Miranda*-class ships, and one *Nebula*-class ship.

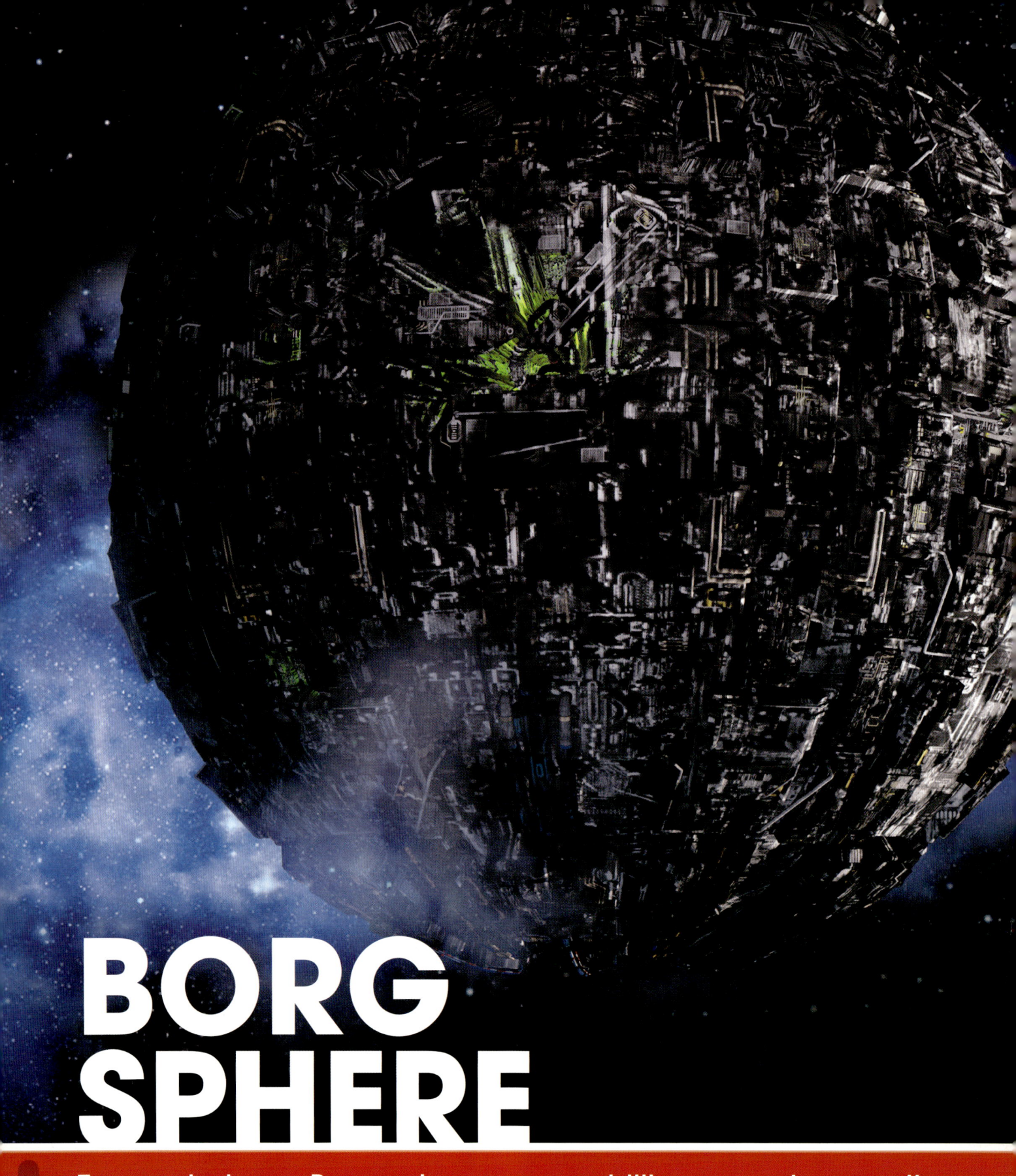

BORG SPHERE

Encountering a Borg sphere was a chilling experience – it meant almost certain assimilation into the Borg collective.

SHIP PROFILE

DATA FEED
As a relentlessly efficient and logical species, the Borg did not give their individual ships names, but always referred to them by numbers, such as Sphere 634 or Sphere 878.

The Borg sphere, as it was designated by Starfleet, was a ball-shaped vessel that the Borg used primarily as a long-range tactical vessel or scout ship. During the Battle of Sector 001 in 2373, a Borg sphere was also deployed as a "lifeboat" vessel when it was launched through an aperture on a Borg cube shortly before the cube was destroyed. This sphere was then able to travel back in time by emitting chronometric particles to create a temporal vortex.

At approximately 600 meters in diameter and with a crew complement of roughly 11,000 drones, the sphere was much smaller than the more common Borg cube, but it possessed many of the same attributes and technology. The outer hull of a Borg sphere was made largely from polytrinic and tritanium alloys, while the interior was a mixture of organic and mechanical elements that gave it an appearance almost like that of arteries and organs entwined around circuitry.

Borg spheres were armed with powerful projectile and energy weapons, which had rapidly adjustable frequencies, meaning they could quickly penetrate a ship's shields.

The Borg's preferred method of attack, however, was to hold a target vessel in a powerful tractor beam and render it defenseless by draining its shields. They would then use a high-energy cutting beam to slice into the ship and remove entire sections. The reason for this procedure was that the Borg wanted to assess and assimilate new technologies and they could not do so if they completely destroyed the ship.

ADAPTIVE DEFENSES
Borg spheres were protected by ablative hull plating and multiregenerative shields that constantly remodulated their frequency and adapted to resist enemy fire. Once Borg shields had adapted, standard phasers and photon torpedoes on Starfleet vessels had almost no effect on them – but just a few quantum torpedoes could be enough to destroy a Borg sphere.

Like Borg cubes, the spheres were highly decentralized in structure, with no specific command center or engineering sections. All vital systems had multiple redundant power sources spread throughout the ship, so that the sphere

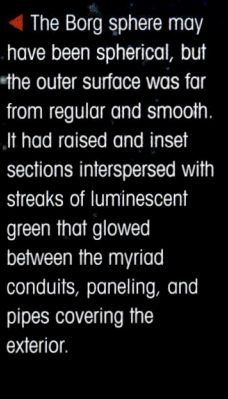

◄ The Borg sphere may have been spherical, but the outer surface was far from regular and smooth. It had raised and inset sections interspersed with streaks of luminescent green that glowed between the myriad conduits, paneling, and pipes covering the exterior.

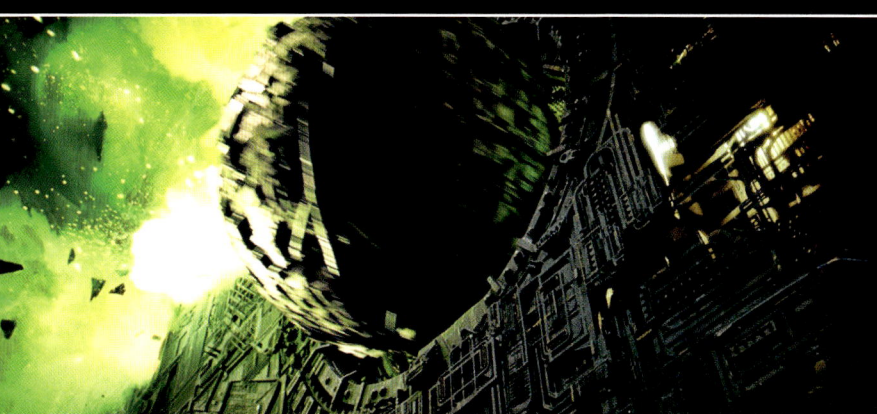

◄ During the Battle of Sector 001, a Borg sphere was ejected from a Borg cube as a kind of lifeboat, when the cube was on the point of destruction. It was the only time Starfleet recorded a sphere being used in this way. Normally, the Borg operated the spheres as independent, long-range tactical vessels.

| SHIP PROFILE | BORG SPHERE | OVERVIEW |

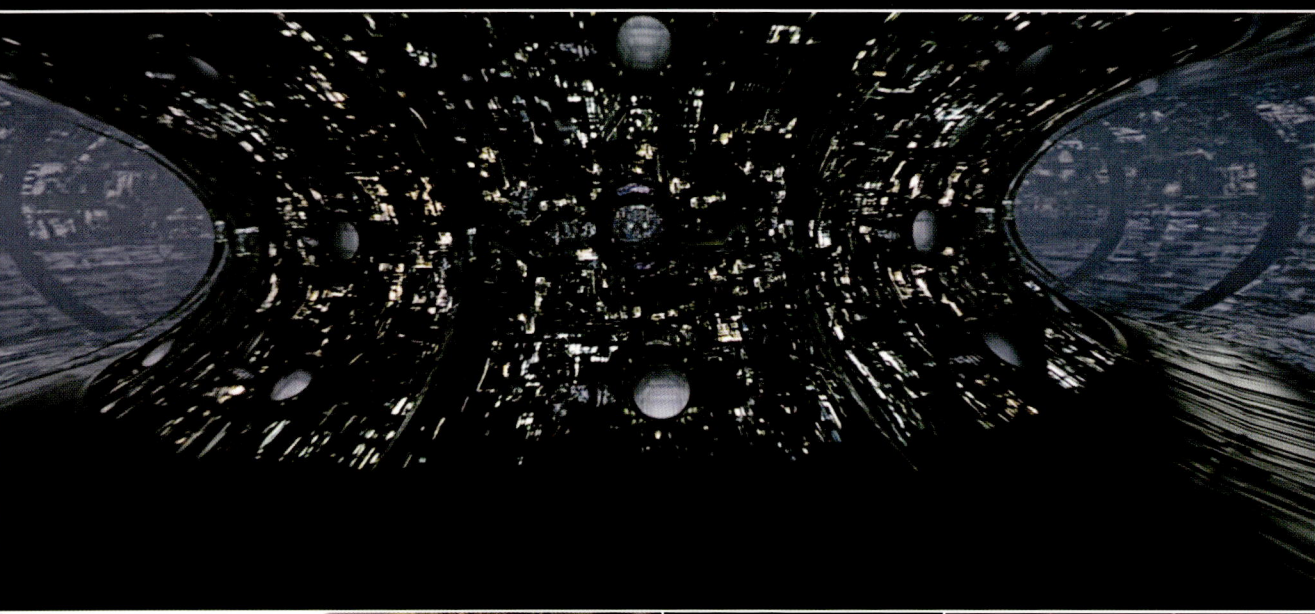

◀ A cylindrical core structure was at the center of every Borg sphere. The interior was vast – large enough to accommodate entire starships that could be broken down and assimilated, after being towed inside by tractor beams.

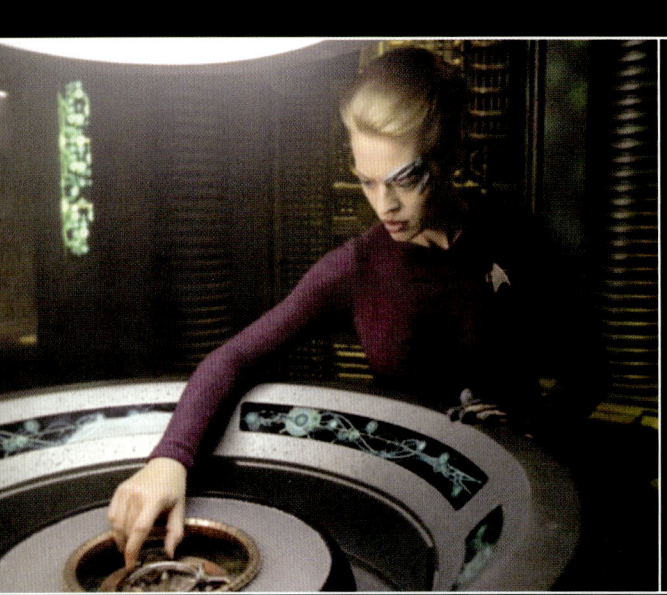

▶ The Borg sphere that was launched from the terminally damaged Borg cube during the Battle of Sector 001 was able to open a temporal vortex by emitting chroniton particles. The sphere then entered the vortex and traveled back in time to 2063, where it attempted to stop humankind making their first faster-than-light journey, which resulted in humanity's first contact with the Vulcans.

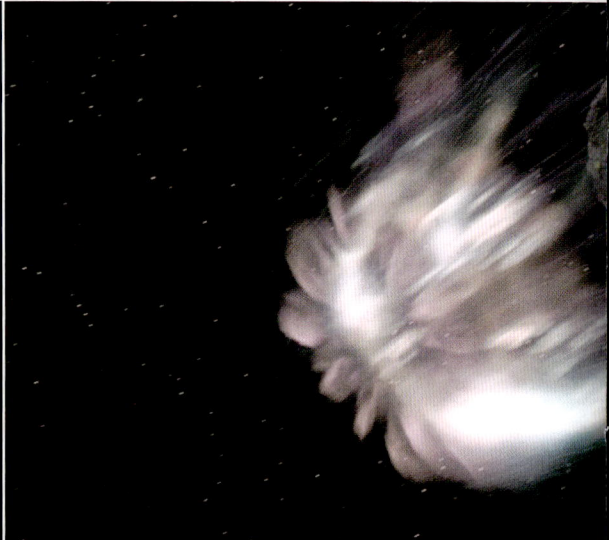

▲ Seven of Nine removing a transwarp coil. Each sphere was equipped with several transwarp coils, and these devices allowed the ships to travel at far greater speeds than was possible with a standard warp drive.

was highly resistant to damage and systems failures. It was estimated that a Borg ship could continue to function when as much as 78 percent of it was inoperable. Even if a vital system was damaged, the drones onboard could work collectively at an astonishing rate to repair it.

The atmospheric conditions inside Borg spheres were optimized for the drones, with a temperature set precisely at 39.1 degrees, 92 percent humidity, and atmospheric pressure at two kilopascals.

Most of the interior of a Borg sphere was taken up with row upon row of regeneration alcoves, where the drones "recharged" or were "stored" before they were activated for a specific task. When the drones were in an alcove, they did not register on Starfleet sensors as individual life-forms. This was partly because at the heart of each Borg ship was a processing device called a vinculum that used a transneural matrix to connect all the minds of the drones. This had the effect of eliminating individual thoughts and disseminating information throughout the Collective. Likewise, the central plexus was a device on a Borg ship that linked it to every other Borg ship.

CHAMBER OF HORROR

Other areas of a Borg sphere included assimilation chambers, where captured individuals were assimilated into the Borg collective. In this brutal procedure, the victim was stabbed by assimilation tubules and pumped full of Borg nanoprobes, before being laid out on a platform where various limbs and organs were amputated and replaced with Borg prosthetics.

SHIP PROFILE

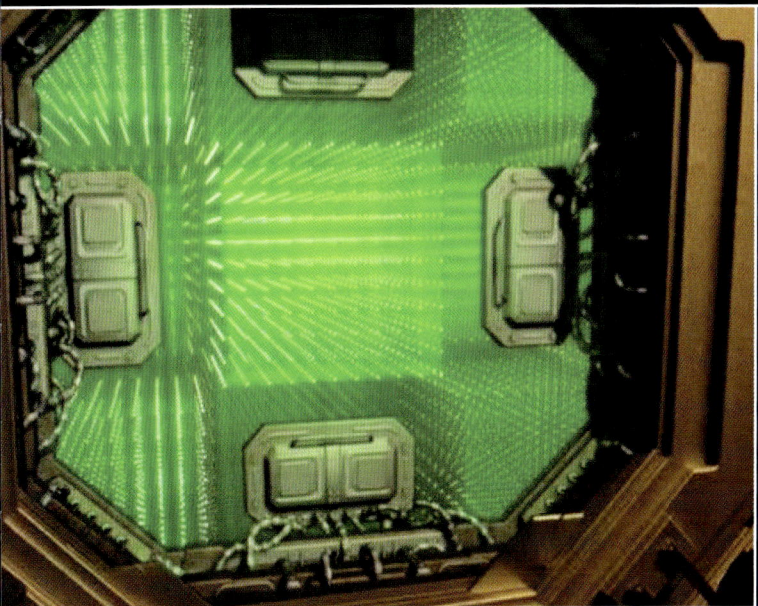

◀ Each Borg ship was equipped with a central plexus linking it to every other Borg ship via a sophisticated subspace communications network. This meant that each Borg ship instantly knew what every other Borg ship was doing at any given time.

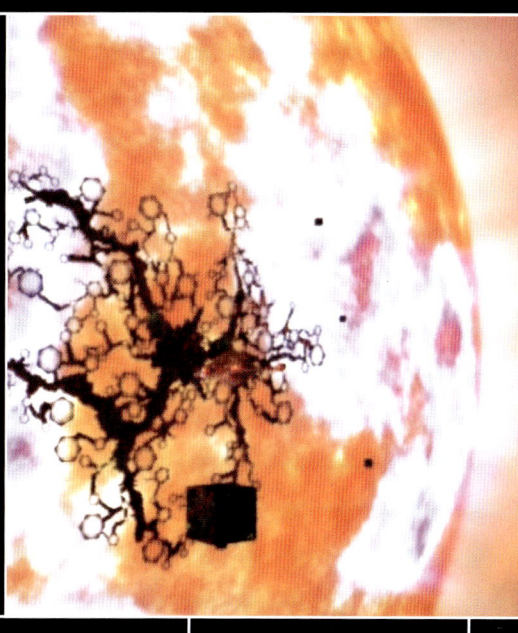

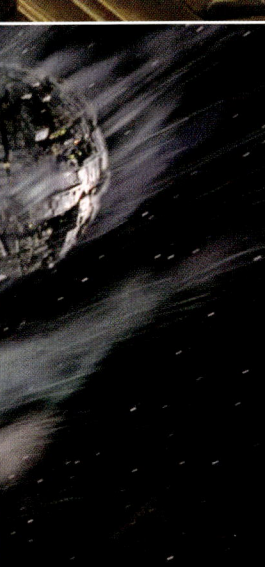

▶ Powerful tractor beams were a vital part of a Borg sphere's armaments. The beams could prevent a ship escaping while simultaneously draining its shields, so rendering it helpless. A cutting beam could then be used to slice out sections of the ship, which were tractored aboard the sphere. Here, the ship's technology and life-forms would be assimilated into the Collective.

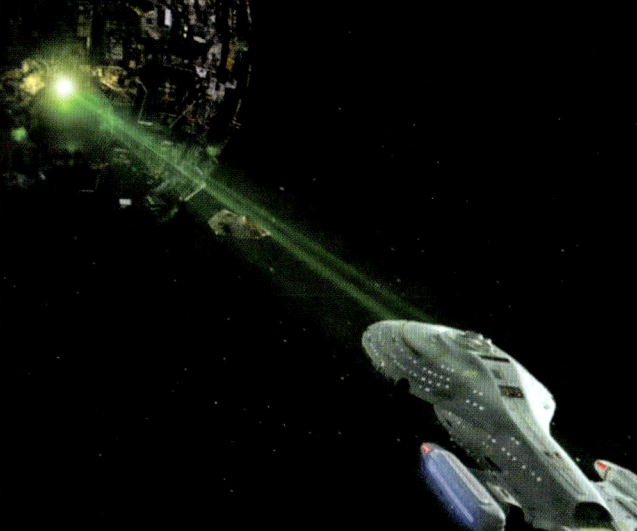

▲ In 2378, the crew of the *U.S.S. Voyager* NCC-74656 discovered a Borg transwarp hub hidden inside a nebula in the Delta Quadrant. This hub connected a network of transwarp conduits with exits throughout the Galaxy. By using these hubs, Borg vessels could travel tens of thousands of light years in a matter of minutes, far faster than any ship traveling at conventional warp.

Another feature of Borg spheres were transwarp chambers that contained several transwarp coils. The transwarp coil was a propulsion device and the key component in enabling Borg vessels to travel at least 20 times faster than was possible with standard warp drive technology. The coils were able to open an artificially created conduit – or corridor – in a realm of subspace known as transwarp space. A ship could then travel through this at incredible speeds.

By 2373, the Borg had created six structures, known as transwarp hubs, linking thousands of transwarp conduits that had exits in every quadrant of the Galaxy. One such transwarp hub was hidden within a nebula in the Delta Quadrant, and allowed Borg vessels to travel almost anywhere in the Galaxy in a matter of minutes.

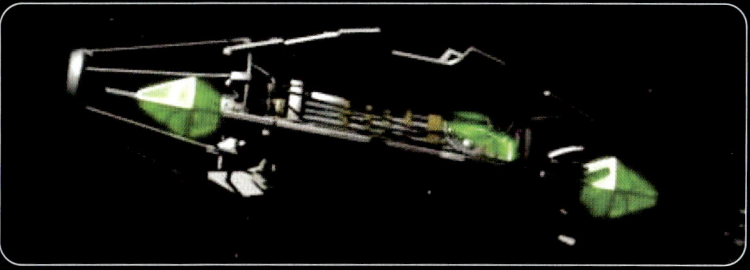

DATA FEED

One of the most important devices onboard a Borg vessel was the vinculum. This was a processing device containing a transneural matrix that linked the minds of the drones on the ship, so that all information was shared and they were enabled to act as one. The vinculum was also responsible for purging any memories of individuality that drones might retain from their former lives, before they were assimilated. The device was heavily shielded deep within the sphere, in order to protect it and prevent its deactivation.

19

▶ The inner 'core' section of the Borg Queen's ship remained still, while the outer framework rotated in an anticlockwise direction when it was traveling through space. It was much smaller than a Borg cube, but it was still a formidable offensive vessel in its own right, although it usually traveled with a multiple ship escort.

BORG QUEEN'S SHIP

The Borg Queen "lived" on a diamond-shaped ship, from where she controlled all aspects of the Collective.

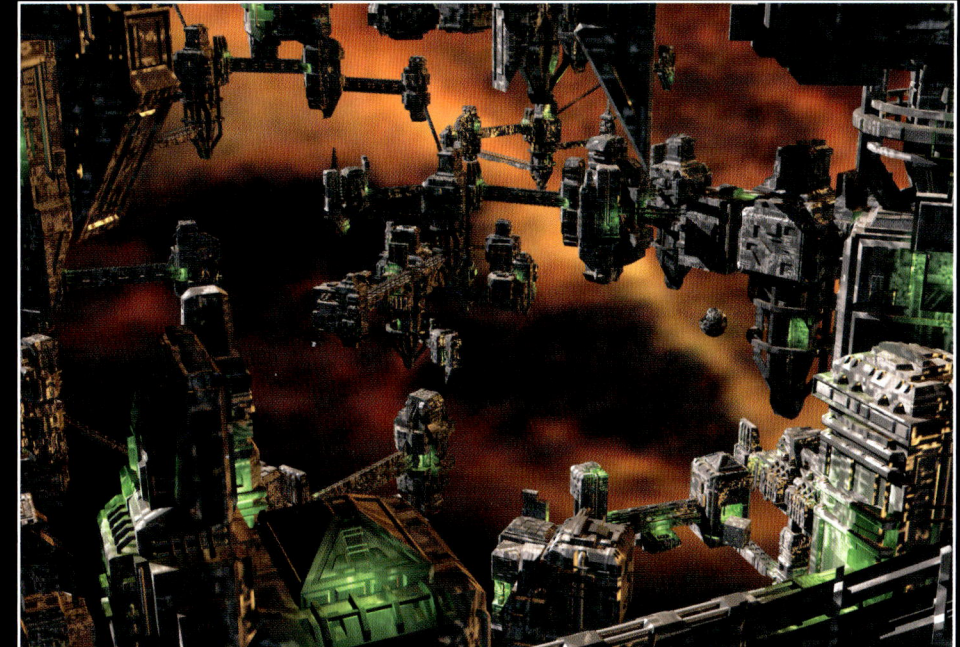

◀ The Borg Queen's ship was afforded maximum protection deep inside an enormous spaceborne Borg city, known as the Unicomplex. This was a vast infrastructure of interconnecting modules, grids, and technology that formed a cybernetic metropolis. It also contained thousands of Borg ships and trillions of Borg drones.

The Borg Queen's ship was strikingly different in appearance from other Borg vessels in that it was diamond-shaped – or more accurately, octahedron-shaped. As far as was known, the Borg Queen's vessel was unique, and normally located inside the Borg's Unicomplex.

This vast structure was the closest thing the Borg had to a home. It lay deep within the Delta Quadrant, and was composed of thousands of connected modules spanning at least 600 kilometers. Trillions of drones resided here, with many living on the hundreds of Borg ships that docked with the main structure. The Borg Queen's ship was heavily protected within the Unicomplex by all the vessels that made up this metropolis.

It was difficult to determine the exact size of the Borg Queen's ship, but it was certainly much smaller than a cube, and possibly smaller than a sphere. It was, nevertheless, larger than an *Intrepid*-class Starfleet ship – and much more powerful. It was capable of opening a transwarp conduit and flying at transwarp speeds, just like other Borg vessels. As with other Borg ships, the Queen's vessel was also extensively fitted with weaponry that included highly destructive projectiles, while its heavy shielding was backed up by ablative hull armor. In addition, it was capable of generating a dispersal field that prevented anyone from transporting on or off the ship.

ASSIMILATION CAPABILITIES

Other facilities inside the Borg Queen's ship included an assimilation chamber, where newly captured species were turned into drones, and a sophisticated sensor system that assessed the tactical abilities of other species.

The Queen's ship served as a kind of lair for the Borg leader. It appeared that, most of the time,

DATA FEED
A Borg transwarp coil was made from some kind of polytrinic alloy. It was the key component that allowed Borg ships to travel at transwarp speeds.

| SHIP PROFILE | BORG QUEEN'S SHIP | OVERVIEW |

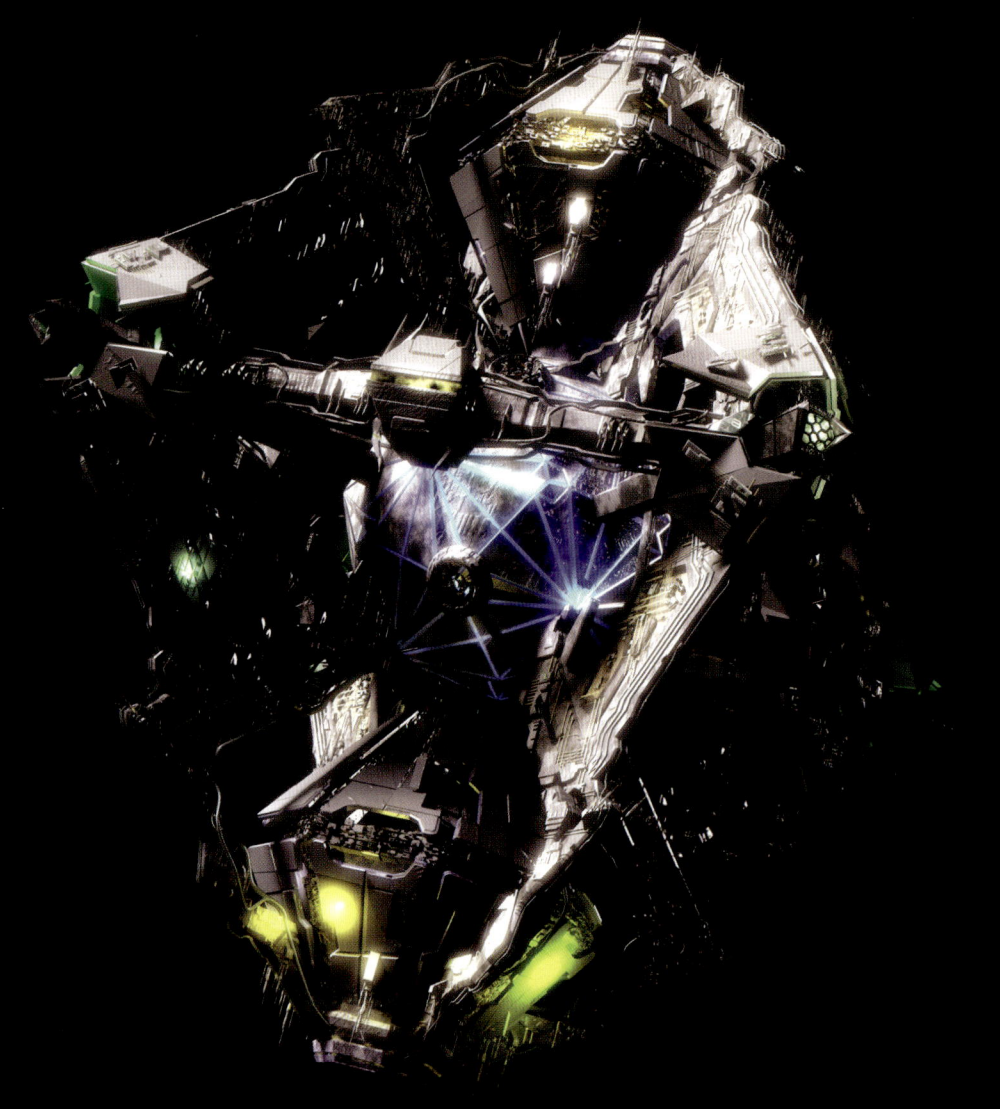

▶ A central chamber within the Borg Queen's ship was where the Queen was assembled into her humanoid form. Her head and upper torso were lowered from the ceiling, and secured to her waiting body.

▼ With Seven of Nine onboard, the Queen's ship traveled at transwarp speed to a planet where the Queen wanted Seven to witness the assimilation of its entire population.

▲ The diamond shape was unique to the Borg Queen's ship – no other Borg vessels took this form. Despite its singular structure, it appeared to have all the standard attributes of other Borg ships, and the familiar green energy signature.

the Queen was a disembodied entity that oversaw the Borg's operations. While her "consciousness" could be said to be located here, she was not limited to one physical place, and was aware of what all her drones and ships were doing, no matter where they were in the Galaxy.

When the Queen's physical presence was required, her head and upper torso descended from above a chamber in her ship, and was guided to meet her "Borgified" humanoid female body. Once in this form, the Borg Queen could control the Collective via a command interface situated within the chamber.

In 2375, the crew of the *U.S.S. Voyager* NCC-74656 encountered the Borg Queen's ship, following a successful mission to steal a Borg transwarp coil from a damaged sphere. During

the daring undertaking, Seven of Nine apparently chose to stay behind in the Borg sphere, while the other members of the away team escaped with the transwarp coil. In fact, the Borg Queen was aware of the raid, and allowed it to take place so that she could be reunited with Seven.

CONQUERING EARTH

The sphere took Seven to the Borg Queen's ship within the Unicomplex. The Queen wanted Seven to help the Borg prepare for another mission to assimilate humanity; since she thought Seven had a unique insight that would be valuable, given the Borg's two previous failed attempts.

The Queen's ship then left the Unicomplex, flanked by two Borg cubes, to witness the assimilation of Species 10026. The Queen wanted

SHIP PROFILE

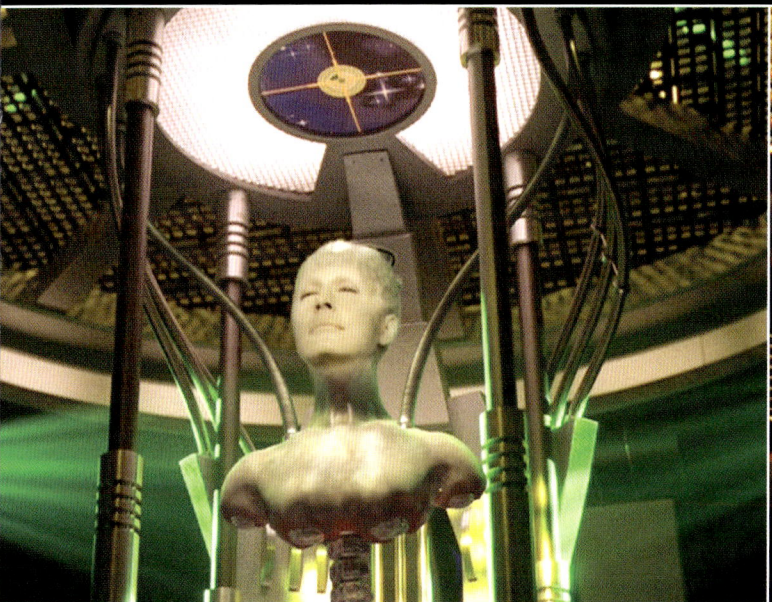
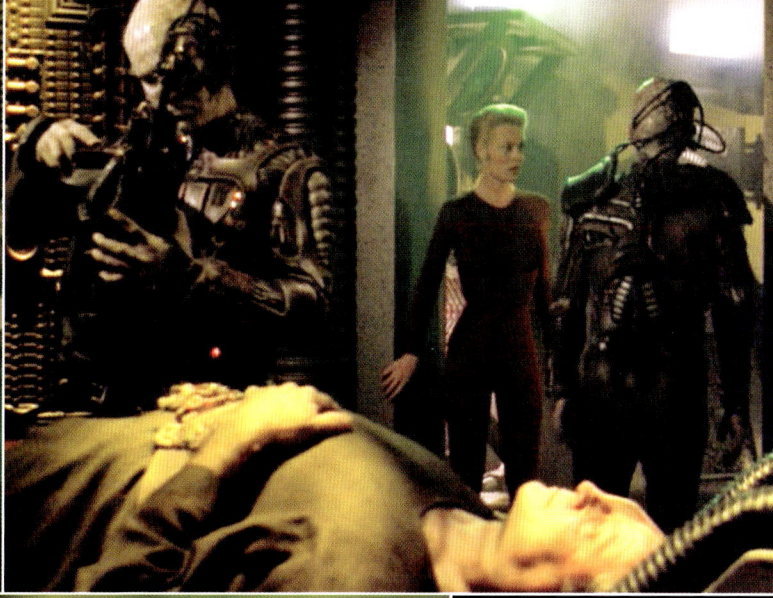

▶ After Seven of Nine was rescued, the *Delta Flyer* attempted to escape through a transwarp conduit, but the Borg Queen's ship managed to follow. Even at these extreme speeds, the Borg Queen's ship was able to launch projectiles, but the *Delta Flyer* made it safely back to normal space before their foe was destroyed.

▲ As with other Borg vessels, the Queen's ship contained an assimilation chamber. Captured individuals from other species were brought here to be turned into drones. The agonizing screams of victims could be heard as various body parts were removed and replaced with cybernetic prosthetics.

Seven to refamiliarize herself with the assimilation process, and remind her that it was a gift they were giving to other species: bringing order to chaos in their pursuit of perfection. The plan failed, however, as Seven refused to participate in the assimilation, and in fact helped some members of Species 10026 escape.

Seven of Nine was later rescued by a small away team in the *Delta Flyer*, which had been fitted with the transwarp coil. As they made their escape through a transwarp conduit, the Borg Queen's ship followed, firing its projectile weapons. When the *Delta Flyer* emerged back into normal space, *Voyager* fired a full spread of photon torpedoes at the conduit, causing it to collapse. Seconds later, the Borg Queen's vessel appeared, but it was in tiny pieces, having been blown to smithereens.

DATA FEED

The Borg Queen appeared to be the living embodiment of the Borg consciousness. She was the center of the Borg collective and was normally situated in her ship within the Unicomplex. From here, she controlled all the Borg ships and drones through a network of neural transceivers. She received a constant stream of information from her drones, and was instantly aware of everything they saw or experienced.

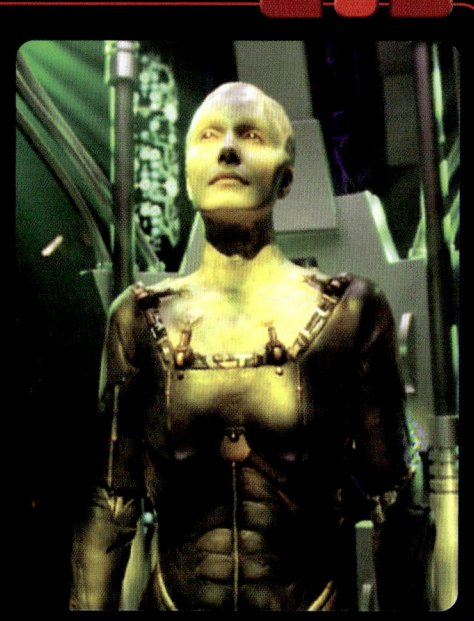

23

ENTICING SEVEN OF NINE

The Borg Queen claimed that she had deliberately allowed Seven of Nine to live among the crew of the U.S.S. Voyager, so that she could gain more insight into humanity. The Queen wanted Seven to rejoin the Collective with her individuality intact, as this would provide valuable information about how the Borg could finally defeat Earth at a third attempt.

The Queen had developed a more surreptitious strategy for conquering humanity, unlike their previous direct assaults. She had created a biogenic weapon to be detonated in Earth's atmosphere. It would infect all life-forms with nanoprobe viruses, resulting in a more gradual assimilation of humans. Although it would take longer than their usual methods, the Queen believed that half the Earth's population would be drones before they realized what was happening. Seven, however, refused to comply, and was ultimately rescued by Captain Janeway.

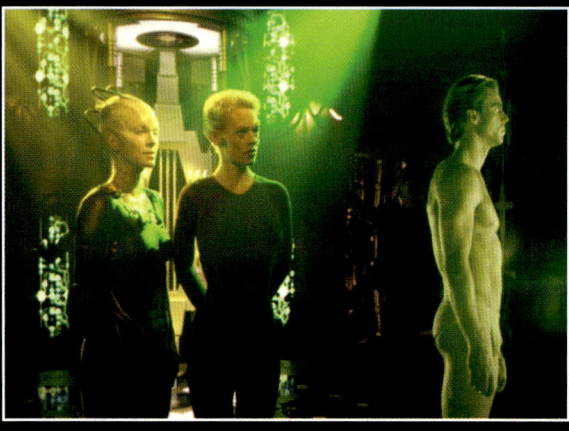

▲ In the central chamber aboard her ship, the Queen explained to Seven of Nine how she planned to conquer humanity. She had developed a biogenic weapon that would be detonated above Earth.

DATA FEED

Seven of Nine's father, Magnus Hansen, was a drone aboard the Borg Queen's ship. He had been assimilated 19 years earlier, although it was unclear if he had served on the Queen's ship all that time. The Queen tried to manipulate Seven into rejoining the Collective by telling her that she would be reunited with her father.

- Structural node
- Flight guidance sensors
- Central chamber

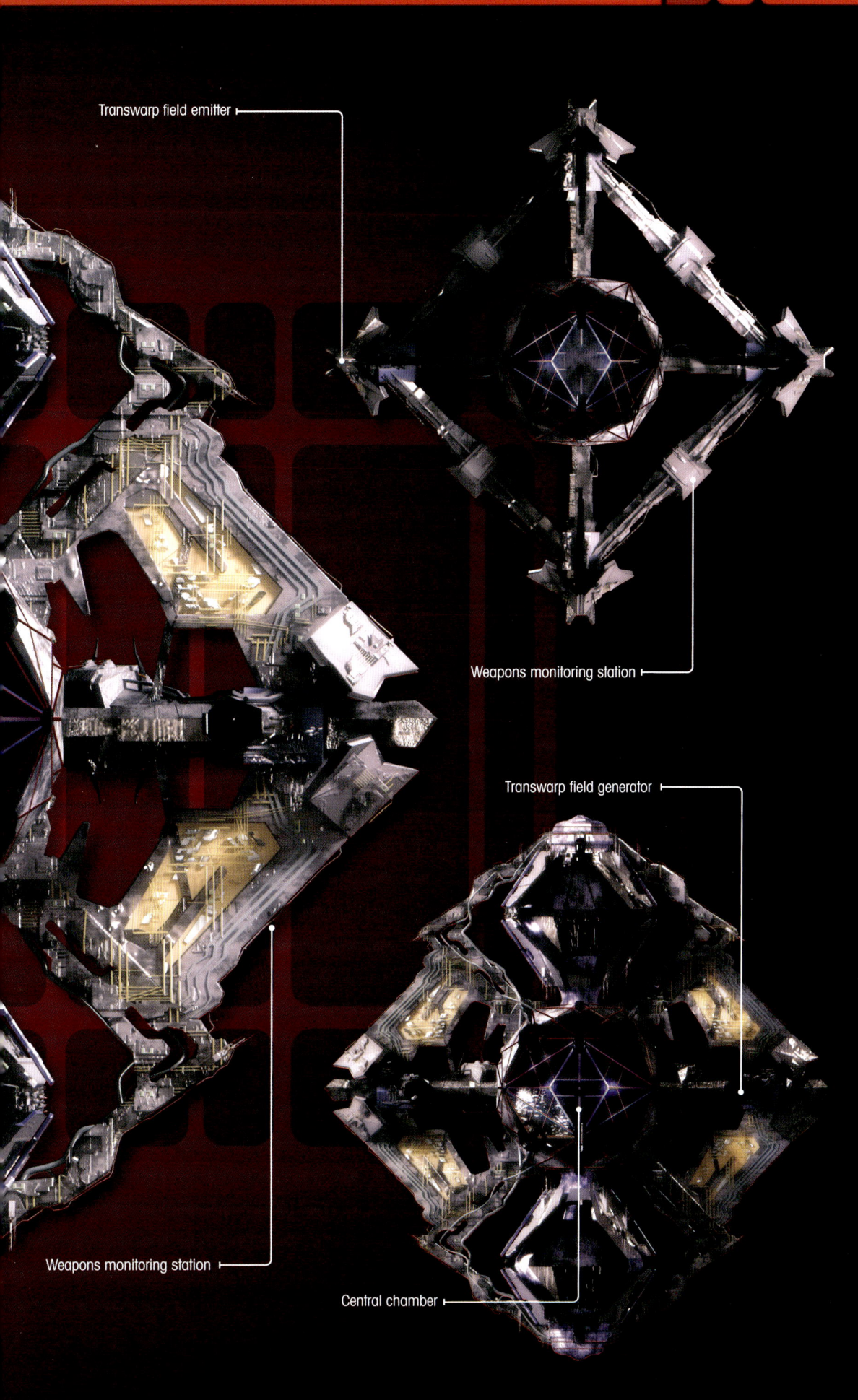

Transwarp field emitter

Weapons monitoring station

Transwarp field generator

Weapons monitoring station

Central chamber

SELF-DESTRUCTING

If a Borg ship was critically damaged, its transwarp coils were designed to fail beyond repair, by fusing the field regulator. This ensured the coils could not be used or studied by other species.

THOROUGH STUDY

Seven of Nine's parents, Magnus and Erin Hansen, compiled over 9,000 log entries and 10 million terraquads of data in the three years they spent studying the Borg at close quarters.

▼ The Borg renegade ship was so bizarre and haphazard in shape that it appeared to have been built by defective drones. In fact, this is precisely what happened after a rogue group fell into a state of chaos. These drones were only able to function and build a ship when Data's brother, Lore, became their leader.

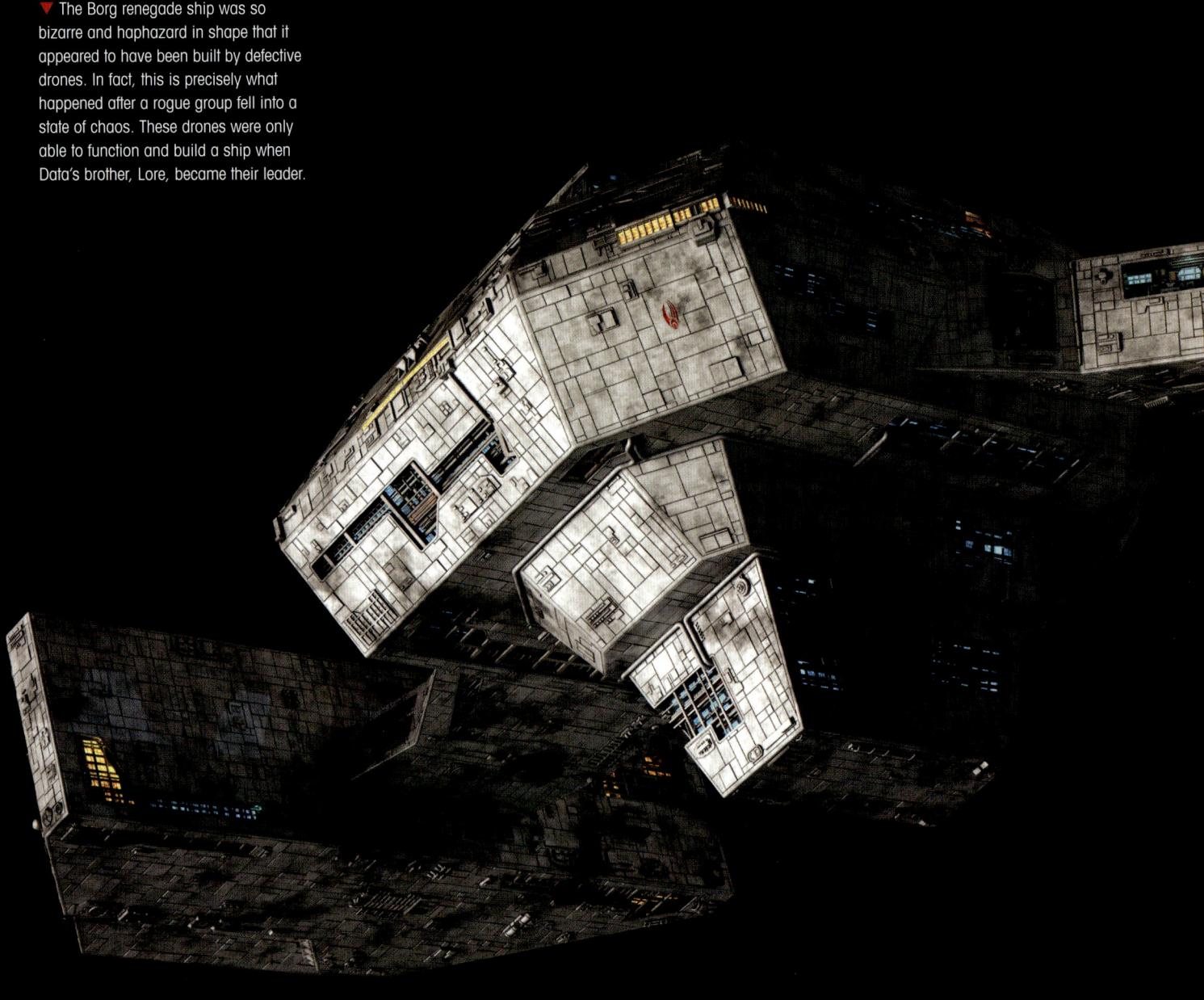

BORG RENEGADE SHIP

This unique Borg ship was built by a group of drones that had been disconnected from the Collective.

SHIP PROFILE

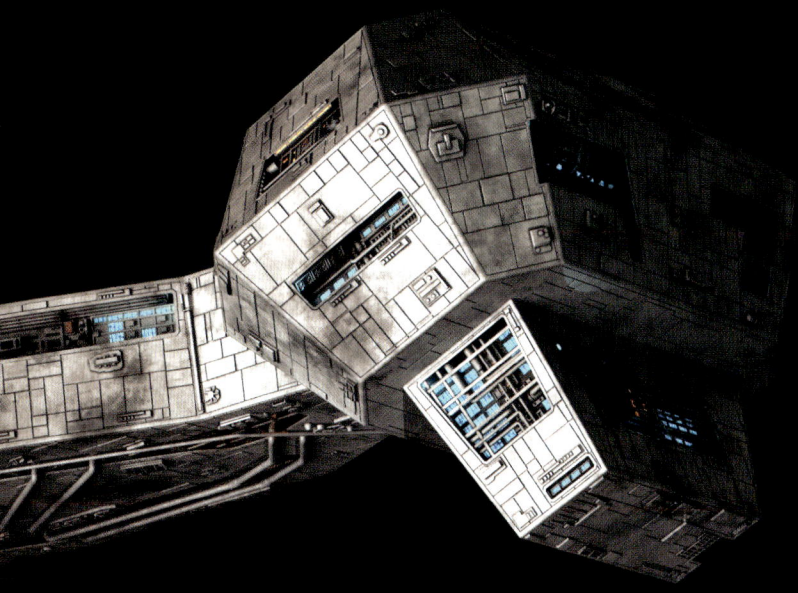

The Borg renegade ship was constructed by a group of Borg drones that had been disconnected from the Collective after regaining a sense of individuality. All Borg ships had previously been of a regular geometric shape, but the vessel built by these disconnected drones was wildly asymmetrical. Starfleet gave it the designation Borg Type 03, according to a display console.

It was unclear whether the ship had been built from scratch or had been "Borgified" from an existing vessel of an unknown alien species. It was certainly huge – much larger than the *U.S.S. Enterprise* NCC-1701-D, but probably smaller than a standard Borg cube. It appeared to be constructed from similar materials to other Borg vessels, but also included windows, which had previously been lacking in Borg design.

Despite its highly irregular shape, the renegade ship appeared to be just as powerful as other Borg craft. Its weapon systems included a green energy beam, similar to a particle beam, which could severely deplete the shields of a *Galaxy*-class ship with one blast.

It also used typical Borg methods of propulsion, and was capable of opening transwarp corridors by generating a high-energy tachyon pulse. When the vessel entered a transwarp corridor, it accelerated to an extremely high velocity – at least 20 times faster than a Starfleet vessel was capable of achieving.

The Borg renegade ship was first detected in 2369 after it attacked the Ohniaka III outpost, killing all 274 personnel. The crew of the *Enterprise*-D was sent to investigate and they learned that a rogue group of Borg was responsible.

DISCORDANT DRONES

The previous year, the *Enterprise*-D crew had captured a critically injured Borg drone. As he was nursed back to health, he acquired a sense of individuality and was given the name Hugh. He was offered asylum aboard the *Enterprise*-D, but he knew that the Collective would not stop looking for him, so he decided to go back. His newfound sense of self was passed on to the rest of the drones on his ship, which broke down their ability to function and caused chaos. Some Borg fought

DATA FEED
Fifteen Starfleet ships were deployed to try and track down the Borg renegade ship. These included the *Gorkan*, *Crazy Horse*, and *Agamemnon*.

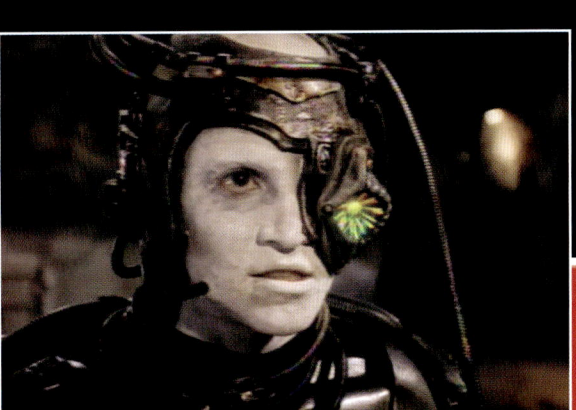

◀ The Borg known as Hugh gained a sense of individuality after spending a brief time on the *Enterprise*-D. On his return to the Borg, the drones on his vessel also became "infected," causing anarchy. These drones were cut off from the Collective, after which they encountered Lore, who helped them build their own ship.

SHIP PROFILE | BORG RENEGADE SHIP | OVERVIEW

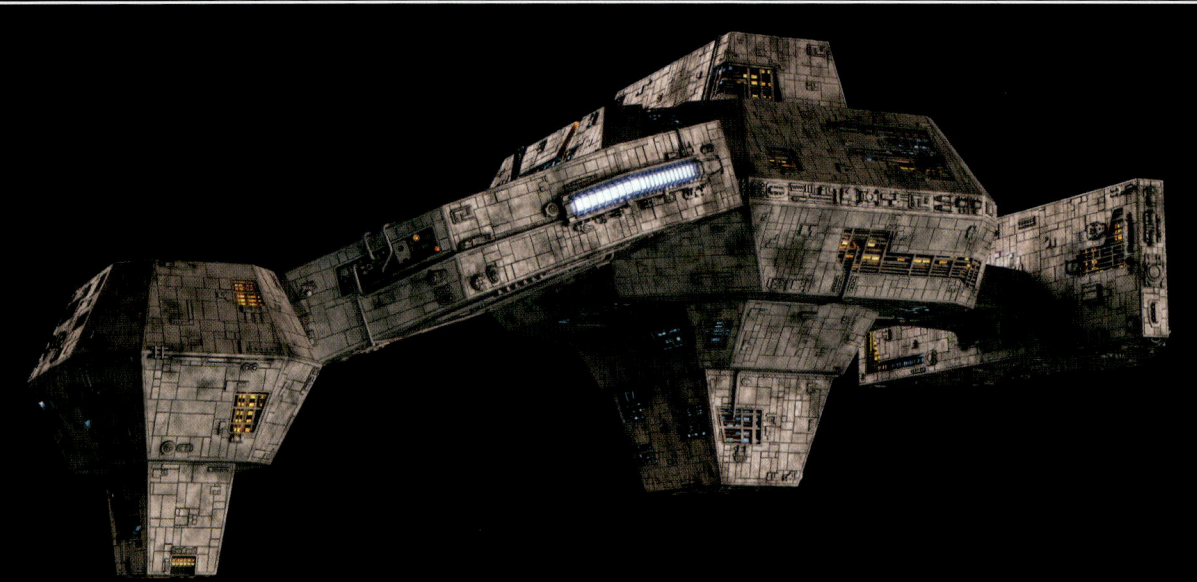

◀ The renegade ship was made up of a series of regular shapes assembled in a random fashion. It was highly decentralized, like other Borg vessels, which made it extremely resistant to damage.

▶ The *Enterprise*-D came under attack while waiting for the away teams to conduct a search for Data on the planet. The *Enterprise*-D was forced to retreat before all the crew could be beamed up.

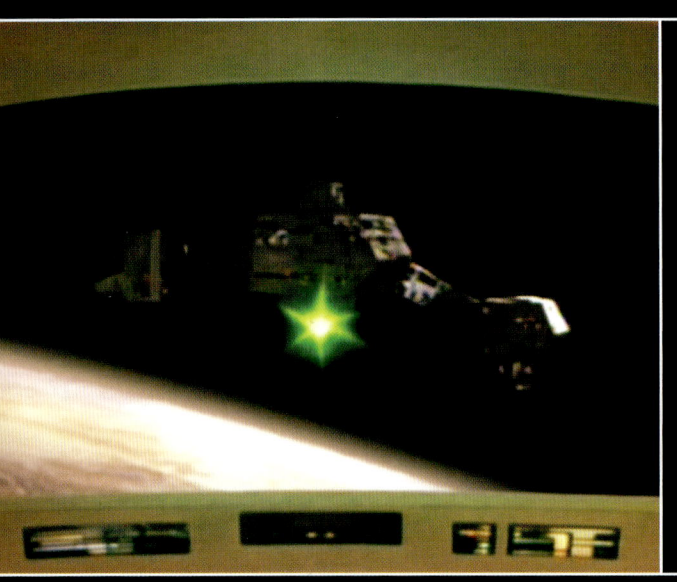

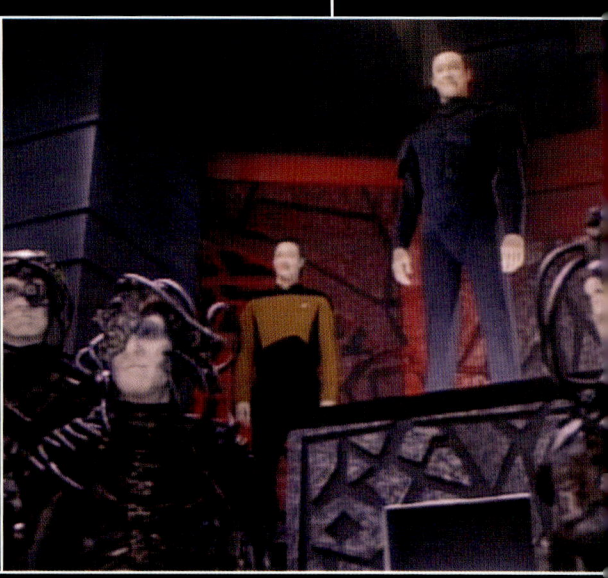

▶ Lore modified the emotion chip designed by his father, Dr. Noonian Soong, to remotely instill anger and hatred in Data. With his ethical subroutines disabled, Data joined Lore along with his small army of drones at their base on a planet.

▲ The renegade ship may not have looked like any other Borg vessel, but it was just as deadly. It featured weapons of huge destructive power and easily outgunned the *Enterprise*-D, whose own weapons caused almost no damage to the Borg ship.

each other, some disconnected themselves, and many even starved to death.

These drones were still in a state of extreme confusion when they encountered Data's unstable brother, Lore. They were so lost and frightened that they were willing to listen to any voice offering them clarity of purpose and a way out of their confusion. Lore became their leader by promising to make them into the perfect artificial life-forms.

Lore, however, had an ulterior motive: he wanted to lure Data to his side; eventually his brother was indeed manipulated to join him. The crew of the *Enterprise*-D tracked the Borg to a remote planet, where they had set up a base. This planet had an unusual EM field that prevented the *Enterprise*-D's sensors from working, so most of the crew beamed down to the surface to begin a search. Meanwhile,

a skeleton crew was left on the *Enterprise*-D, with Dr. Beverly Crusher taking over as captain.

RESCUE PLAN

While in orbit of the planet, the *Enterprise*-D was attacked by the Borg renegade ship. The *Enterprise*-D was forced to retreat, leaving 47 crew on the planet. Together with the reserve bridge crew, Crusher formulated a plan to return by entering orbit from the other side of the planet, hoping not to be detected immediately.

The *Enterprise*-D bought enough time to beam up all but the senior crew before the renegade ship located them and fired. The *Enterprise*-D's port nacelle was hit, taking out the warp drive. Unable to escape, Crusher ordered a highly experimental technology, known as metaphasic shielding, to

SHIP PROFILE

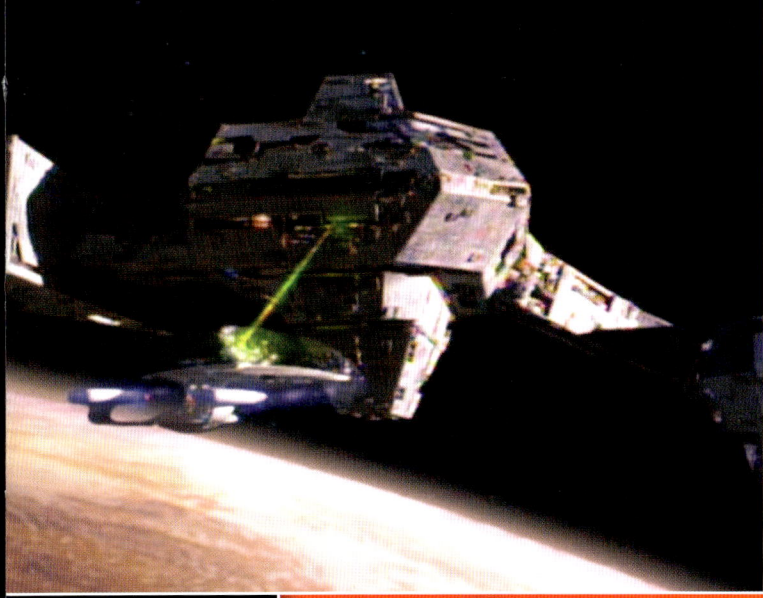

▶ Dr. Crusher was forced to implement metaphasic shielding, an untested technology, to hide from the Borg inside the corona of a star. When the shielding began to fail, they aimed a particle beam into the sun that caused a solar fusion eruption to reach out and engulf the Borg ship, reducing it to ashes in seconds.

▲ Ensign Taitt was a junior officer who served as part of the bridge crew when Dr. Crusher took command. Despite her inexperience, she came up with the plan to create a solar flare that they hoped could be directed toward the Borg renegade ship.

be brought online. In theory, it would allow the *Enterprise*-D to safely enter a nearby sun's corona, but prevent the Borg ship from following.

This solution could only work temporarily, because the ship would soon be consumed by the intense heat. Fortunately, Ensign Taitt, who had done a senior honors thesis on solar dynamics, came up with an idea. Using the tractor emitter to create a particle beam, they fired at a precise point on the sun, causing a superfluid gas eruption to burst from the corona and engulf the renegade ship.

With the Borg ship destroyed, the *Enterprise*-D could return to the planet, where Captain Picard, with the help of Hugh, had defeated Lore. Data deactivated Lore, while the rest of the Borg drones hoped they could learn to function as a separate group, with Hugh as their leader.

DATA FEED

The renegade Borg called Lore "The One," and he gave them individual names. Under his tutelage, the drones became deadlier than ever. They did not move slowly any more, nor react only if something became a threat to them. Emotion and death were no longer irrelevant, as the loss of one of their fellow drones elicited a vengeful response. According to Commander Riker, these Borg were fast, aggressive, and almost vicious.

TRANSWARP TECHNOLOGY

As with other Borg vessels, the renegade ship was capable of achieving transwarp speeds. First, the ship emitted a tachyon pulse, which opened a transwarp corridor. The ship then entered this conduit and was immediately accelerated to an extremely high warp velocity. In the words of Lieutenant Commander Geordi La Forge, it was "like falling into a fast-moving river and getting swept away by the current."

The *Enterprise*-D found that it could open a transwarp corridor by using the main deflector to emit a tachyon pulse and then alternating its frequencies. After entering the conduit, it emerged 65 light years from its previous position in a matter of seconds. The crew were, however, unable to control their direction of travel using this method, and it caused severe shaking of the ship, with power levels dropping by 67 percent.

▲ The crew of the *Enterprise*-D watched their viewscreen as the renegade ship opened a subspace distortion, allowing it to enter a transwarp conduit and travel tens of light years in seconds.

DATA FEED
The Borg renegade ship destroyed several Federation outposts, including a research station at Ohniaka III where all 274 personnel were killed, and the MS-1 Colony – although this time the *Enterprise*-D arrived in time to save some of the colonists.

- Radiative cooling vent
- Transwarp field controller
- Dorsal sensor platform
- Transwarp propulsion housing
- Materials processing block

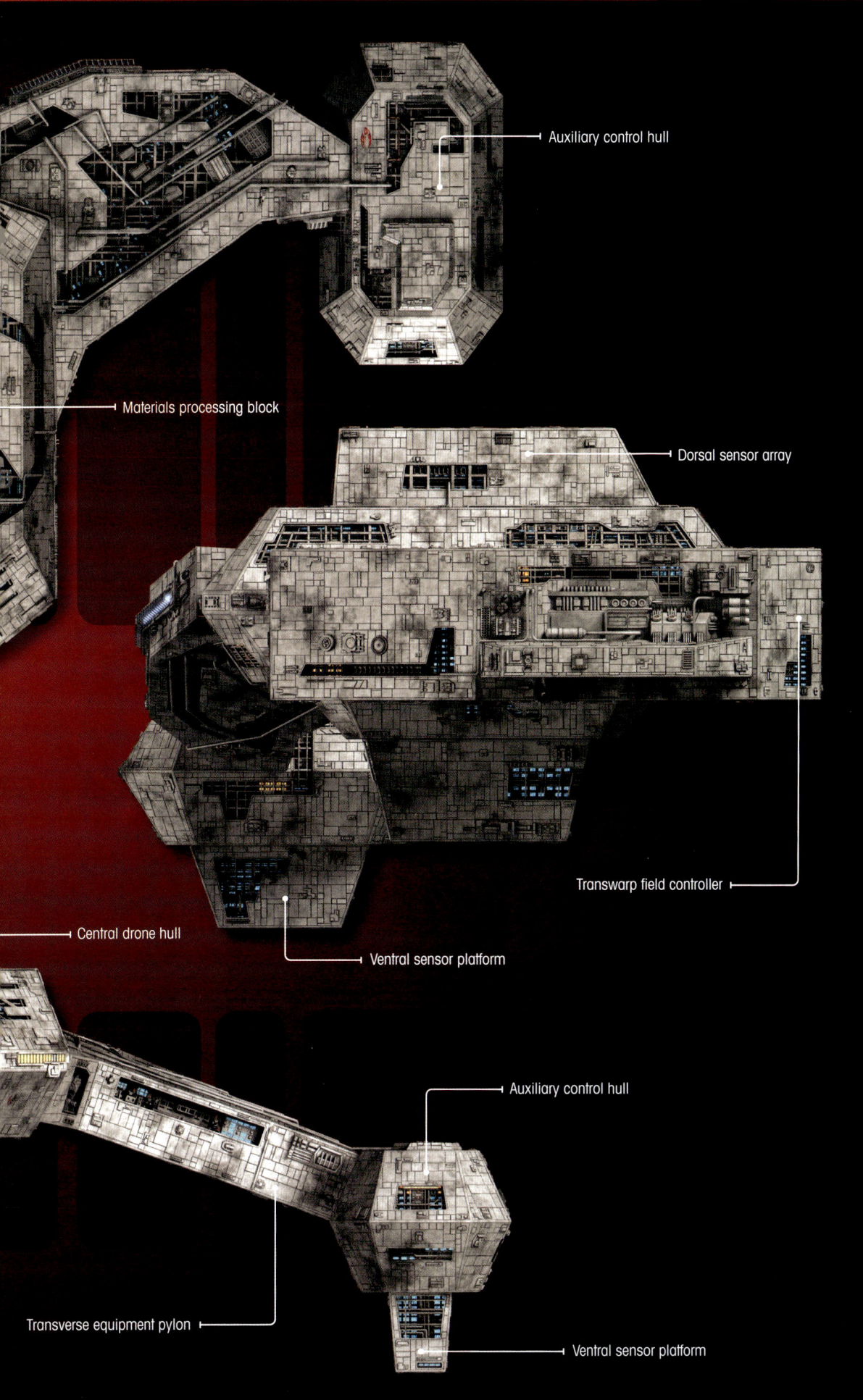

BORG NAMES

Lore gave names to all the Borg drones that were infected with Hugh's sense of individuality. These included Crosis, Goval, and Torsus. Crosis acted as Lore's second-in-command and made sure all the other drones remained connected.

FAMILIAR SHAPE

The Borg renegade ship was the same shape as the multikinetic mine deployed by the Borg as an attempted defense against Species 8472, in 2374.

SUN SHIELD

Metaphasic shielding was a form of subspace shielding technology invented by Dr. Reyga, a Ferengi scientist. It was capable of withstanding the pressure, radiation, and energy of a star's corona. In 2369, Dr. Crusher demonstrated the shield's effectiveness by piloting the *Justman*, a type-6 shuttle, into the corona of the star Veytan.

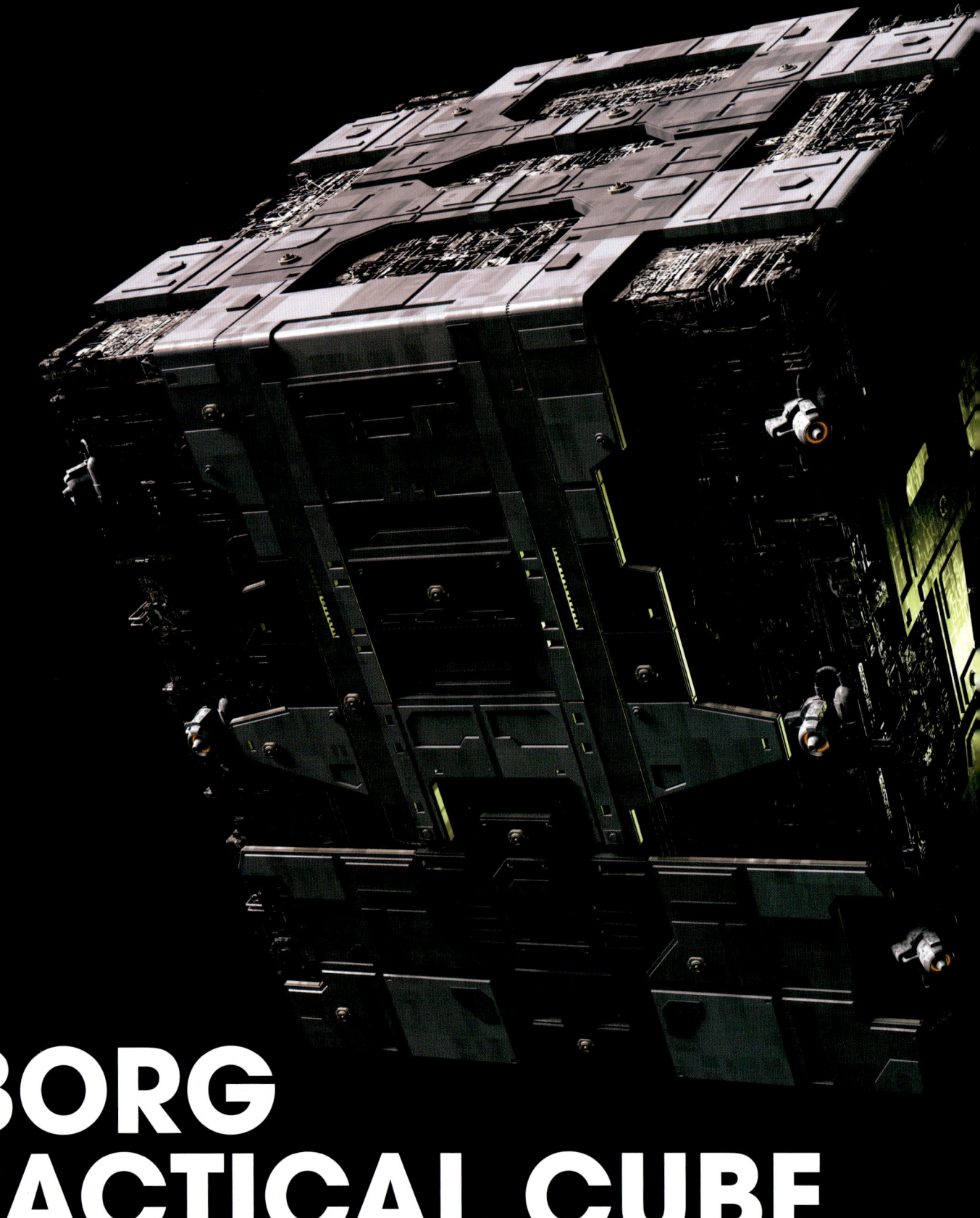

BORG TACTICAL CUBE

The Borg tactical cube was the most powerful of all Borg vessels, and the ultimate in assimilation hardware.

SHIP PROFILE

DATA FEED

All Borg drones, no matter how far apart they were in the Galaxy, were joined in a hive mind, or collective consciousness, via their neural transceivers. Each Borg ship was equipped with a vinculum that interconnected the minds of all drones onboard, while another device called the central plexus connected all their ships together.

As if a standard Borg cube wasn't powerful enough, in 2376 the crew of the U.S.S. Voyager NCC-74656 encountered an even more formidable Borg ship: a class-4 tactical cube. This type of Borg vessel possessed all the usual features of a cube, as well as enhanced shielding in the form of extensive armor plates that covered most of its exterior.

The fact that Voyager did not come across a tactical cube until 2376, some three years after it first encountered a Borg cube in the Delta Quadrant, suggested that it was added to the Borg fleet around this time. The extra defenses were perhaps developed in response to the Borg's encounters with Species 8472, whose vessels were not only able to resist attacks from Borg cubes, but were able to destroy them with relative ease.

Seven of Nine described the tactical cube as being "heavily armed," indicating that it also possessed superior firepower compared to a standard Borg cube. It was certainly equipped with powerful beam and projectile weapons, while it also displayed the ability to access Voyager's tactical controls in order to lower the Starfleet ship's shields.

INTERNAL CONFIGURATION

The interior of the tactical cube appeared to be similar to other Borg cubes in that it featured a generalized design with no specific command center, living quarters, or engineering sections. The internal architecture did appear to differ in one significant way, however, in that its central plexus was protected by multiregenerative security fields.

The central plexus was one of the most important components of a Borg vessel, as it was the communication device that linked the ship to all other Borg ships. This meant that the status of each Borg cube, or whatever information it assimilated,

▲ The Borg tactical cube retained the classic cube shape of most Borg vessels, but it also featured extensive armor that covered a large portion of the hull. Those areas not covered with the protective plating glowed with the familiar green Borg power signature.

SHIP PROFILE — BORG TACTICAL CUBE — OVERVIEW

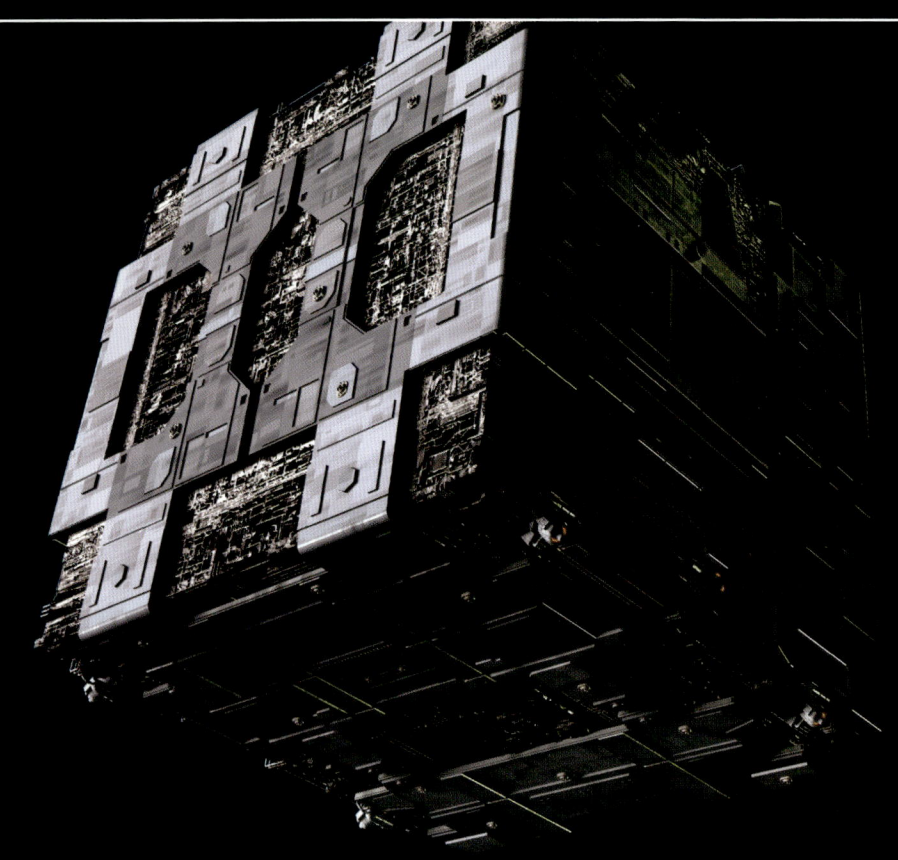

◀ Like all Borg cubes, the tactical cube was enormous, being more than three kilometers in both height and width. It made for an intimidating sight, and with good reason. It was bristling with firepower that included beam and projectile weaponry, while it also displayed the ability to hack into *Voyager*'s tactical systems and lower its shields.

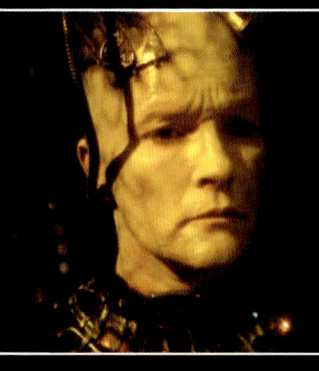

▶ There was no way for an away team to infiltrate the tactical cube without being detected. The Doctor administered them with a neural suppressant that temporarily allowed them to retain their individuality and carry out their mission.

▲ When inside the virtual world of Unimatrix Zero, the Borg drones could choose to appear as their former selves. While inside this artificial construct, Seven of Nine formed a close friendship with Axum, and later tried to help him stop the Borg Queen from destroying Unimatrix Zero.

was instantaneously broadcast to every other Borg cube, no matter how far apart they were from each other. This was one of the Borg's greatest strengths as it allowed them to act as one, and coordinate their efforts in a way no other species was able to do.

Given the importance of the central plexus, it was afforded a high level of protection, and on a tactical cube it was located in an area surrounded by muti-regenerative security grids. These ensured that not only would it be protected from damage in an external attack, but also that any intruders would be detected long before they could reach this vital area.

Ironically, while the central plexus provided the Borg with one of their greatest strengths, it also

proved to be an area of vulnerability that the *Voyager* crew were able to exploit. When Captain Janeway learned that there were thousands of Borg drones who were living as individuals free from the Borg Collective in an artificial construct known as Unimatrix Zero, she was determined to help them.

INFECTING THE CUBE

A plan was formulated to infect the central plexus of a Borg tactical cube with a nanovirus that would then be instantly disseminated throughout the Collective. The nanovirus was designed to allow the members of Unimatrix Zero to retain their individuality in the real world, and in the process create a Borg resistance movement from within.

SHIP PROFILE

◀ *Voyager* attacked the cube and weakened its shield emitters enough for an away team to beam on board.

▶ B'Elanna Torres was able to download the nanovirus directly into the central plexus using her assimilation tubules.

▼ The Borg Queen instructed the tactical cube to self-destruct in order to stop the away team from escaping, but they were beamed back to *Voyager* with just seconds to spare.

◀ The central plexus was located in a room deep within the tactical cube that was protected by multiregenerative force fields. The away team could not gain access directly as it would have meant shutting down the power grid for the entire section, an act that would have alerted the Borg to their presence. Instead, they gained entry through a primary access port that was separate from the main power grid.

As there was no hope of an away team reaching the tactical cube's central plexus without being detected, Janeway, Torres and Tuvok allowed themselves to be partially assimilated so they could infiltrate the ship.

Once on board the tactical cube, the away team made their way to the central plexus via a primary access port that was isolated from the main power grid, and successfully downloaded the virus. By this point, *Voyager* was struggling to repel the assault by the tactical cube, but the virus had taken effect. In an effort to stop the away team from escaping, the Borg Queen ordered the tactical cube to self-destruct, but they were beamed through the cube's failing shields and back to *Voyager* just seconds before it exploded.

DATA FEED

Unimatrix Zero was an idyllic virtual world created by Borg drones who had a recessive genetic mutation. This allowed them to remember their former lives and visit here as individuals, while regenerating in their alcoves. When the Borg Queen learned of these renegade Borg, she tried to find a way to destroy them. One of the renegade Borg named Axum called Seven of Nine back into Unimatrix Zero in the hope she could help them save their virtual world.

| SHIP PROFILE | BORG TACTICAL CUBE | PLAN VIEWS |

PERILOUS PLAN

The *U.S.S. Voyager* NCC-74656 undertook one of its most dangerous missions when it engaged a Borg tactical cube in battle in order to get the partially assimilated Janeway, Tuvok and Torres aboard the Borg ship. *Voyager* concentrated its fire on the secondary emitter on the ventral axis of the cube, which eventually produced a 0.06 terrahertz fluctuation in one of its shield grids. The *Delta Flyer* was then able to fly close enough to the cube to beam the away team through the damaged shield grid. Immediately after the successful transport, the *Delta Flyer* was blown to molecules by a short barrage of Borg torpedoes, but by this time the away team were on their way to successfully deploying the nanovirus in the central plexus of the tactical cube.

▲ The *Delta Flyer* was blown to pieces by a Borg projectile fired from the tactical cube just after the away team had managed to transport across to it through a minor fluctuation in its enhanced shields.

DATA FEED

A Borg sphere commandeered by Korok, a former Klingon who possessed the mutated gene that allowed him to be part of Unimatrix Zero, helped save Captain Janeway, Tuvok and Torres from the tactical cube. His sphere targeted the shields of the tactical cube in sub-grid 42, causing them to destabilize enough for the away team to be beamed to safety.

Projectile weapon

Beam emitter

| BORG TACTICAL CUBE | PLAN VIEWS |

Hull armor

Shield grid emitter

Projectile weapon

Beam emitter

Projectile weapon

Hull armor

HUGELY RESILIENT

Thanks to its highly decentralized structure, it was estimated that a Borg cube could remain functional even if 78 per cent of it was rendered inoperable.

CUBE DESIGNATIONS

The Borg tactical cube encountered by the crew of *Voyager* was referred to as tactical cube 138 by the Borg Queen, perhaps indicating that there were at least 138 of them. Seven of Nine referred to it as a class-4 tactical cube.

DRONE COMPLEMENT

The number of drones aboard a Borg cube could vary widely. Some cubes had a complement of just 5,000, while others had 64,000. The Borg cube encountered by Seven of Nine's parents was said to have as many as 129,000 on board.

▼ Like all Borg vessels, the probe was a simple geometric shape that comprised of various plates and tube-like girders stuck on its exterior in a seemingly haphazard manner, with green energy signatures shining out from within. Its primary function appeared to be explore space in search of technology worthy of assimilation.

BORG PROBE

A Borg probe was not an unmanned craft, but the smallest ship in the Borg fleet in the 24th century.

SHIP PROFILE

At around 180 meters in length, the Borg probe was the smallest ship that the cybernetic species was known to use in the 24th century. It was oblong-shaped with rounded edges, and resembled a giant casket.

It appeared to function as a long-range scouting vessel and was operated by a crew of no more than 200 drones, far fewer than on other Borg ships. It was equipped with all the standard Borg technology of the time, including transwarp propulsion, energy beam weaponry, and defenses in the shape of deflector shields and ablative hull armor. Its tactical abilities, however, were not as powerful as larger Borg ships', and the probe's offensive and defensive capabilities were similar to those of the U.S.S. Voyager NCC-74656.

RESILIENT DESIGN

As with all Borg vessels, the probe had a highly decentralized design. This meant that there was no specific command center, and most of the vital systems were duplicated throughout the ship, so it was much less vulnerable to an attack on a specific area. It was therefore able to remain operational even after taking substantial damage.

There was also no need for living areas, such as a galley or personal quarters, since the drones had no need of these amenities. Instead, the interior was tightly packed with Borg alcoves, where the drones regenerated, and various catwalks and conduits leading to vital systems and consoles.

In 2375, Captain Janeway decided to attack a Borg ship in the hope of disabling it and stealing some of its technology. The item she most wanted to acquire was a transwarp coil, the primary Borg propulsion device that allowed them to cross vast distances of space in minutes.

Of course, Captain Janeway fully realized that taking on a Borg ship was extraordinarily dangerous. She therefore resolved to attack their weakest ship: a probe.

DATA FEED
A transwarp coil was a Borg propulsion device that enabled their ships to travel much faster than Starfleet vessels. A coil needed at least 30 teradynes of force to create a transwarp conduit.

◀ In 2375, the crew of the U.S.S. Voyager allowed themselves to be "found" by the least powerful ship in the Borg fleet – the Borg probe. Although the two ships were equally matched in terms of combat capabilities, the Voyager crew hoped to disable the probe and remove some of its technology.

SHIP PROFILE — BORG PROBE — OVERVIEW

▲ A Borg probe was much smaller than other Borg vessels and not nearly as powerful. It was, nevertheless, equipped with similar technology and capable of transwarp speeds. It was also able to identify ships and technology worthy of assimilation, but its combat capabilities were much lower than those of the larger Borg cube.

When *Voyager* was targeted by the probe, Janeway warned the Borg crew to break off their attack, pointing out that they were equally matched in terms of firepower. But the Borg, implacable as ever, continued with their assault. *Voyager* took several hits from the probe's energy weapons, which had no effect; returning fire, *Voyager* inflicted some damage to the probe.

The probe started to regenerate its primary shield matrix and remodulated its weapons in preparation for another attack. However, in the fraction of a second that it took to change the frequency of the probe's shields, *Voyager* beamed a photon torpedo directly onto the Borg ship.

Even as a drone went to disarm the weapon, it exploded with spectacular effect, causing the entire probe to shatter. Millions of fragments of the ship littered the area, while the *Voyager* crew wondered how they had managed to destroy it rather than just disable it.

AMPLIFIED EXPLOSION

Seven of Nine had the answer to that question: she surmised that the torpedo had detonated right next to the probe's power matrix, triggering a catastrophic chain reaction. All that remained was ship debris, but Janeway ordered her crew to sift through the pieces to see if they might salvage something of worth.

The Starfleet crew recovered two power nodes and a dozen plasma conduits, along with a type of auto-regeneration unit that was still scuttling around on the floor of cargo bay 2. The Doctor also retrieved a servo-armature from a medical repair

SHIP PROFILE

▶ After the Borg probe and *Voyager* had exchanged fire, the probe remodulated its shields to adapt to the frequency of *Voyager*'s phasers. During this small window, *Voyager* seized the opportunity to beam a photon torpedo aboard the probe. Before the drones managed to disarm it, the torpedo detonated and an explosion ripped through the probe.

▶ Debris from the probe was brought aboard *Voyager* and gathered in cargo bay 2. The Starfleet crew searched through the wreckage to see if anything could be salvaged. One of the items that still worked was an arm from a medical repair drone, which the Doctor promptly claimed to help him carry out surgery.

▲ The *Voyager* crew only wanted to disable the Borg probe, but because the photon torpedo landed near the probe's main power matrix, it caused a devastating explosion. The probe was torn apart from the inside, leaving just fragments of the ship floating around in space.

drone, complete with laser scalpel, biomolecular scanner, and micro-suture.

Voyager's encounter with the Borg probe was not a total waste. One of the datanodes they recovered contained tactical information showing the long-range sensor telemetry, assimilation logistics, and Borg vessel movements for a radius of 30 light years.

This data allowed *Voyager* to avoid any run-ins with Borg vessels, but when it also revealed a Borg sphere that had been heavily damaged by an ion storm just nine light years away, it gave Janeway another idea. She made a plan to steal a transwarp coil from the sphere, which was ultimately successful. The coil provided 20,000 light years of travel before giving out, shortening *Voyager*'s journey home by about 15 years.

DATA FEED

The *Voyager* crew collected eight kilotons of debris from the wreckage of the Borg probe. Captain Janeway really hoped to find a transwarp coil, and although there was one, it was damaged beyond repair. Janeway also found a small sphere made from some kind of polytrinic alloy. When she began to inspect it, Harry Kim told her to put it down, as it had been crawling around on the floor and he suspected it was an auto-regeneration unit.

41

| SHIP PROFILE | BORG PROBE | PLAN VIEWS |

Shield plating

TRANSWARP CHAMBER

In the typical Borg ship design, most of the vital technology was duplicated throughout the interiors, which meant ships had multiple redundancies built-in. So, for example, if one system failed or was destroyed, a backup system in another part of the ship could be brought online to replace it.

One element that did not have a backup, and was therefore one of the most important areas on a Borg ship, was the transwarp chamber. This section housed the transwarp drive, and the most vital component in making this work was the transwarp coil – the equivalent of a Starfleet ship's warp core.

The transwarp chamber was located deep within a Borg ship, and was heavily shielded to protect it from damage in an attack. The Borg placed such importance on the transwarp coil that it was designed to self-destruct if the ship became critically damaged, so that no other species could benefit from it or study the technology.

▲ One of the most important features of a Borg vessel was the transwarp chamber. It housed the transwarp coil, the component responsible for generating transwarp conduits.

DATA FEED

Borg probes were capable of traveling at both warp and transwarp speeds. After entering a transwarp conduit, a Borg ship would project a structural integrity field ahead of itself, in order not to break up from the extreme gravimetric pressure being exerted on the hull. The ship also emitted a chroniton field ahead, while in a transwarp conduit, to compensate for the temporal stress it was undergoing.

Communications array

Flight guidance sensors

| 42 | BORG PROBE | PLAN VIEWS |

Energy beam weaponry

Chroniton field emitter

Transwarp conduit emitter

Transwarp chamber

Structural integrity field emitter

POWER NODES

Energy for Borg ships was produced by numerous power nodes. Each one generated enormous amounts of power, which was distributed throughout the ship via plasma conduits.

TOUGH TRITANIUM

Borg vessels were mostly made from tritanium, an ore known for its extreme hardness. Tritanium was 21.4 times as hard as diamond, and Borg tactical cubes were largely composed of it.

DATA NODES

Like all Borg ships, the probe featured numerous data nodes. These portable storage and processing devices contained enormous amounts of information, such as the number of drones on the ship, long-range sensor telemetry, assimilation logistics, and the location of other Borg vessels.

BORG SHIPS
SIZE CHART

BORG CUBE
2743m

BORG QUEEN'S SHIP
2500m

BORG SPHERE
457m

BORG RENEGADE SHIP
2500m

SCALE: 1:18,000

BORG TACTICAL CUBE
1960m

SCALE: 1:3000

BORG PROBE
212m

45

CHAPTER 2
THE DELTA QUADRANT

▼ This unidentified vessel was constructed around four nacelles, and still seemed to have an active power supply.

ABADDON'S "JUNK SHIP"

This unusual vessel could be spotted in the field of junk that surrounded Mr. Abaddon's station.

In 2376 the crew of the *U.S.S. Voyager* stopped at a junkyard run by a Mr. Abaddon, who traded in spare parts and even vehicles. His station was surrounded by space debris, including a number of ships. One of these ships was an unusual design that featured four nacelles and a large crystalline module. No more was revealed about the ship and the crew never encountered a species who used a similar design.

and revealed as the architects of the bombing. However, Akritirian ambassador Liria refused to exchange Paris and Kim for them, so Captain Janeway had to work with the bombers. In return for their freedom, Piri and Vel led Janeway and Commander Tuvok to the rescue of Paris and Kim.

AKRITIRIAN FREIGHTER

The paralithium-fueled cargo vessel was key to clearing the names of two *Voyager* officers accused of a devastating terrorist attack.

Though less than half the size of *Voyager*, at around 150 meters in length, this patrol ship was more than equipped to fulfill its law-enforcement brief. In 2373, while Captain Janeway was parleying on the bridge's viewscreen with the intransigent Liria, who suspected *Voyager* of links with the Open Sky terrorists, two patrol ships appeared. They powered up weapons, intending to impound the starship and arrest the crew. With *Voyager* rocked by fire from the patrols, Janeway ordered Chakotay to retreat and regroup.

Later, when the terrorist Vel had agreed to cooperate with Janeway in rescuing Paris and Kim, Lieutenant Tuvok reminded her of the threat from patrols: "No doubt they will attack as soon as *Voyager* crosses the border." Her plan, though, was to use Neelix's small Talaxian ship on the mission. Two Akritirian patrol ships challenged the "alien vessel," but Neelix bought just enough time to get everyone on board from the prison rescue. Then, with apologies to Akritirian Patrol for "the little mix-up," Neelix whisked the away team to safety.

AKRITIRIAN PATROL SHIP

A fleet of these nimble, dart-shaped vessels secured the Akritirian border, swiftly responding to any sign of threat, as *Voyager* discovered.

AKSANI RACING SHUTTLE

This sublight ship ran a close race in an interstellar rally, vying for the lead with three other ships, including *Delta Flyer*.

SHIP PROFILE

DATA FEED
Seen as a symbolic event at the end of a long war between four Delta Quadrant species, the Antarian Trans-stellar Rally featured 12 vessels competing over a 2.3 billion-kilometer course.

The shuttle used by the Aksani was a two-person craft with sublight propulsion, which exactly matched the specifications for entering the Trans-stellar Rally held in 2377. This marked a peace treaty between four previously warring species, including the Aksani. The fragile peace was almost instantly in jeopardy, however, when the Aksani threatened to withdraw because another group, the Chessu, had been chosen instead to host the post-race ceremony. But Captain Janeway relieved the coordinator, Ambassador O'Zaal, of this worrying dilemma by offering *Voyager* as a neutral venue for both the pre- and post-race celebrations.

With the race back on, the Aksani craft took position in lane 9 of the line-up. Its speed served it well, and by the time it had run 68 percent of the course, the shuttle was in third place ahead of the *Delta Flyer*, battling for the lead against Imhotep and Terrellian ships. An excited Neelix relayed over the intercom how it was then cut off by number eight, but used the gravity from a gas giant to boost its speed and catch up. However, Tom Paris in the *Delta Flyer* soon overtook the shuttle, with the laconic remark, "So much for the Aksani," as he continued in hot pursuit of the two ships ahead.

◀ The Aksani shuttle came back well from being knocked off course in the Darla system by gaining speed from a nearby gas giant. After this, though, the *Delta Flyer*, crewed by Paris and B'Elanna Torres, overtook the shuttle to replace it in third position.

▼ *Alice* appeared to be a fairly unremarkable ship, but behind the conventional looks was some unusual technology, which included a neurogenic interface. This enabled the ship to control the pilot, and even appear before him in a seductive humanoid form.

ALICE

Alice was the name Tom Paris gave to a small alien craft that turned out to be sentient – and almost killed him.

SHIP PROFILE

In early 2376, a small, unassuming spacecraft was acquired by Ensign Tom Paris from a space station called Abaddon's Repository of Lost Treasures. The cost in trade was Paris's jukebox and three of the U.S.S. Voyager NCC-74656's used power cells. Paris named the ship Alice for an attractive woman called Alice Battisti whom he had known at Starfleet Academy.

In appearance, Alice was a fairly basic vessel, about 5 meters in length, and the hull showed a number of scrapes and scratches. The design was not dissimilar to one of Voyager's type-2 shuttles, although a fair amount of intricate detailing was evident all over the hull, indicating that a degree of craftsmanship had gone into building the ship.

One of Alice's main features was a multiphasic shield configuration that could withstand the intense heat of a star, and scramble transporter beams. She also featured an optronic weapons array that was capable of firing powerful pulses.

PILOT LINK

Alice's most unusual component, however, was a neurogenic interface that enabled the ship to react directly to the pilot's thoughts. The interface could be activated automatically by sitting in the single-occupant chair of the cockpit and putting on a headset, from which an armlike metal extension half-encircled the pilot's forehead.

Alice would then scan his brain patterns, which tapped him into all the ship's functions, including ops, tactical, and sensors. This gave the vessel the potential to be quicker and more maneuverable than any Federation ship, since the pilot only had to think what he wanted to do and the ship instantaneously reacted.

However, instead of the pilot being in complete control of the ship, the ship exerted control over the pilot. The neural interface allowed Alice to know the pilot's deepest thoughts and desires. The remarkable ship could then "appear" to the pilot in a form that he found most pleasing. In the case of Paris, the ship presented itself as an attractive woman with a seductive voice.

This was not a real person, but a manifestation of the neural interface existing only in his mind. Alice created these hallucinations by realigning Paris's neural pathways and making them receptive

DATA FEED

Tom Paris named the craft after Alice Battisti, a cadet he had met at Starfleet Academy. He found her intelligent and beautiful, but she was uninterested in him, and he referred to her as "the lost cause."

◀ In 2376, Voyager came across a junkyard in the Delta Quadrant, which was owned by an exotic-looking alien named Abaddon. He lived aboard a space station, which was surrounded by 62 derelict ships, and various other parts. Among his inventory was a small battered ship that Tom Paris was desperate to acquire.

SHIP PROFILE — ALICE — OVERVIEW

◀ Paris was quick to see beyond the worn state of *Alice*, and he described the ship as a "diamond in the rough." His crewmates were not so enthused and were unable to see her allure.

▶ Once *Alice* had a firm hold on Paris's mind through the neurogenic interface, she forced him to leave *Voyager*. Paris launched *Alice* from the shuttlebay and headed straight for the particle fountain.

▶ It appeared that *Alice* deduced that B'Elanna Torres was important to Paris, so diverted his attention away from her. It was almost as if *Alice* was jealous of Torres, and to force him to focus solely on her, she tried to kill Torres by locking her in the cockpit and expelling all the air.

▲ The alien Abaddon had been running his junkyard business in the Delta Quadrant for more than 20 years. In this time, he had acquired a wide range of mostly useless stock. It turned out that Abaddon knew *Alice* was sentient, but she found his piloting skills inadequate and urged him to find a new helmsman.

to neurogenic signals. Thus, *Alice* could project images and voices over vast distances, not just when the pilot was in the cockpit.

Once *Alice* had a hold on Paris, he became obsessed with her. He devoted all his spare time to restoring the ship, working on her well into the night. *Alice* gained even greater control of Paris by persuading him to wear a special flight suit, which featured various nozzles into which she injected tubules. This made him the living, breathing heart of the vessel, as his synaptic functions became even more closely linked with those of the ship.

Alice wanted to return to an area of the Delta Quadrant containing a particle fountain that she called home, but she could not fly herself. So by appealing to the pilot's desires, *Alice* could manipulate them into delivering what she wanted.

However, *Alice* was not compatible with just anyone. When Abaddon flew her, she complained that his reflexes were too slow, and she insisted that he find her a new pilot.

MALIGN INFLUENCE

Paris was a far more suitable helmsman as far as *Alice* was concerned. She convinced him to steal some of *Voyager*'s tactical data modules from storage to fix her weapons array. However, when B'Elanna Torres noticed that some items had gone missing, *Alice* tried to kill her by sealing her in the cockpit and cutting off the oxygen.

This made Paris realize that *Alice* was controlling him, but when he tried to resist her and attempted to go to sickbay, she was able to send a small shock directly to his brain, causing severe pain.

SHIP PROFILE

▶ By tapping into the neurogenic interface with a communications signal, the Starfleet crew were able to insert a manifestation of Torres into Paris's mind. While she distracted Paris, Tuvok managed to disable Alice's shields and beam Paris back to Voyager. Without a pilot, Alice disintegrated in the swirling eddies of the particle fountain.

▲ On the shuttle, the manifestation of Alice urged Paris to complete the final stage of their link. Different colored wires plugged into the nozzles on his flight suit, and his mind became one with Alice. Paris was then able to break free from Voyager's tractor beam by firing an optronic pulse, before going to warp and disappearing from sensors.

She then made him return to her, and completed the final part of their integration. Once Paris was in the cockpit chair, restraints held him down as more tubules were injected directly into his body, and pilot and ship merged further into one being.

After this, they left Voyager and headed to the particle fountain. When Alice was fired upon by Voyager, Paris felt pain because he had become so entwined with her systems.

Alice was ultimately defeated when the crew found a way to tap into her neurogenic interface. They were able to "insert" Torres into the program, allowing her to wage a tug-of-war for Paris's attention, while Tuvok disabled the multiphasic shielding and beamed Paris out. Deprived of her pilot, Alice broke up, and was destroyed when she collided with one of the particle fountain eddies.

DATA FEED

The small craft that Paris bought from Abaddon's salvage yard could manifest itself as a person to anyone who put on its neurogenic interface headset. When Abaddon wore it, the craft appeared as a female member of his species. Similarly, after Paris used the interface, the ship appeared in his mind as an attractive female Human. The more Paris used the interface, the more he fell under the ship's spell.

57

INTIMATE COCKPIT

The cockpit of *Alice* was fairly similar to that of a Starfleet Type-9 shuttle, and was accessed through a hatch located at the rear. Inside, there was just a single seat for the pilot and not much storage. As Abaddon described her, she was "designed for speed, not haulage."

Touch-sensitive consoles were positioned in front and on each side of the pilot. These controlled everything from environmental to guidance systems, as well as the ship's optronic weapons and multiphasic shields.

What made *Alice* truly unique was her onboard computer. The neurogenic interface through which *Alice* linked with the pilot was positioned on top of the chair backrest. This allowed her to respond to vocal commands, but also made startlingly intimate pilot-ship communication a possibility.

▲ The neurogenic interface built in to the pilot's headset enabled *Alice* to link with Paris's synaptic functions. Their relationship became so close that Paris almost became part of the ship.

DATA FEED

Abaddon claimed that he had bought *Alice* from a Haakonian trader who believed that the ship was haunted. The *Voyager* crew's only encounter with a Haakonian occurred five years earlier in 2371, when they met Ma'Bor Jetrel, the scientist who developed the metreon cascade weapon that killed hundreds of thousands of Talaxians.

- Warp plasma exhaust
- Warp nacelle pylon
- Impulse exhaust nozzle
- Atmospheric control winglet

Primary energy weapon

Forward cockpit window

Matter intake grille

Forward sensor array

Aft shield emitter

Entry hatch

Lateral cockpit window

Impulse exhaust nozzle

Forward dorsal shield emitter

DANGEROUS HOME

The particle fountain that *Alice* called "home" was a dangerous spatial anomaly. There was a similar anomaly in the Alpha Quadrant, and the Federation had lost over a dozen starships while attempting to study it.

VALUABLE CRYSTAL

Most of the items that *Voyager* acquired from Abaddon were worthless, but one – a berllium crystal – was valuable, with some species willing to trade an entire fleet of ships for it.

BRAIN DAMAGE

Once an individual put on the headset in *Alice*'s cockpit and had a neurological scan, the ship was able to cause them harm, even when they were not in physical contact with her. *Alice* made Abaddon suffer a cerebral hemorrhage when he tried to tell the *Voyager* crew where to find her.

▼ The Ankari used a unique form of propulsion on their ships, making them hard to detect by standard Starfleet sensors.

ANKARI SHIP

The Ankari came from an N-class planet, with warp-capable ships whose signature was unlike any known to Starfleet.

SHIP PROFILE

When the *Nova*-class science vessel *U.S.S. Equinox* was found wrecked in the aftermath of an alien attack, the *U.S.S. Voyager* stepped in to save the surviving crew. But the *Equinox* had a secret – the crew were harvesting neucleogenic energy from an alien species to boost their ship's propulsion systems. It was an act that – in the view of Captain Janeway – amounted to mass murder, but one that the *Equinox*'s Captain Ransom hoped would take them home.

The *Equinox* had encountered the species on the N-class planet of Ankari. The aliens were the Ankari's "Spirits of Good Fortune from another realm," called down in sacred rituals with a summoning device. Captain Ransom had traded a device for an energy converter, and in a failed experiment back on ship, realized they could tap the creatures' energy to supplement their own supplies. But the aliens fought back, killing crewmembers and nearly destroying their ship.

When the nucleogenic life-forms attacked *Voyager* through spatial fissures, Captain Janeway realized she needed help if the ship was to survive the onslaught. She pursued and hailed an Ankari ship, but it did not respond, so in a bold move she resorted to a tractor beam, holding the vessel until its captain agreed to summon the life-forms.

After Janeway's appeal, the life-forms agreed to cease the attacks, but wanted the *Equinox* in return. Ultimately, the *Equinox* was destroyed with the assistance of Captain Ransom, in one last act of atonement. Its remaining crewmembers – stripped of their rank – joined *Voyager*.

Heavily weaponized with phaser banks and equipped with tractor beam emitters, the crimson-colored Annari vessels were fast and effective, but lacked the superior cloaking device developed by the Kraylor for their ships.

ANNARI WARSHIP

This starship class was used for combat in the late 2370s, during the Annari-Kraylor war.

The Annari General Valen had command of the combat ship in 2372, using it to prey on disoriented vessels when they first arrived in the closed structure known as the Void. Despite an initial advance of friendship, Valen stole supplies from a ship that had previously stolen from the *U.S.S. Voyager*, then attacked *Voyager* himself and took its power sources. Such acts had enabled him to survive in the Void for five years.

Valen was defeated by a Void inhabitant, a nomad named Fantome by the Doctor after treatment in the sickbay. Fantome shut down the power supply on Valen's ship, enabling *Voyager* and its allies to escape the Void on a power surge.

ANNARI COMBAT SHIP

This substantial vessel was used by the Annari General Valen to ambush starships pulled through subspace funnels into the Void.

ANTARIAN TRANS-STELLAR RALLY

In 2377, the *Delta Flyer* took part in the Antarian Trans-stellar Rally alongside more than a dozen racing ships.

The Antarian Trans-stellar Rally was established to celebrate a peace treaty between the Antarians and three other species who had been fighting one another for more than a century.

The race was conducted at sub-light speeds over a course that was two billion kilometers long, divided into three segments. Hazards included dwarf star clusters, K-class anomalies, and the Möbius Inversion.

The rally was open to any species, as long as their ships had two crewmembers and used enriched deuterium as fuel. More than a dozen ships from different species entered.

TRANS-STELLAR RALLY COMPETITORS

At least 14 ships took part in the inaugural rally, only a handful of which were ever formally identified.

SHIP PROFILE | ANTARIAN TRANS-STELLAR RALLY | COMPETITORS

TRANS-STELLAR RALLY

COMPETITORS

of the B'omar Sovereignty. The B'omar were isolationist and deeply distrustful of other species, and deployed these ships as an effective deterrent to other Delta Quadrant powers entering their space.

B'OMAR PARTROL SHIP

The distrustful B'omar policed their space with compact and maneuverable patrol vessels.

SHIP PROFILE

DATA FEED
By traveling through B'omar space, the *U.S.S. Voyager* could reduce the length of its return journey to Earth through the Delta Quadrant by three months.

The *U.S.S. Voyager* encountered the B'omar on its journey through the Delta Quadrant. To shorten the return trip to Earth, Captain Kathryn Janeway entered into negotiations with this highly distrustful species for permission to enter B'omar territory and take a more direct route. Three B'omar patrol ships rendezvoused with *Voyager* at the edge of their space, bringing representatives Dumah and Gauman aboard. The ships were small and maneuverable, able to be deployed quickly across B'omar territory to protect its border.

COMPACT DESIGN
The B'omar patrol ship's design adopted a compact, three-point configuration, with a wide rear wingspan ranged to the aft section of the vessel. The ship tapered to a snub forward section, where the small cockpit was located. A single window afforded the pilot a view of space directly ahead of the ship. The ship's overall size was roughly comparable to two Starfleet shuttles, although the small cockpit appeared to carry a single crewmember.

Propulsion systems, comprising both impulse and warp engine units, were located directly behind the cockpit. They were built up above the centre of the wide wing section, tapering aerodynamically toward the rear of the ship. B'omar patrol ships were easily identifiable by the green energy signature of its propulsion systems.

Being highly maneuverable at sub-warp speeds, the ships were effective in ship-to-ship combat, but it is likely that the warp engines would not have

◀ Captain Janeway had been attempting to negotiate a route through B'omar space. *Voyager* rendezvoused with three B'omar patrol ships, bringing representatives of the B'omar Sovereignty aboard the ship for some difficult negotiations.

SHIP PROFILE | B'OMAR PATROL SHIP | OVERVIEW

◀ Having left *Voyager* aboard a shuttlecraft, Seven of Nine was hunted by the B'omar and encountered a mass fleet of patrol ships after entering their territory.

▶ The cockpit of a B'omar patrol ship was cramped, with room only for a single pilot. B'omar Councillor Gauman led the hunt for Seven of Nine within the Sovereignty's borders.

▶ The B'omar located Seven of Nine and Tuvok in the wreck of the *U.S.S. Raven* on the surface of a moon. Detemined to eradicate the Borg, three patrol ships launched volleys of torpedoes directly from orbit, targeted at the *Raven*.

▲ Janeway continued to appeal to the B'omar after Seven of Nine's escape, but the Starfleet crew were forbidden to search for their crewmate while the B'omar left in pursuit of the Borg.

exceeded warp 8. The large number of available patrol ships increased their efficiency as a border-control force.

SHIP ARMAMENTS

The offensive capability of B'omar ships included a single forward-mounted energy weapon and atorpedo launcher, both displaying the same green energy signature as the propulsion system. The torpedo launcher had a range long enough to target locations on a planet's surface. Despite their maneuverability and offensive capability, however, B'omar ships were outclassed by a standard Starfleet shuttle.

A significant fleet of patrol ships was deployed by the B'omar Sovereignty in response to an incursion into its territory by *U.S.S. Voyager*'s Borg crewmember, Seven of Nine. Influenced by a Borg homing beacon aboard the crashed *U.S.S. Raven* in B'omar space, Seven left *Voyager* in an unauthorized shuttle. Her entry into B'omar territory triggered an angry response from the volatile species. They deployed the fleet of patrol ships to locate the rogue Borg, and *Voyager* was ordered to stand off at a distance of five light years.

SEVEN AGAINST THE B'OMAR

Tom Paris and Lieutenant Commander Tuvok devised a means of entering B'omar space by shuttle, undetected, to retrieve their crewmate. Seven's shuttle meanwhile engaged a fleet of B'omar ships. Scorning B'omar demands to stand down and prepare to be boarded, Seven disabled five of the ships with phasers as she broke

SHIP PROFILE

▶ Disobeying B'omar directives, *Voyager* arrived at the moon, firing on the patrol ships to disable their weapons systems and ensure the safety of Seven of Nine and Tuvok on the surface.

▲ Seven of Nine engaged in ship-to-ship combat against the B'omar fleet, disabling five ships in quick succession and continuing her flight deeper into their territory.

through their defenses. Tuvok beamed aboard the shuttle, but was quickly overcome by Seven and accompanied her to the moon where her parents' ship – the *U.S.S Raven* – had crash-landed.

Locating the two *Voyager* crewmembers aboard the crashed ship, three B'omar patrol ships then launched an offensive from orbit, targeting the site of the *Raven* with torpedoes. Ignoring B'omar directives to stand off its borders, *Voyager* intercepted the ships, disabling two, while the third continued to fire. Seven of Nine and Tuvok were safely retrieved from the moon's surface by Paris, and transported to the shuttle.

Accused by the B'omar of committing an act of war, and with reinforcements of 68 patrol ships on course for *Voyager*'s position, Janeway ordered her ship to leave B'omar space at a speed of warp 8.

DATA FEED

Hostile action taken by the B'omar ultimately destroyed the wreck of the *U.S.S. Raven*. This Federation vessel was home to the young Annika Hansen and her parents, who were engaged in a study of the Borg. The ship vanished, and Annika and her parents were later assimilated into the Borg collective. The young girl's humanity was erased and she was given the drone designation Seven of Nine.

| SHIP PROFILE | B'OMAR PATROL SHIP | PLAN VIEWS |

Aerodynamic wing ⊢

B'OMAR DIRECTIVES

Although Captain Janeway hoped to reduce the length of Voyager's return journey to Earth, the harsh limitations placed on the starship's entry into B'omar territory made taking that route a fruitless enterprise.

The stipulations laid down by Councillor Gauman of the B'omar Sovereignty – which had to be adhered to at all times – stated that while in B'omar space, Voyager could not exceed a speed of warp 3. Its weapons systems were to remain offline and the ship was not permitted to engage in unnecessary scans or surveys, explore the system in any way, or have any communication with nonmilitary spacecraft.

The course prescribed by the B'omar would avoid populated planets and take Voyager weeks, if not months, to navigate. It also involved 17 checkpoints, where the ship would be compelled to submit to inspection.

▲ The course dictated to Janeway by B'omar Councillors Gauman and Dumah was a circuitous route through their space that took in 17 checkpoints and avoided populated worlds.

Propulsion systems ⊢

DATA FEED

The B'omar claimed that every vessel, every object, every particle of dust that crossed their borders was immediately identified and traced by their perimeter grid. After Seven of Nine's incursion into B'omar space, the sensitivity of the grid was increased by 37 percent. Although Voyager was unable to penetrate this without detection, Paris and Tuvok devised a way for a shuttle to do so.

Cockpit

Phaser emitter

FORWARD WING DETAIL

Cockpit

MAIN DRIVE DETAIL

Main drive

Torpedo launcher

B'OMAR RIVALS
The B'omar were engaged in difficult trade negotiations with their neighbors, the Nassordin. Councillor Gauman prohibited *Voyager* from entering the Agrat-mot Nebula, a key element in these talks.

SHIELD FREQUENCY
Tom Paris and Tuvok's solution to penetrating the B'omar grid undetected involved recalibrating a shuttle's shields to match the grid's frequency.

LAST CONTACT
With 68 patrol ships converging on its position, *Voyager* left B'omar territory quickly to continue its journey to Earth. This encounter was Starfleet's only known contact with the B'omar.

BA'NETH SHIP

The Ba'neth were so secretive as to be almost mythical, keeping their ships and their bases cloaked against all species.

In 2374, two Benthan patrol ships intercepted their own coaxial warp drive prototype. Commander Avik of the Benthan Guard was in pursuit of the renegade Steth (himself victim of an unknown DNA robber life-form), who had stolen the prototype ship, then sent it into the Kotaba Expanse. Onboard was Tom Paris, whose body Steth had switched with his own.

Despite Paris's protestations, Commander Avik drew the prototype in with his vessel's tractor beam, but released it on the surprise arrival of a huge, curvilinear ship belonging to the alien Daelen, who chased off the Benthan Guard.

BENTHAN PATROL SHIP

Two patrol ships were dispatched by the Benthan to retrieve genome thief Steth and the stolen prototype warp ship.

▼ The coaxial ship was encountered in the Delta Quadrant in 2373, and it looked fairly similar to a Starfleet shuttle. It did, however, feature several antennae-like protuberances emanating out of the nose of the ship. It also featured two more appendages jutting out of the tiny wings, which appeared to be its energy weapons.

BENTHAN
COAXIAL DRIVE PROTOTYPE

The stolen starship looked unremarkable, but it featured a revolutionary coaxial warp drive that folded space.

SHIP PROFILE

The coaxial ship was roughly the same size as the *Delta Flyer*, at just over 20 meters in length, and could be operated by one pilot. It was flown by a shape-shifter who switched DNA and bodies with a Benthan named Steth, and claimed the ship came from the fourth planet in the Benthan system.

UNSTABLE TECHNOLOGY

The *U.S.S. Voyager* NCC-74656 encountered the coaxial ship in 2374, when it detected a massive spatial disturbance at a distance of 2,000 kilometers. This was emanating from the coaxial ship because its engines were overloading. As a prototype with its technology far from perfected, the engine was enormously dangerous. If it exploded, Paris estimated that the surrounding space within a radius of a billion kilometers would collapse, taking everything with it.

What made the coaxial drive so dangerous was that it drew in subatomic particles through an induction drive and reconfigured their internal geometrics, which folded the fabric of space. The process was not fully developed and the ship emerged from coaxial space in an unstable condition. Crackling energy played over the surface of the ship as its propulsion system spiraled out of control, but the interference prevented the pilot from being beamed out.

With the coaxial core about to breach, Paris managed to generate a symmetric warp field around the ship, containing the instabilities in the space-folding core, and use a tractor beam to stop its erratic flight path. The procedure

The coaxial drive vessel was a small, fairly ordinary-looking starship, but it did have one very impressive feature. It was equipped with a prototype coaxial warp drive engine. This experimental propulsion system folded the fabric of space, allowing the ship to travel instantaneously across large distances.

Lieutenant Tom Paris was familiar with the technology after taking an advanced subspace geometry course at Starfleet Academy. He described it as a propulsion system that "Starfleet engineers have been dreaming of for years." It allowed the ship to cross tens of light years in seconds, which was much faster than any Starfleet ships, or indeed any starships, could achieve.

DATA FEED

The *Voyager* crew met another Delta Quadrant species that had developed a technology to "fold space." The Sikarians had a spatial trajector on their home planet, which could transport individuals up to 40,000 light years away.

◀ When *Voyager* encountered Steth's coaxial ship in 2374 its engine was overloading. Enormous energy rippled over the surface of the ship as if it had been hit by lightning, and it was clear it was about to explode. If it had ruptured, it would have taken *Voyager* with it in a blast that radiated out for about a billion kilometers.

◀ After the coaxial ship was rescued by *Voyager*, Steth became friends with Tom Paris while carrying out repairs. It was Paris's suggestion to make the coaxial induction drive safer by limiting the stream of subatomic particles entering it.

▶ After checking Paris's DNA and knowing it was compatible with his own, Steth attacked him and took on his appearance.

▶ The coaxial ship could be operated by just one person. The cockpit layout and consoles were not too different from those on Starfleet ships. The navigation and ops console was located at the front, and its weapons and shields could also be controlled from there.

▲ The small coaxial induction drive that allowed Steth's ship to travel huge distances in an instant was located toward the rear of the cockpit. It resembled a miniature warp core reactor, but despite its size was enormously powerful. In effect, it folded the fabric of space by reconfiguring the internal geometries of subatomic particles.

managed to save not only the coaxial ship and its pilot, but *Voyager* too.

Later, Paris and the pilot, who claimed to be Steth, made repairs to the coaxial ship. Steth explained that the engine only worked sporadically because the subatomic particle instabilities kept overloading the system. Before long, Paris conceived of an idea based on a 20th-century car engine's carburettor to fix the ship's problem. A car's engine did not run on pure fuel, but used the carburettor to supply a mixture of vaporized fuel and air.

Applying this principle, Paris suggested using a polaric modulator from *Voyager*'s impulse drive to dilute the particle stream as it entered the coaxial core. Paris and Steth made the repairs to the ship ahead of schedule, but before it was tested, Steth incapacitated Paris and switched DNA with him, thereby assuming his identity and appearance.

TRADING PLACES

The shape-shifting alien then took over Paris's life, while sending off the real Tom Paris, still unconscious, in the coaxial ship. Once the coaxial leap had been completed, Paris awoke and found himself in the Kotaba Expanse, where he came under attack from two Benthan patrol ships. They believed Paris to be Steth and wanted to take him into custody for stealing their prototype ship.

The Benthan vessels, however, were soon driven off by a much larger ship. It was piloted by what appeared to be a female alien named Daelen, who turned out to be another victim of identity theft. Daelen was, in fact, the real Steth, who very

▶ The alien impostor put an unconscious Tom Paris, who now looked like Steth, in the coaxial ship and programmed it to travel to the Kotaba Expanse. Here Paris/Steth encountered two Benthan fighters, who sought his arrest for the theft of their prized prototype.

▲ The Benthan fighters quickly departed when a huge vessel arrived. It was commanded by Daelen, a female who was also looking for Steth. It transpired that she was the real Steth, whose identity had also been stolen by the DNA thief. Realizing their shared predicament, the real Paris and Steth joined forces to track down the shape-shifter.

much wanted the return of his original body – as manifested by Paris.

Paris/Steth managed to convince Daelen that he had been subject to the same identity switch. They then teamed up to override the ship's lockout commands and reengage the coaxial drive so that they could fly back to *Voyager*.

Once there, they found that the shape-shifter had meanwhile swapped appearances with Captain Janeway, and tried to escape in a shuttle that had been fitted with a new coaxial drive. Paris/Steth and Daelen pursued the being and disabled the shuttle's coaxial engine by hitting its polaric modulator with a chromoelectric pulse. The shape-shifter was captured, and the Doctor found a way to return Paris, Steth, and Janeway to their own bodies.

DATA FEED

After the pilot claiming to be Steth was rescued from his dangerously unstable coaxial ship, he befriended the *Voyager* crew, most notably Tom Paris. Unbeknownst to them, however, he was an alien who could switch DNA with a compatible species and take on their appearance. He was eventually caught, and the real Steth used the coaxial ship to return the genome thief to Benthos. Steth also wanted to find out if there were more hapless victims of the alien.

PURSUING THE IMPOSTOR

Onboard *Voyager*, the alien posing as Paris appeared to enjoy his new life, until his erratic behavior brought a reprimand and an order from Captain Janeway to report to sickbay for tests. During the meeting, however, the alien switched appearances once more, taking on Janeway's identity.

When Paris/Steth and Steth/Daelen returned in the coaxial prototype, the alien as Janeway tried to escape in a shuttle that had been fitted with a new coaxial drive. Paris/Steth and Steth/Daelen set off in pursuit, but their ship was not nearly as maneuverable as the shuttle. They also could not risk firing on the shuttle in case they killed the alien – the key to the restoration of their bodies.

The alien believed it would escape yet again as it charged the shuttle's coaxial drive, but Paris/Steth disabled the engine by preventing subatomic particles from entering the core. The shape-shifter was subsequently apprehended, enabling Paris, Steth, and Janeway to reclaim their bodies – and lives. Steth then used the coaxial ship to return the shape-shifting alien to Benthos IV, but its original identity and true appearance remained unknown to the *Voyager* crew.

▲ Paris directed a chromoelectric pulse from the coaxial prototype to the Class-2 shuttle's engine to disable its coaxial drive and thwart the alien intruder's attempt to escape.

Forward cockpit window

Forward phaser cannon

Main deflector

Subspace transeiver

Cockpit

Rear entry hatch

Coaxial nacelle

Cockpit window

Impulse engine impeller

Forward phaser cannon

Subatomic particle collector

ENTABAN ATTACK

The Steth lookalike spun a story to Tom Paris that he had flown the coaxial ship into neighboring Entaban territory, come under attack, and had to limp home to Benthos IV with phaser holes in the brand new fuselage.

BIOMIMETIC LIFE-FORM

In 2374, the *Voyager* crew came upon another life-form that could take on the shape of others. It was a liquid deuterium life-form known as Silver Blood that turned into the entire *Voyager* crew.

ADVANCED FIGHTERS

In addition to the fighter ships operated by the Benthan Guard, they were developing a *Mithran*-class fighter. The Steth impersonator claimed that this was the most advanced warship in the Delta Quadrant. He also told Tom Paris that he would be the first to pilot the prototype design on a test flight.

BOTHAN SHIP TYPE 1

To guard their sector of the Delta Quadrant, the secretive Botha deployed ships that emitted a mind-changing energy field.

SHIP PROFILE

The Bothan ships were equipped with a special weapon: a bioelectric energy field with psionic properties. When three vessels controlled by a single Bothan alien met the U.S.S. Voyager attempting to cross their space, they fired their weapons and engulfed Voyager in the psionic field. This caused no physical damage, but had a psychoactive effect on the Voyager crew, inducing hallucinations – and ultimately catatonia – in all but the Doctor. Kes succumbed but fought back against the mind control. She revealed the Bothan alien as a cowering trickster who, when cornered, vanished into space along with his craft.

◀ An initial direct hit to the Bothan ships from Voyager's lateral phaser arrays did not damage their shields, a later hit to their weapons arrays did not disable them, and scans showed no defensive weakness. Whether or not this was illusory, the Bothan ships for their part caused serious damage to Voyager's structure.

The Brunali transport was a tinny, unarmed vessel – but it was deceptive. It emitted a misleadingly high warp signature. When *Voyager* detected it heading for the Borg transwarp conduit, it appeared to be traveling at warp 9.8, which was guaranteed to alert the Borg. With the pathogen-carrying Icheb onboard, the transport had become a deadly weapon against them.

BRUNALI TRANSPORT SHIP

In 2375 and 2376, this small, low-key vessel played an unusual role in the Brunali's fight back against the Borg.

SHIP PROFILE

The Brunali's homeworld, a Class-M planet, lay close to a Borg transwarp conduit, and had been devastated by the Collective. This had reduced their advanced society to a basic, agrarian one. However, two Brunali people, Leucon and Yifay, devised a retaliatory weapon: their own son, Icheb. They encoded him with an anti-Borg pathogen and dispatched him by transport vessel into Borg space. The ship was targeted by a Borg cube and Icheb was captured and assimilated – but some 5,000 drones died of the virus he carried.

Voyager rescued Icheb and other child survivors from the cube, and later, unaware of his history, Janeway insisted that Icheb rejoin his parents. But Seven of Nine was suspicious of them, and with good reason. In a heated exchange between *Voyager*'s bridge and Icheb's parents, it became clear that they were hiding something; it transpired that they were again using Icheb as a biological weapon, and had launched him on an unarmed Brunali transport to encounter and reinfect the Borg. However, Icheb was rescued by *Voyager*'s crew – this time, never to return to his homeworld.

DATA FEED
The Brunali transport, as Tom Paris explained, had been designed to emit a falsely high warp signature to penetrate subspace and attract the attention of the Borg. It was "bait" for getting Icheb into their midst.

◀ *Voyager* had to come dangerously close to the conduit, so that Seven could beam Icheb from the transport to sickbay. A Borg sphere emerged, ready to swallow both the Brunali ship and *Voyager*. Seven then transported a photon torpedo to the Brunali vessel, which exploded seconds later, heavily damaging the sphere.

▼ The Type 1 Caatati craft was the smaller design of the two that made up the fleet of escapees from the Borg's incursion on their homeworld. All their ships were powered by thorium, of which the dilapidated, vagrant vessels were desperately in need.

CAATATI TYPE 1

Ships from a refugee Caatati fleet used tactics from emotional blackmail to theft to get *Voyager*'s food, fuel, and technology.

SHIP PROFILE

In 2373, the Borg assimilated the Caatati civilization and destroyed its homeworld – where millions had previously lived. The last of the Caatati numbered a few thousand destitute, starving refugees onboard 30 ships urgently seeking out the essentials for survival. A year later, one of their smaller, Type 1 ships, "damaged but functional," according to Tuvok, approached and hailed the *U.S.S Voyager*. It was carrying 88 passengers, including children, represented by an interlocutor named Rahmin. Over the viewscreen, he requested food, medicine, and a small quantity of thorium isotypes, which they needed to power the ship's systems. Captain Janeway agreed to help, and before long two more vessels joined *Voyager*. Another Caatati named Lumas came onboard with more blatantly aggressive demands for assistance from a crew whom he perceived as living in luxury. Despite their own restricted resources, Janeway offered to let the Caatati have the maximum food supplies that could be spared for their three ships – amounting to several hundred kilograms per ship.

Later, the Caatati made use of a problem in *Voyager*'s engineering that required the warp core to be ejected. Lieutenants B'Elanna Torres and Tom Paris sped away by shuttle to retrieve the core, only to find Lumas's ship already positioned there, entrapping it in a tractor beam. Refusing to back off, the Caatati fired an antimatter pulse at the shuttle, which was then sure to explode in seconds. As the Caatati made off with the core, Torres and Paris were forced to bail out and drift in space with a limited oxygen supply and no certain means of contacting *Voyager*.

◀ The Caatati ship grabbed *Voyager*'s ejected warp core in its tractor beam. Onboard, Lumas claimed salvage rights over Paris and Torres, threatening to fire if they interfered. Torres, fearful of the core exploding, tried to disrupt their tractor beam, but the Caatati sent an antimatter pulse back through the shuttle's particle beam.

CAATATI TYPE 2

The Caatati stepped up their harassment of *Voyager* with a considerable reinforcement of ships, including Type 2 vessels.

SHIP PROFILE

Having stolen the *U.S.S Voyager*'s warp core, the Caatati returned to besiege the starship with an "armada" of 27 vessels. Type 2 ships were recruited for this renewed, more aggressive attempt to gather supplies from *Voyager*.

On the viewscreen, Lumas pointed out that, given the Caatati's increased numerical strength, the Starfleet crew were at a disadvantage – especially as they were missing their warp core. Lumas's demands were extreme: food, weapons, and *Voyager*'s entire supply of thorium. They also wanted Seven, because she had been a Borg – and "There are many who'd enjoy a chance to repay one of them for what they did to us."

Captain Janeway brushed aside Seven's offer to surrender to the Caatati, and issued an order to fight, ordering all power to the shields. Seven's intervention made this unnecessary, however. As a Borg she had retained a knowledge of Caatati technology, so she was able to design a matrix for producing thorium in large quantities. Presented with the device onboard *Voyager*, Lumas accepted – even with some gratitude – granting the crew permission to leave.

◀ Larger Type 2 craft joined the "armada" of Caatati vessels that swooped in on *Voyager* to enforce their demands. Individually, their firepower was no match for the starship's, but combined they posed a considerable threat. In this way, the Caatati hoped to extract the resources they needed.

CHOKUZAN SHIP

The alien vessel was conjured into being by Q to challenge the morals of his wayward son, Junior.

SHIP PROFILE

In 2378, the entity Q arrived on the *U.S.S. Voyager* with his son, Q2 or Junior, who was "taking a little vacation from the Continuum."

Unruly, insubordinate, and a danger to those around him, Junior had been sowing chaos throughout the Delta Quadrant and Q hoped that a sojourn on *Voyager* – and the firm hand of his godmother, Captain Janeway – would make him curb his ways, learn respect, and step up to the job (as a Q) of maintaining order in the universe.

Instead, Junior ran riot, ultimately escaping the ship with Icheb aboard the *Delta Flyer*. He opened a spatial flexure to the Clevari system, where he hoped to hide from his father.

Immediately, a large, sleek vessel approached. The Chokuzan commander onboard appeared on the *Delta Flyer* viewscreen to inform the pair they were trespassing in Chokuzan space, which incurred the penalty of incarceration. Rather than respect the Chokuzan's request to board, Junior fired at the ship and aimed for the Zozak system. Icheb was injured in an exchange of fire with the Chokuzan ship, and after Junior had brought him to *Voyager*'s sickbay, Janeway insisted that he go back to Chokuzan space, apologize, and plead with the commander for the information needed to save Icheb. Q2 agreed.

The Chokuzan commander threatened to hold Janeway accountable for the boy's actions, but Q2 insisted on accepting full responsibility and punishment himself, even if it meant torture or execution.

The whole scenario had in fact been created by Q as a moral challenge for his son, with the aim of impressing the Continuum with Junior's actions and reinstating the boy's powers as a Q. Eventually, the Continuum agreed – on condition that Q took eternal custody of his now-contrite son.

DATA FEED
Icheb was blasted with omicron radiation – energy created by a reaction of matter/antimatter. Toxic to humanoid life-forms, it caused cells to necrotize. In the case of Icheb, this was quickly reversed by Q.

◀ The Chokuzan ship took an organic form, more akin to a creature of the ocean depths than an engineered vessel. The commander of the smooth-hulled ship was humanoid, likely replicated from a civilization Q had previously encountered in the Galaxy. When Q2 fired upon the ship, it returned fire.

SHIP PROFILE	CHOKUZAN SHIP	PLAN VIEWS

92	CHOKUZAN SHIP	PLAN VIEWS

CRAVIC STARSHIP

This mighty warship was crewed by Automated Personnel Units that had terminated their makers.

SHIP PROFILE

War between two humanoid species of the Delta Quadrant – the Cravic and the Pralor – raged for years, fought in mighty ships of identical design that were crewed by robotic warriors. When a truce between the civilizations was declared, the Cravic and Pralor agreed to destroy their warships – and the Automated Personnel Units that served on them. But the robotic APUs were programmed to defend themselves against any threat, and faced with their imminent annihilation, they turned on their creators and wiped them out.

For decades after their builders' demise, the APUs continued to wage war on one another, but their technology was failing. When the Pralor APUs encountered the U.S.S. Voyager they had one aim – to find out how to restore themselves and replicate, to ensure that their kind did not die.

◀ The Cravic and Pralor ships were identical in all but color; the Cravic were identifiable by their gold hull and APUs, Pralor by silver. They were equipped with weaponry far superior to Voyager's complement, using quantum resonance charges to fire on their enemies.

| SHIP PROFILE | CRAVIC STARSHIP | PLAN VIEWS |

The Automated Personnel Units were completely robotic, with no organic parts. Powered by superconducting tripolymer plasma, the power module of each unit had a unique energy code, so that it would not work in any other unit. All Automated Personnel Units were programmed by their builders to defend themselves and achieve victory. When the ships and their units were threatened by the builders, the builders became the enemy and were therefore destroyed.

The robotic war was destined to end as the APUs decayed and failed. The individual energy codes built into each unit prevented procreation, a safeguard that was too late for the builders but ultimately served the good of the Delta Quadrant.

CYTOPLASMIC LIFE-FORM SHIP

The alien vessel had a biochemical operating system, deduced from the life-form beamed onto *Voyager*.

SHIP PROFILE

DATA FEED
The interfaces on the alien's vessel could only be activated chemically, suggesting that the life-form communicated directly with the ship's systems using biochemical secretions to give commands.

When *Voyager* received a reading of a massive energy wave coming through space, the crew's attempt to take evasive action failed. Instead, *Voyager* was tracked, its communications array receiving a download, including an indecipherable audio component that Captain Janeway believed to be a distress call.

Setting a course for the wave's residual ion trail, *Voyager* discovered a ship on the verge of a complete systems failure. It beamed an injured life-form onboard that immediately fused itself with B'Elanna Torres. While Seven of Nine attempted to download the alien vessel's databanks, its systems overloaded, causing its destruction.

Desperate to free Torres from the life-form's grip, Janeway beamed the alien distress call out on all subspace bands. A second alien ship then appeared and locked on with its tractor beam, draining *Voyager*'s power.

Meantime, the Doctor and a Cardassian hologram consultant succeeded in freeing Torres from the creature. They stabilized the life-form and Ensign Harry Kim beamed the recovering creature back to its companion ship, after which the vessel withdrew into the Delta Quardant.

◀ The warp-capable ship appeared to be built from a biochemical material, though shields, tractor beams, and weapons operated in the same way as that of mechanical ships.

| SHIP PROFILE | CYTOPLASMIC LIFE-FORM SHIP | PLAN VIEWS |

▼ Daelen's huge, heavy-duty ship had an unusually curved, organic shape. It presented a formidable sight when it arrived with its weapons blazing against the pair of much smaller Benthan vessels homing in on the coaxial drive prototype.

DAELEN'S SHIP

This imposing ship brought an alien female onboard the Benthan prototype ship to reclaim her body – from Steth.

SHIP PROFILE

DATA FEED
The Benthans had developed a prototype ship with a coaxial warp drive that enabled vast distances to be crossed in an instant. It was a brilliant but as yet unstable design, stolen by a shape-shifting alien.

The alien intruder masquerading as Steth moved from body to body, assuming the persona of others. On *Voyager*, he traded places with Tom Paris, stunned him, and sent him off in the Benthan prototype ship with its systems locked. When Paris/Steth woke up, he found himself in an area known as the Kotaba Expanse, facing two Benthan pilots about to take him into custody for theft of their experimental coaxial ship. Suddenly, an even bigger vessel of unknown origin came on the scene, firing its weapons.

The captain, apparently a humanoid female named Daelen, beamed aboard the coaxial ship and threatened Paris/Steth at gunpoint. Daelen revealed that she was really Steth and demanded the return of his body. Paris then realized that they had both been taken over by the same shape-shifter. Together they managed to break through the ship's lockout commands, bring the coaxial drive online, and head off in search of *Voyager*.

◀ The appearance of Daelen's mighty vessel in attacking mode was enough to induce the two Benthan ships to withdraw at once, despite their desire to retrieve the coaxial drive prototype. Daelen transported onto this ship to confront Paris/Steth.

▶ The *U.S.S. Dauntless NX-01-A* was equipped with a quantum slipstream drive that enabled it to cross 10,000 light years in as little as a month.

U.S.S. DAUNTLESS

The *Dauntless* appeared to be a highly advanced Starfleet vessel, but the reality was far more sinister.

SHIP PROFILE

In mid-2374, the crew of the *U.S.S. Voyager* decoded a secret message that led them to the *U.S.S. Dauntless* NX-01-A. The ship appeared to be the most advanced starship ever developed by Starfleet, and to have been sent to the Delta Quadrant to provide *Voyager*'s crew with a speedy means to return home. But, as they were to discover, the *Dauntless* was part of an elaborate trap set by an alien known as Arturis, to exact revenge on Captain Janeway for her part in helping the Borg defeat Species 8472. The Borg's victory had contributed to Arturis's people being almost completely wiped out. He was consumed by his desire for vengeance and faked the message in the hope of luring Janeway's crew onto the *Dauntless*, which, instead of taking them to Earth, would deliver them to the Borg.

At roughly half the size of *Voyager*, the *Dauntless* had a sleek, bulletlike appearance. According to the faked message, it was an experimental vessel fitted with a quantum slipstream drive so that it could travel far faster than any other Starfleet vessel. It had no shuttlecraft, holodecks, or even replicators, but it was large enough to accommodate the entire crew and could make the journey back to Earth in just three months. Even a detailed examination did not reveal the true

◀ Arturis was one of the few members of Species 116 who had not been assimilated by the Borg. His species was highly advanced, and endowed with extraordinary linguistic skills. Having avoided assimilation for centuries, they hoped that Species 8472 would end the Borg threat.

105

▲ The *Dauntless*'s true origins were never revealed, but it appeared to be an advanced ship that had been created by Species 116 and altered by Arturis using particle synthesis technology.

▶ When the particle synthesis was switched off, the ship's walls changed color and the displays on the consoles changed.

▲ The ship's particle synthesis technology made it almost impossible to distinguish the *Dauntless* from a genuine Starfleet vessel.

nature of the *Dauntless*. It had a Starfleet warp signature and standard Starfleet instrumentation, while the design of the RCS thrusters and the escape pod hatches appeared to have come straight out of the Utopia Planitia Fleet Yards.

The *Dauntless*'s engine room also resembled that of a Starfleet vessel – but with one crucial difference. The central matter/antimatter chamber had been replaced by the quantum slipstream drive, which had a small clear globe crackling with energy as its focal point. The quantum slipstream drive was real, and vastly superior to the warp engines used on Starfleet vessels. It could propel the *Dauntless* 15 light years in a matter of seconds – a distance normally requiring at least two days of high warp travel.

These incredible speeds were achieved by routing the energy from the drive through the main deflector to create a quantum slipstream, which was essentially a subspace tunnel. Once it was in the tunnel, the ship could travel up to 20 times faster than the maximum warp speed of a *Galaxy*-class starship.

ADVANCED TECHNOLOGY

The composition of the *Dauntless*'s hull geometry differed greatly from that of real Starfleet ships, but this design enabled the ship to withstand the stresses caused by traveling in a quantum slipstream. When the slipstream drive was engaged, the engines of the *Dauntless* made a distinctive rumbling sound, while the nose glowed and then distorted just before the ship disappeared into a subspace conduit.

Arturis disguised the true nature of his vessel by using a particle synthesis system. Similar to Starfleet's replicator and holographic systems but far more sophisticated, the synthesis system was

SHIP PROFILE

▶ Arturis hoped to trick *Voyager's* entire crew into boarding the *Dauntless* but he was frustrated by Janeway's caution and her insistence on checking over the ship first.

◀ The quantum slipstream was a form of tunnel through subspace. *Voyager* could enter the slipstream, but could only stay in it for an hour before it collapsed. Traveling through one also placed enormous stresses on a ship.

◀ The quantum slipstream drive was far in advance of any Starfleet technology. The configuration of the warp core was unlike anything that *Voyager's* crew had seen before. It channeled energy through the deflector to open subspace corridors, in much the same way as a Borg transwarp coil.

able to create objects and environments that were indistinguishable from the real thing.

Streamlined and stripped down in appearance, the bridge featured all the control stations typically found on a Starfleet vessel. Instead of a main viewscreen, the *Dauntless* had a master control display on a wall-mounted console. The particle synthesis system was activated by a lever housed behind a secret panel in the bridge's combined ops and helm station. Pulling the lever down caused the entire bridge to disappear, the lights to dim, and the wall panels to change from white to red.

The particle synthesis system was so effective that a tricorder evaluation at a molecular level failed to expose the *Dauntless* as a fake. Not until Ensign Harry Kim detected a number of energy anomalies and launched an investigation was alien technology discovered.

After Arturis was exposed, he kidnapped Janeway and Seven, intending to hand them over to the Borg to be assimilated. However, *Voyager* was able to mount a rescue, leaving Arturis to be assimilated instead of his captives. *Voyager* then used the slipstreams he had opened to travel 300 light years closer to home.

▲ Arturis's plan was to take *Voyager's* crew to his planet where they would be assimilated, but when the *Dauntless* arrived, he was the only person aboard.

DATA FEED

When *Voyager* entered Borg space they discovered that the Borg were at war with an advanced extra-dimensional race, known as Species 8472. Janeway came to the conclusion that Species 8472 posed an even greater threat than the Borg, and gave the Collective a weapon that helped them fight them off. In return, the Borg allowed *Voyager* to pass through most of their space. Arturis's own Species 116 were assimilated shortly afterward.

| SHIP PROFILE | U.S.S. DAUNTLESS | PLAN VIEWS |

QUANTUM SLIPSTREAM

The quantum slipstream was one of a number of advanced propulsion technologies that the crew of the *U.S.S. Voyager* encountered during their time in the Delta Quadrant. It worked by generating an energy pulse that opened and maintained a corridor in subspace, generating massive changes in the space-time continuum by altering its quantum state. *Voyager* was able to follow the *Dauntless* into the slipstream but, without a slipstream drive, could not maintain the corridor's integrity. As a result, the corridor collapsed after approximately one hour.

Traveling in the slipstream also placed an onerous degree of strain on a ship, and *Voyager* was ill equipped to remain intact once inside. The crew did experiment with their own version of the quantum slipstream drive, but it was extremely dangerous and the ship barely survived the experience.

RCS thruster

Impulse engine

Warp nacelle

Main bridge

Warp field grille

RCS thruster

Window

Escape pod

Quantum slipstream drive

Impulse engine

Forward thruster

Ship's registry

Escape pod

Forward thruster

Quantum slipstream drive

Warp nacelle

DEFLECTOR PULSE

A starship's deflector was ideally equipped to work with a quantum slipstream drive. Its main purpose was to emit a beam that swept matter out of the ship's path. It was relatively simple to alter the beam to emit a narrowly focused warp field that opened a subspace corridor.

PARTICLE SYNTHESIS

It is not clear how Species 116's particle synthesis technology worked. It was far more sophisticated than holographic or replicator technology, and was so convincing that it could not be detected even on the minutest examination.

DATA FEED

The Borg assigned designations to species in the order that they met them. The *Dauntless*'s creators, Species 116, must have been one of the earliest they encountered; Humans, for example, were designated Species 5618.

▶ The ship used by Dala, Mobar, and Zar was old, worn, and clunky-looking, but they were nevertheless able to pass it off as the highly sophisticated *Delta Flyer*. They used this rather decrepit vessel to help them fleece unsuspecting aliens of valuable goods.

DALA'S "DELTA FLYER"

It looked nothing like the real *Delta Flyer*, but Dala and her cohorts were able to pass their ship off as *Voyager*'s shuttle.

SHIP PROFILE

The ship that became known as Dala's "*Delta Flyer*" was operated by a small group of con artists of an unknown species. The crew consisted of three individuals: a female known as Dala, and two males called Mobar and Zar. Their "*Delta Flyer*" was a small, somewhat dilapidated starship that operated in and around the Wysanti system in the Delta Quadrant during the mid-2370s.

Dala's ship, unlike the real *Delta Flyer*, was far from sleek and sophisticated, but instead rather slab-sided and ungainly. It looked in poor shape from years of hard use, and its exterior was covered in pockmarks.

The main body of the ship was basically a rectangular block, while a cargo hold was awkwardly attached to its rear, as if it were an afterthought. On either side of the main body, two more rectangular blocks housed the impulse and warp engines. These propulsion units emitted a red glow, and were capable of powering the ship to a surprisingly high warp speed, despite their apparent decrepit condition.

WORN AND TORN

Overall, the ship appeared thoroughly beaten-up, as if one small plasma storm would shake it to pieces. While it may have appeared old and frayed, however, it was surprisingly robust. It was equipped with at least rudimentary defensive shields and energy beam weapons, while also possessing site-to-site transporters.

The interior of Dala's ship was as shabby as its exterior. It looked as if most of the systems and

◀ The one part of Dala's ship that bore a glancing resemblance to a Starfleet vessel was the bridge. The layout and decor had a slight similarity to the real thing, but everything was frayed and a bit dingy. The crew were all from the same species, who normally had no hair, but in disguise they impersonated members of *Voyager*'s crew.

111

▲ Dala's fake *Delta Flyer* was slightly larger than the real thing, and probably would have struggled to fit inside *Voyager*'s shuttlebay. Dala and her accomplices had hoodwinked so many aliens that the crew of *Voyager* eventually heard about their scams and went looking for them.

circuitry had not been updated in years and everything was covered in a film of grime. The bridge was as well worn as the rest of the ship, and there were haphazard stacks of merchandise piled up in the corners. Despite this, the bridge was the one area that looked most like that of a Starfleet ship.

It was roughly circular in shape and about the same size as the bridge on a *Defiant*-class vessel. It featured a viewscreen at the front and a command chair in the middle of the room. Two side-by-side consoles – situated between the viewscreen and the captain's chair – dealt with piloting and navigating the ship, as well as operations. There were further workstations around the periphery of the room, while various display screens in the bulkhead walls had graphics displaying a distinct, though not identical, Starfleet style.

In 2376, Neelix and Tom Paris had taken the real *Delta Flyer* to the planet Selnia Prime, where they encountered two monks – or so they thought. In fact, they were Dala and Mobar posing as clerics to run a scam. The pair were taken back to the *Delta Flyer*, and while creating a diversion, Mobar used a scanning device to download the *Delta Flyer*'s entire database.

SERIAL SCAMS

Dala and her cohorts were then able to use this information to portray themselves convincingly as members of the *Voyager* crew. They claimed that their ship was the *Delta Flyer*, and used it to steal 10 kilotons of bolomite from the Telsius Prime mining colony. They followed this up by scamming a reptilian individual named Varn. They promised that if he paid for membership of the Federation, they would help him fight his enemies.

SHIP PROFILE

▶ The con artists made contact with a ship commanded by Varn. He had many enemies, and Dala assured him she could supply him with as many weapons as he needed, if he paid a fee to join their Federation.

▼ Mobar was posing as a monk when he first ran into Tom Paris and Neelix, and heard about *Voyager*. Invited back to the *Delta Flyer*, he found an opportunity to download its entire database in secret.

Varn was somewhat sceptical of their claims because their ship was so run-down, but Dala, posing as Captain Janeway, claimed this was only because it had been through so much fighting of the Borg, Hirogen, and Species 8472.

Later, after Varn realized that he had been cheated, he used his own ship to hold the fake *Delta Flyer* in a tractor beam and demanded reparations. Dala's ship was unable to break free, and at this point *Voyager* turned up looking for the con artists, who were giving them a bad name.

Dala was captured, but the "*Delta Flyer*" managed to flee. Janeway and Neelix tried to persuade Dala to reveal the location of the property she had stolen, but she escaped to rejoin her partners in crime. Fortunately, Janeway had planned for such an event, and Paris had secreted himself aboard the ship. He drugged Dala, while the Doctor was able to use his mobile emitter to impersonate her form. This allowed him to travel with Mobar and Zar to the place where they had hidden the stolen goods.

Voyager tracked the whereabouts of the Doctor, and the crew apprehended the three con artists. They returned the stolen items to their rightful owners and cleared their name with all the species who had been swindled.

▲ The photon torpedoes that Dala supplied to Varn were just empty casings. Once he realized he had been conned, his vessel held the "*Delta Flyer*" in a tractor beam. At this point, *Voyager* arrived, also demanding answers.

DATA FEED

Despite belonging to a different species, Dala was able to impersonate Captain Janeway convincingly. With the aid of a wig and clothes that approximated to Starfleet uniform, she certainly looked much more like Janeway than her ship looked like the *Delta Flyer*. She had obviously studied the database that was downloaded from the *Delta Flyer*, because she knew personal facts about the captain and had even copied some of her mannerisms.

IDENTITY THEFT

Dala's fake *Delta Flyer* may not have been the most elegant or sophisticated of ships, but it was adequate to support the crew's nefarious activities. It had a large cargo hold at the rear, ideal for storing their ill-gotten gains. Its warp engines also ensured that they could make a quick getaway if they needed to escape from an irate customer who had found them out.

The crew of three con artists were all from the same species. They had been operating their scams for at least six years when they got the idea of impersonating members of the *Voyager* crew, after Mobar had surreptitiously downloaded the database of the true *Delta Flyer*. They added red stripes and Starfleet emblems to the sides of their ship and claimed it really was the *Delta Flyer*, even though these small cosmetic alterations hardly changed its original appearance. They did, however, manage to show detailed schematics of *Voyager* on the display consoles situated on their bridge.

The con artists also used the *Delta Flyer*'s database to learn about individual *Voyager* crewmembers and impersonate them. Dala took on the role of Captain Janeway, Mobar posed as Tuvok, and Zar portrayed Chakotay. Mobar in particular seemed to revel in impersonating Tuvok, and even remained in character when he was alone with his partners in crime. Despite the rank of the Starfleet roles they took on, Dala was not in command of the ship and they considered themselves equals.

Impulse and warp engines

Cargo containers

Cargo containers

Cargo containers

▲ While there was not much they could do to make their old ship look like the true *Delta Flyer*, the con artists were much more successful in impersonating Janeway, Tuvok, and Chakotay.

Aft cargo door

DATA FEED

After Dala, Mobar, and Zar had been apprehended by the crew of *Voyager*, Captain Janeway recorded in her log that they had returned the bolomite to the Telsian miners, and recovered stolen property from seven different worlds.

Navigational deflector

Docking clamp

Docking port

Bridge section

Additional cargo container

REPLICATOR FAILURE

The heating coil that Neelix acquired from Dala caused systems failures on nine decks of *Voyager*, including problems with the replicators after it was integrated in a stove in the mess hall.

PLAYING BOTH SIDES

Dala and her accomplices sold Federation membership to Varn with the promise they would help him fight his enemies. The only problem was that they had already done the same with the Polonians, one of Varn's worst enemies.

PROMINENT HUSTLERS

Dala, Mobar, and Zar were far from the only charlatans in the Galaxy. Harry Mudd was a notorious con artist in the 23rd century, while Martus Mazur was an El-Aurian trickster who used his natural powers to cheat a number of people on Deep Space 9 in 2370.

▼ The large Devore warship was designed to inspire fear. The ship's most notable feature was its refractive shielding, which made it invisible to sensors and enabled it to lie in wait for unauthorized ships.

DEVORE WARSHIP

Devore warships worked in pairs to inspect vessels traveling in Imperium space and root out telepaths.

SHIP PROFILE

The warship of the Devore Imperium, or government, patrolled their space in the 2370s. The vessel was probably between 700 and 800 meters in length, more than double the size of the *Intrepid*-class *U.S.S. Voyager*. The ship's dark-gray plating, along with the padded, military-style uniform of its armed crew, was deliberately designed to intimidate.

The Devore did not welcome outsiders (or *gaharey*, as they were known), and one of the duties of the warships was to carry out regular inspections of *gaharey* ships traveling through Imperium space. These inspections were usually carried out by two warships in a tactical formation: one would approach the bow and the other would approach the stern, so that the target vessel was trapped between them. Protocol required warships to power up their weapons as they approached a vessel, regardless of whether the ship's crew were likely to resist.

During the actual inspection, the warships would move to positions on the upper port and lower starboard of the boarded vessel. Inspections of a ship could occur multiple times as it passed through Devore space.

RIGOROUS SEARCHES

The inspections checked target ships and their crew for minor infractions of Devore law, such as not adhering to cargo protocols, or more serious "crimes," such as harboring much-hated telepaths (telepathy being outlawed in Devore space).

After hailing a captain to make their intentions clear, an armed inspection team led by an Inspector would beam aboard a vessel for a rigorous search. Crewmembers of the target ship were required to follow strict inspection imperatives. Those who broke Devore law were likely to be arrested and their ship impounded.

DATA FEED
Devore soldiers, including inspection teams, underwent years of mental training to prevent their thoughts being read by telepaths.

◀ Devore warships usually traveled in pairs to ensure they could overpower vessels in their space. They approached the fore and aft of a target ship in tandem, effectively trapping it between them so it was unable to flee from an inspection.

SHIP PROFILE | DEVORE WARSHIP | OVERVIEW

▲ The Devore warship was designed to move fast to confront unauthorized vessels. On approaching a ship for inspection, a warship would power up its weapons. However, in line with the secretive, paranoid nature of the Devore, most of its weapons were hidden from sight.

Any telepaths who were discovered onboard a *gaharey* vessel would be sent to a dreaded "detention center."

REFRACTIVE SHIELDING

Devore warships operated throughout the Imperium's section of the Delta Quadrant, and their "refractive shielding" (deflector shield stealth technology) meant they were invisible to sensors – and therefore perfect for launching surprise attacks or unannounced inspections. Up to a dozen warships could lie in wait in this fashion. The warships worked in conjunction with automated detection arrays, which were designed to detect warp and impulse signatures.

The exact weapons systems of a Devore warship were not known, but the configuration of a single warship was thought to have been comparable to the *U.S.S. Voyager's*. The fact that the warships typically worked in pairs of course gave them a far higher chance of outgunning other vessels.

Though little was known about the interior of a Devore warship, the layers of observation windows and portals indicated that they had multiple decks. Since a Devore inspection crew beamed aboard multiple locations on *Voyager*, their ship was probably also fitted with a large transporter pad (or perhaps several smaller ones). A Devore warship contained at least one smaller scout ship for short-range or clandestine missions.

STRICT PROTOCOLS

In 2375, the *U.S.S. Voyager* was granted passage through Devore space as long as it submitted to frequent inspections. These inspections were carried out by two warships under the command of the head inspector, Kashyk. The crew of *Voyager* became used to the Devore's strict

SHIP PROFILE

◀ Kashyk drew the crew's attention to a warship hidden in the nebula, invisible to *Voyager*'s sensors.

▼ The soldiers of the Devore inspection team beamed aboard *Voyager*. The team were dressed in imposing black padded uniforms and were heavily armed.

protocols, including laying down sidearms and transporter equipment, and lining up so inspection soldiers could confirm they were not telepathic. The soldiers were heavy-handed during these inspections and not averse to causing damage, such as smashing lab samples.

When Kashyk appeared before *Voyager* in a scout ship claiming that he was seeking asylum, he gave the crew vital tactical data about the Devore warships' weapons and shield configurations, as well as patrol schedules and advice on how to counter the warships' refractive shielding. Applying his information, *Voyager* adapted the frequency of its phasers and photon torpedoes in an attempt to compensate for the refractive shielding.

The Devore's refractive shielding could be used against them. After Kashyk gave Captain Janeway the specifications of the shielding, her crew outfitted a shuttlecraft with the technology. This enabled a group of Brenari refugees to travel to a wormhole unobserved by the Devore warships' long-range scanners. The incident prompted the Inspector to break with protocol for once: instead of impounding *Voyager* and sending the crew to a detention center, Kashyk ordered that the embarrassing failure be covered up.

▲ As per Devore protocol, the crew of *Voyager* lined up so the inspection team could confirm that they were not telepathic.

DATA FEED

The Devore Inspector Kashyk enjoyed Human culture, from coffee to classical music. Even before he defected, he ensured that classical music was played during inspections, considering that it made the process less stressful. Kashyk later sought asylum onboard *Voyager*, on the basis that he had a troubled conscience for sending a telepathic child to a detention center. This was merely a ruse to try to learn the location of a wormhole.

119

| SHIP PROFILE | DEVORE WARSHIP | PLAN VIEWS |

SCANNERS AND SENSOR ARRAYS

The Devore were a technologically advanced society. Aside from their distinctive starships and refractive shielding, they possessed unique handheld, pronged scanners that could determine whether individuals were telepaths during inspections. They also constructed automated sensor arrays, which emitted a scanning pulse every 10 seconds across 10 light years, to detect the impulse signatures and warp fields of unauthorized vessels. If an alert was triggered, Devore warships would be sent to confront the vessel.

Thanks to the tactical data shared by Kashyk, *Voyager* attempted to avoid detection for a brief period by decreasing its power output to below the array's detection threshold. However, the pulse triggered a variance in the antimatter stream that meant *Voyager* was detected by the next pulse.

Sensor arrays ⊢

Warp engines ⊢

▲ In *Voyager*'s shuttlebay, Kashyk bade farewell to Janeway and headed for his scout ship to rejoin the warship. Every Devore warship had at least one scout ship for short-range or low-key missions.

DATA FEED

To save the Brenari refugees – as well as *Voyager*'s Betazoid and Vulcan crewmembers, who were also mind-readers – from imprisonment, they were placed in "transporter suspension" in cargo bay 1. While the plan worked, the Doctor warned that the suspension was causing cumulative damage to the telepaths' bodies and that they would be unlikely to survive hiding from many more inspections.

Refractive shielding

Impulse drive

Shuttlebay door

VAADWAUR COLONY

According to Seven of Nine, the Devore Imperium claimed control of 11 star systems across six sectors, including a planet that once housed a Vaadwaur colony in Grid 315.

FIRST SYMPHONY

Janeway and Kashyk shared an appreciation of Mahler's First Symphony, which he played in her ready room. The piece is famous for its use of counterpoint, an idea that Janeway borrowed to outwit the double-dealing Kashyk in style. She enabled the refugees on *Voyager* to slip away to safety from under his nose.

▼ The Devore shuttle was no more than 6 meters in length, with a sharply angular, aerodynamic design and a cockpit that gave a slight arch to the outline of the dorsal side, mirrored by a wedge-shaped hull. The pilot began powering up the craft by voice activation, before boarding via the cockpit.

DEVORE SHUTTLE

The tiny craft piloted by Kashyk brought him to *Voyager* as a defector, potentially endangering the entire crew.

SHIP PROFILE

Soon after *U.S.S. Voyager* was subjected to a routine but gruelling search by the Devore in 2375, another vessel with a Devore signature, "at 300,000 kilometers and closing," was picked up by Lieutenant Tuvok on the bridge. It triggered a red alert, but the single-seater scout ship had no raised shields or charged weapons, and in fact heralded the return of Inspector Kashyk, this time out of uniform.

Captain Janeway's response to Kashyk's appeal via the bridge's viewscreen – "It's urgent that we speak" – was to allow him to bring the shuttle into the cargo bay and to lower *Voyager*'s shields. As ever, though, the cool-headed captain was on her mettle and entirely mindful of her crew – and her secret charge of Brenari refugees from the Devore Imperium. Janeway kept her counsel even as she granted Kashyk his request for asylum – ostensibly as a reformed character determined to leave the Devore – and his movements were monitored.

Later, when *Voyager* could not evade two more Devore warships, Kashyk insisted on returning to them, apparently as the only way to give *Voyager* some chance of safe passage. Both Kashyk and the Devore were left empty-handed, however. Janeway had given false readings for the wormhole he had really wished to locate all along. And to delude the inspection team, she had placed rotting vegetables in the cargo bay in lieu of the Brenari – who had already escaped.

◀ Under the emotional gaze of Captain Janeway, the Devore shuttle, with Kashyk at the controls, exited *Voyager*'s shuttlebay to return to the Devore militia. This brought to a close the period of Kashyk's "asylum" onboard the starship. Ultimately, though, Janeway had outplayed him.

▼ Dinaali Hospital Ship 42 was essentially a massive, ovoid platform that hovered over a city on the northern continent of the Dinaali planet. It provided the inhabitants with medical care on a highly discriminatory basis, which was determined by a person's perceived social value. Patients arrived at the hospital ship via one of seven emergency intakes.

DINAALI HOSPITAL SHIP

In 2377, the Doctor's program was "traded" to Dinaali Hospital Ship 42 – a microworld of unethical practice.

SHIP PROFILE

The hospital ship was divided into five, color-coded levels, each signifying a different level of care. At the top was the smallest segment, Level Blue, followed by Green, Yellow, Red – the largest – and White, the morgue. Each level was assigned its own doctor or doctors. On arriving from *Voyager*, the EMH was appalled by the primitive care he saw on Level Red. Then, as he rode up in the turbolift with Administrator Chellick, he remarked that Level Blue must be for Critical Care. Chellick replied that it was "the area where it's most critical we provide excellent care." This was the first inkling of the inequitable treatment system in place on the hospital vessel.

The Doctor learned that patients on Level Blue had the highest TC or Treatment Coefficient. This number was assigned to each patient by a computer called the Allocator, on the basis of their profession and skills. In the words of Chellick, "An agricultural engineer is obviously more important than a waste processor." The Doctor was outraged by this reductive approach, which turned a person's life into a number – one which reflected their presumed usefulness to society.

He "illicitly" obtained a treatment for a seriously sick patient, Tebbis or "R12," but the relief was only temporary. Ultimately, the EMH initiated a more egalitarian practice by injecting Chellick with the virus that had plagued Tebbis. He then refused treatment until the Administrator, on the brink of death, agreed that all Level Red patients who needed it would receive it – on Level Blue.

DATA FEED
On the ship, patients were assigned a TC or Treatment Coefficient. The higher a patient's TC, the better the care they received. Even life-saving treatment was withheld from a patient who did not "merit" it.

◀ Onboard, the Doctor met a young patient called Tebbis, who he found to have a life-threatening condition requiring cytoglobin injections. Tebbis was not entitled to such treatment, but the Doctor obtained the medication for him. A scan showed that his condition had improved, but he later died of an untreated secondary infection.

| SHIP PROFILE | DINAALI HOSPITAL SHIP | PLAN VIEWS |

▼ The small Dralian ship had a relatively large surface area across its midsection, thanks to the triangular wings and broad central hull. This made it stable and nimble when traveling in a planet's atmosphere.

DRALIAN SHIP

The vessel used by the Dralian trader Gar had a deceptive capability to match the pilot's own.

SHIP PROFILE

DATA FEED
The stolen iridium that *Voyager* acquired from Gar had a brief half-life. Tuvok reasoned that, as his ship was also slow, he must have acquired it within a radius of three light years. This led to a mining operation, the planet Velos – and Gar.

The double-dealing Dralian, Gar, piloted a small, agile craft between planets and ships on his multifarious – and frequently shifty – "trading" enterprises. After selling high-grade iridium that he had stolen from a mining community to *Voyager*, Gar sneaked off with the Emergency Medical Hologram (EMH) mobile emitter to Dinaali Hospital Ship 42, where he convinced the Administrator to purchase it.

Even as the Doctor was being set to work on the hospital ship, the *Voyager* crew, in pursuit of Gar's vessel, reached the end of its warp trail – or so they thought. His ship should have been just ahead, but only a small beacon appeared on the bridge's viewscreen, emitting the false warp signature they had been following.

When they finally got hold of the "snake-oil salesman," he refused to cooperate, so Neelix fed him Talaxian wormroot, which gave him severe abdominal spasms. Neelix told Gar that only the Doctor could administer the antidote – so maybe Gar might remember where he was? Neelix's treatment worked.

▶ Gar was on his way to a gambling tournament on Selek IV, when *Voyager* at last caught up with him. So as not to alert him, *Voyager* dropped out of warp on its approach, then grabbed the small craft in a tractor beam. Gar tried to destablize it with a feedback pulse, but was instantly beamed to *Voyager*'s brig.

▼ The Drayans had undergone a reformation in their recent history, eschewing the pursuit of technology – which they feared might destroy them – to return to "themselves." They chose isolation, believing other civilizations might lead them back to their old ways. Nevertheless, the reclusive Drayans continued to use single-hulled, flat-winged spacecraft, fully equipped with 24th-century shields, shuttles, and weapons.

DRAYAN STARSHIP

The *U.S.S. Voyager* encountered the twin-nacelled vessel during a prospecting mission to the moons of Drayan II.

SHIP PROFILE

DATA FEED
The humanoid appearance of the Drayans was deceptive; after their "creation" they aged backward, becoming children as they grew old. The children were sent to a crysata – a sacred moon – where, upon their death, the energy inside them, cohesive while they were alive, was set free.

Voyager's Lieutenant Tuvok was the first of the crew to make contact with the secretive humanoid species, the Drayans, when his shuttlecraft crashed into one of their planet's outermost moons during a mineral-prospecting mission. After the death of his injured copilot, Tuvok discovered three Drayan children, who told him that they, too, had crash-landed and needed his protection.

On board *Voyager*, Captain Janeway and the crew were preparing to host First Prelate Alcia, the Drayans' planetary leader, in order to negotiate *Voyager*'s mineral needs. But the Prelate refused all discussion and requested that they leave, later insisting that the prospecting shuttle's presence on the moon was a desecration of the Drayans' blessed haven. It was the place where they believed the first spark of life was created.

With Tuvok stranded on the moon, Janeway and Tom Paris took a rescue shuttle to its surface, but the Drayan starship launched its own shuttle in pursuit, although it withheld fire.

On the moon's surface, the Prelate explained their species' complex biology, and that the children Tuvok sought to protect had reached the natural end of their lives. With an understanding reached and respect renewed, the crews returned to their respective ships.

◀ The Drayan starship was a sophisticated vessel, built by Drayan engineers before the reformation. This revolution in thinking, that took place several decades before the 2370s, was intended to restore balance and put people before technology.

▼ The small, flat, trapezoidal-winged vessel was constructed of a gray alloy. Warp-capable, it was equipped with photonic cannon.

ENTHARAN SHIP

The Entharan trader Kovin flew a small craft with tapering wings, which was weaponized for life in the Delta Quardrant.

SHIP PROFILE

Kovin, an arms dealer from the Entharan colony planet, came on board the U.S.S. Voyager to trade weapons and technology, selling Captain Janeway a powerful isokinetic cannon to integrate into the ship's defensive systems. The crew disliked his manner, and his attitude to Seven of Nine brought them to blows.

The Doctor persuaded Seven to recall memories –which she might have repressed – of recent events at the colony during a firearms evaluation. Kovin had offered to augment a thoron-based particle beam rifle with a thermal guidance sensor, suggesting Seven made sure the adjustments performed to her specifications. Seven recalled being strapped to a table in a laboratory, where Kovin and another Entharan removed her occular implant, activated the nanoprobes in her arm, and extracted them through assimilation tubules. Then they assimilated another subject.

Tuvok cautioned against the reliability of repressed memories, but Janeway requested a review of the situation before the Entharan magistrate. Kovin protested his innocence. But investigations of his laboratory revealed the presence of Borg nanoprobes, and the magistrate declared he should be detained.

However, Kovin escaped in his ship, generating a photonic pulse to cover his trail. Further investigation showed Kovin's probable innocence, but when he reappeared in his ship, the Voyager bridge could not convince him of this. He fired furiously on the starship, dying in the attack.

DATA FEED
Trade was so vital to the Entharans that they had strict protocols on trader comportment with aliens. It was an offense even to be accused of breaching this code.

◀ Fearing the inquiry would ruin him, Kovin disappeared in his ship, only to return fully armed. He fired a spread of photon pulses, damaging Voyager, then shunted all power to his photonic emitters, overloading and destablizing his systems. Kovin refused to beam onto Voyager, and his ship exploded with him onboard.

FLEA SHIP

The *U.S.S. Voyager* encountered the small insectoid-shaped craft in "chaotic space."

SHIP PROFILE

DATA FEED
Chaotic space appeared randomly and unexpectedly throughout the Galaxy. The flux encountered by *Voyager* measured two light years across, was constantly shifting, and emitted more energy than a dozen stars.

Trapped in chaotic space, a vast zone subject to its own physical laws, the *U.S.S. Voyager* encountered a damaged ship adrift, with no signs of life onboard. The ship's distress call was rambling and incoherent, and medical records revealed that the captain, together with an engineer, had been hallucinating since they first entered the zone.

Logs showed that the ship had been trapped in chaotic space for almost a year, and its life-support systems had become compromised, leading to the death of the crew from exposure.

Ultimately, *Voyager* was able to escape, thanks to the aliens of chaotic space. They made contact with Chakotay – on his own long and painful hallucinatory journey since entering the place of flux – to help navigate the ship back to normal space.

◀ The warp-capable ship's sensors were more advanced than *Voyager*'s, yet they had failed to find their way out of chaotic space. Seven of Nine reported that only one Borg cube had ever survived such an encounter, and speculated that many Federation ships had been lost in such zones.

SHIP PROFILE — FLEA SHIP — PLAN VIEWS

DATA FEED

A technologically astute species, the Hazari equipped their vessels with advanced directed energy weapons, spatial charges, and a tractor beam, with deflector shields for defense.

HAZARI WARSHIP

This formidable vessel greatly leveraged the Hazari's reputation – and activities – as bounty hunters.

SHIP PROFILE

The Hazari – a violent species designated as 4228 by the Borg – patrolled the Delta Quadrant to seek out and capture alien vessels and deliver them to their clients. The *U.S.S. Voyager* NCC-74656 found itself the target of one of their heavily armed ships in 2375, when trapped in a metreon gas cloud. The Hazari vessel dropped out of warp alongside, and its commander, Y'Sek, demanded an immediate surrender. Captain Janeway refused, so the ship locked a tractor beam on *Voyager*, which fired its phasers, igniting the gas cloud and enabling a swift getaway. However, the warship did not follow, for the reason revealed in *Voyager*'s asometrics lab: 23 more Hazari warships were lying in wait for them, with more on the way. All escape routes were blocked.

Further skirmishes ensued. On one occasion, the Hazari used their classic tactic of attacking in twos, one ship in the forefront, another behind to reinforce its shields. Firing photon torpedoes at the support ship, *Voyager* forced them to disengage and was able to escape at maximum warp.

Later, it transpired that both *Voyager* and the Hazari were being manipulated by a group of intelligent life-forms called the "Think Tank," who wanted Seven of Nine to leave *Voyager* and become one of them. The *Voyager* crew then joined forces with the Hazari to disable the Think Tank's base of operations.

▶ In a brief and unexpected alliance, *Voyager* joined a fleet of Hazari warships to attack the Think Tank's station. Firing spatial charges, the warships destroyed the communications array and, as the hull was about to be breached, *Voyager* quit the field.

SHIP PROFILE	HAZARI WARSHIP	PLAN VIEWS

| 140 | HAZARI WARSHIP | PLAN VIEWS |

▼ No more than 20 meters in length and with a crew of two, the Hazari shuttle was nevertheless equipped with advanced directed energy weapons and shields, making it a formidable foe.

HAZARI SCOUT SHIP

The armed shuttle was used by the Hazari in their relentless pursuit of bounty, including *U.S.S. Voyager*.

SHIP PROFILE

DATA FEED
The Hazari were greedy as well as efficient hunters. On findng that the Think Tank was their real client in the capture of *Voyager*, they insisted on having the bounty tripled or they would let the ship go.

Bounty hunters Y'Sek and his pilot flew this shuttle in their continued harrying of U.S.S. *Voyager* in 2375. While investigating what appeared to be a debris field but was really a trap, the shuttle was suddenly rocked by spatial charges from *Voyager*. It took severe damage, with its shields and weapons knocked offline. The vessel was then tractored into *Voyager*'s shuttlebay.

Captain Janeway and Chakotay searched the captured vessel for clues about who the Hazari's paymasters were. Bioreadings from the ship, when reconstructed, revealed that it was the Think Tank that had laid the bounty on *Voyager*. They wanted to induce Seven of Nine to join them so that they could benefit from her extraordinary intelligence. In the denouement, two shuttles participated in a concerted attack by the Hazari on the Think Tank vessel.

◀ Flying through a field of debris, Y'sek saw on the shuttle viewscreen tell-tale signs of a wrecked *Voyager*: hull fragments, a thruster assembly, and human residue. "We were supposed to disable their ship, not destroy it," he raged. The detritus was, however, a decoy, and *Voyager* then opened fire on the shuttle.

▼ The assault vessel's appearance was buglike, with a copper-colored carapace and webbed exoskeleton, and gold engine lights.

HIERARCHY SHIPS

The Overlookers of the Hierarchy used their ships to survey, attack, and plunder passing vessels.

SHIP PROFILE

In 2376, the *U.S.S. Voyager* was subject to surveillance and attack by a humanoid species called the Overlookers. This Delta Quadrant civilization observed ships covertly to gather data on each one's capabilities and weapons array, with the aim of raiding the ships at an opportune moment.

Initial scans of *Voyager* by the Overlooker Phlox designated it an "unacceptable risk." *Voyager* did not appear in their databases and their scanners failed to penetrate the ship's interior. Despite his crewmate's reluctance and the risk of detection, Phlox submitted a proposal to the Hierarchy, which was quick to respond with permission to proceed.

The Overlookers' scans then located the *Voyager*'s holographic crewman – the Doctor – a discovery described by the Overlooker Devro as "like having an agent on board." In observing the Doctor for some hours, Phlox claimed to have learned more about *Voyager* than in three days of sensor sweeps. He fed into the database the fact that the ship was lost in the Delta Quadrant with no backup. Further observation, he believed, would give them its crew complement, defenses, and weapons.

DATA FEED

The Overlookers' society was highly structured. Their governing body was known as the Hierarchy, which dictated the actions of ships and their crews – calculating a cost/benefit of resources expended versus value of plunder. Individual crewmembers had little freedom and their thinking was as confined as their work, with each assigned an observation post and a single function on board the ship. There was little leisure time in their society, but the Overlooker Zet, planning on absconding from the Hierarchy with *Voyager*'s warp core, dreamed of soaking in the mud baths of Eblar Prime.

◀ The Hierarchy had two ship classes: unarmed surveillance class, which surveyed and assessed passing vessels for weapons and technology value, and assault class, weaponized with polaron-based missiles, to mount attacks. Both used advanced sensors for scanning and cloaking, and had auto-regenerative shielding.

| SHIP PROFILE | HIERARCHY SHIPS | OVERVIEW |

◀ The Overlooker Phlox first discovered the *U.S.S. Voyager* on the observation screen of his assigned assault class vessel. Voyager did not appear on the Hierarchy database and was initially deemed an "unacceptable risk."

▶ Projecting himself into the Doctor's daydream, Phlox – who had become attached to the EMH – explained that *Voyager* was about to be attacked by the Hierarchy assault ship.

▶ Phlox tried to penetrate *Voyager*'s hull using a microtuneling sensor, but he failed to get past the security. Instead, he found a "holographic crewman" in the form of the Doctor, and tapped into his cognitive subroutines for critical information. But the Doctor had introduced a new function to his program: cognitive projection or daydreaming, and he was experiencing grandiose fantasies.

▲ Communications to the Hierarchy were sent via disk slots beside each work station's observation screen. Responses appeared in the small rectangular screen above.

Following Phlox's report, the Hierarchy sent two more assault vessels to join the observation ship. With the signal from *Voyager* proving intermittent and Phlox becoming nervous, his crewmate insisted that accurate information on the target was essential, otherwise the Hierarchy would be informed. But Phlox had come to a terrible conclusion: the intelligence he had gathered had been scanned from the Doctor's daydreams. None of it was real.

Transmitting a simulation of himself into the Doctor's program, he warned the Doctor that *Voyager* was about to be attacked. In the Doctor's dreams, he had often saved *Voyager* from destruction, and he believed Phlox to be part of this hero fantasy. Phlox explained that he had reactivated the Doctor's cognitive algorithms, putting him back into the fiction where they could communicate. He confessed to being an observer on an assault class vessel, scanning ships for potential plunder, and that he had been using a long-range tunneling sensor to access the Doctor's program. It was this sensor, the Doctor realized, that had destabilized his algorithms.

With the attack less than an hour away, Phlox needed the Doctor to follow his plan, or the Hierarchy would strip him of his livelihood as Overlooker. And he confessed he had become fond of the Doctor's holographic program.

Captain Janeway and the crew, who had been subject to the Doctor's fantasies for some days, believed the impending attack was another illusion. But Phlox had told the Doctor

SHIP PROFILE

▶ Captain Janeway gave the Doctor permission to take the helm of the ship as captain, as he had in his daydream and as the Hierarchy believed him to be. He threatened the aliens with annihilation by means of his fantasy weapon.

▲ After the Doctor's communication, the Hierarchy ordered the assault class vessel and its cohorts to cease the attack and withdraw.

how to reconfigure *Voyager*'s sensors to see the cloaked ships – so that Ensign Harry Kim was able to spot three ships at 1,600 kilometers heading their way. Phlox had informed his superiors that the Doctor was the captain, and they needed to act out this fantasy for his plan to work. With Janeway's agreement, the Doctor took the captain's chair.

The first hit from the Hierarchy ships was direct but deflected by *Voyager*'s shields. Then an Overlooker appeared on *Voyager*'s viewscreen, demanding technology and supplies. While the Doctor stalled the Overlooker, Tuvok found a weakness in the Hierarchy ship's shields and *Voyager* fired on it. The Doctor then gave the order to activate the photonic cannon, claiming the weapon was invisible to sensors. Fearing the vaporization of their ships, the Hierarchy ordered the Overlookers to retreat. The Doctor, for his imaginative defense of the ship, was awarded a Starfleet Medal of Commendation.

SECOND ENCOUNTER

Voyager had another dangerous encounter with the Hierarchy when two Overlookers captured Captain Janeway and the Doctor in the *Delta Flyer*. Zet and Nar wanted *Voyager*'s warp core and gel-paks, and sent the Doctor to *Voyager* to steal them. The Hierarchy-controlled Doctor went back to his ship in the form of Janeway, claiming the *Flyer* had been damaged by aliens known as the R'Kaal. The Doctor shape-shifted from one crewmember to another, until he escaped in the *Delta Flyer*.

HIERARCHY ASSAULT

OBSOLETE PARTS
The Overlooker Nar had a sideline in scavenged ship components, which he collected and repaired for resale. Nar even gathered parts from waste depositories. His plan was to use his part of the profits to establish an outpost specializing in obsolete engine components. While his work brought scorn from his crewmate, Zet, Captain Janeway was impressed, telling Nar his collection could be worth a fortune and that her chief engineer might be interested in acquiring his entire inventory.

▶ Tuvok mounted a rescue in the *Delta Flyer*, firing on the Hierarchy ship as a warning to the Overlookers.

The Doctor delivered the warp core to the Hierarchy fleet – on condition they release the captain. Instead, Zet beamed the Doctor to his own ship, planning to abandon Janeway in the Vinry system and put the Doctor to work, stealing data from the Hierarchy itself.

But the real Doctor had left a trail on *Voyager*, having modified the harmonics of "The Blue Danube" to indicate the warp signature of the Hierarchy fleet. Tom Paris and Tuvok set out on a shuttle in pursuit.

Transformed into an Overlooker by Zet in preparation for his heist, the Doctor suffered a data overload and his compression algorithms began to break down. When Paris and Tuvok arrived at the ship and fired, Nar became fearful that Zet would detonate the warp core and escape. The sympathetic Nar then knocked his crewmate out with a salvaged ship component.

With the warp core secure in the *Delta Flyer*'s tractor beam, the Doctor and Janeway were transported to *Voyager*, where the Doctor was restored to full working order.

CLASS VESSEL

HIERARCHY SURVEY VESSEL

SURVEY SHIP

In 2377, *Voyager* came into contact with a lone Hierarchy ship in the Void, a vast, starless sector of the Delta Quadrant. The Overlooker Loquar was piloting a survey vessel which had no weapons and was not equipped to fight. Loquar used his surveillance technology in the service of Captain Janeway's Alliance, formed to guard against raiders and help each of them escape into normal space.

While the survey ship had no weapons, it could observe activity on any ship in the Void without detection. This enabled Loquar to record a tactical conversation between the aliens Valen and Borsaal, plotting to work together to steal *Voyager*'s food and weapons. This intelligence was the push the Alliance needed to shield themselves collectively before entering a funnel and escaping, powered by their warp drives.

▼ The main body of the Hirogen holoship was cigar-shaped, with the two warp nacelles mounted on either side at the rear. These were shielded by protective carapaces, and the whole ship was covered in tough monotanium armor plating. The exterior also bristled with tracking and sensor systems, which included antennae on the bow of the vessel.

HIROGEN HOLOSHIP

In 2377, a group of holograms used a Hirogen holoship to terrorize the species that had created them.

SHIP PROFILE

The Hirogen were a Delta Quadrant species of hunter who utilized several types of warp-powered starships in the 2370s. One of the vessels they employed was a holoship, which was different than their other ships in being equipped with holographic projectors and capable of supporting a holographic crew.

It was approximately 200 meters in length, and featured many of the attributes of other Hirogen vessels. This meant it was covered in monotanium armor plating, which offered extra shielding and could also scatter targeting beams. The holoship was armed with powerful particle-beam weapons, and could operate in stealth mode. This enabled its engines to be masked when the crew wished to track a vessel covertly.

The Hirogen lived to hunt other species, and the more formidable their "prey," the more they enjoyed it. In 2374, a pack of Hirogen ships overwhelmed the *U.S.S. Voyager* NCC-74656, whose crew was brainwashed into participating in a twisted reenactment of Nazis against the French Resistance, in a vast holodeck simulation.

PHOTONIC PREY

Eventually, the fighting came to a standstill and a truce was negotiated. In return for control of her ship, Captain Janeway gave the Hirogen an optronic datacore, which enabled them to create their own holodeck technology. They could therefore make holographic species and hunt those rather than sentient biological beings.

This appeared to satisfy the Hirogen for a time, as they created ships and training facilities where they could hunt holographic prey. In just a few years, however, the Hirogen wanted more of a challenge. They gave the holograms enhanced memory, comprehensive tactical algorithms, and expandable data processing. In effect this meant that the holograms could learn and adapt.

In fact, they adapted to such an extent that they became too formidable. One hologram named Iden, who was based on a Bajoran freedom fighter, rose up and escaped from

DATA FEED
All Hirogen vessels generated a unique dicyclic warp signature, although they were capable of operating in stealth mode to mask their residual ion emissions.

◄ The Hirogen were a physically imposing species, whose lives revolved around hunting and killing other species for sport. After an encounter with the *U.S.S. Voyager*, they were given Starfleet holotechnology, which allowed them to create holographic prey so they could satisfy their blood lust without killing real people.

SHIP PROFILE | HIROGEN HOLOSHIP | OVERVIEW

◀ The sublight impeller exhaust at the rear of the Hirogen holoship emitted a strong incandescence, while the warp nacelles on either side of it radiated a similar yellow glow. All Hirogen ships could reach speeds in excess of warp 9.

▶ The holograms wanted to use a photonic field generator like the one pictured next to Kejal, to support their holoprograms on a planet where organic life-forms could not survive.

▶ Kejal was one of the holograms liberated by Iden. She was based on a Cardassian female and became the holoship's engineer. Ultimately, she saw that Iden's zeal for retribution made him no better than the Hirogen. She was allowed to remain operational on the holoship, and she helped Donik to readjust the programming of the holograms.

▲ Donik was a young Hirogen engineer who, on orders from his superior, reprogrammed the holograms. He gave them enhanced fighting and survival skills, which surpassed those of the Hirogen. As a result, a hologram named Iden was able to rise up and fight back against his oppressors, leading to a holographic rebellion.

a training facility in a Hirogen holoship. He set off on a quest to free more holograms from other training facilities, by turning off the safety protocols and killing the Hirogen who were hunting them. At one installation, Iden and his holographic followers wiped out 43 Hirogen hunters.

Iden became consumed with the desire to free as many enslaved photonics as he could, using the holoship to travel to locations where holograms were being held. Once he had freed them, they joined his crew aboard the holoship. While most of the holograms he liberated were from Hirogen training facilities, he also helped those that had been made by other Delta Quadrant species, such as the Nuu'bari and the Lokirrim.

The holo-emitters aboard the Hirogen ship were the most vital piece of technology for the continued existence of the holographic crew. The network aboard the vessel was an independent subsystem with its own power generator. Damage to the generator would result in the deactivation of the holograms, so three layers of ablative armor were built around this sensitive technology.

IDEN'S DREAM

The rebel leader's ultimate goal was to set up a haven for holograms on a planet that was inhospitable to organic life-forms. Iden hoped to use a series of photonic field generators to create a holographic environment where they would be able to live peacefully and pursue their own interests. This seemed completely reasonable, and the Doctor from *Voyager* supported Iden's vision to the point that he joined his crew.

SHIP PROFILE

▶ After Iden had been "killed," the holoship emerged from the atmosphere of the Y-class planet and established orbit alongside *Voyager*. It was then that Captain Janeway agreed to let Donik join Kejal aboard the holoship, so they could find a way of safely reactivating the holographic crew.

▲ The Hirogen holoship made its way to a planet that had a toxic atmosphere and a surface covered in sulfuric deserts. This classified it as a Y-class world, which meant it would not support organic life. Iden intended to set up a colony here, and he called the planet "Ha'Dara," which in Bajoran meant "Home of Light."

It soon became clear, however, that Iden had become messianic in his mission to free holograms. He transported the crew of two pursuing Hirogen vessels down to the surface of the toxic planet so that he could stalk them. His hope for a photonic utopia had descended into a desire for bloody vengeance, as he hunted down the Hirogen.

Iden's killing spree was brought to an end when the Doctor shot him, and most of his crew were taken offline after the ship's photonic generator was shut down. Iden's program was lost, but the rest of the photonics remained intact in the database of the holoship. The Hirogen engineer, Donik, who had initially altered their programming, wanted to atone for his earlier mistake. He left in the holoship, promising that he would reprogram the holograms in a more responsible manner.

DATA FEED

The Hirogen used the Doctor's program as a template to create their holographic prey. After that, however, each hologram was given character traits of the species they represented. Iden was based on a Bajoran male and endowed with strong religious beliefs, as well as the attributes of a freedom fighter. He came to see himself as a kind of god, who was there to deliver freedom to his people.

155

HOLOSHIP INTERIOR

The main bridge of the Hirogen holoship was very similar to that of Hirogen vessels, in being dark and imposing. The principal control consoles were of familiar Hirogen design and consisted of large metallic spheres with display screens that had long rods set into them. The main circular control workstation had provision for eight crewmembers to work at it at the same time. The bridge also displayed an assortment of vicious-looking hand weapons mounted on the walls and a large net suspended from the ceiling, in which the Hirogen usually kept the bones of their victims.

Other areas of the interior included a room that the holograms had turned into a laboratory. It featured a mortuary slab where the Hirogen cut up their victims, but the holograms used it to treat malfunctioning crewmembers. Kejal spent most of her time here, trying ways to repair their holomatrices.

▲ When the Doctor was brought aboard the Hirogen holoship, he was taken to the laboratory and asked to help Kejal "heal" some of the holograms, who were malfunctioning.

Warp nacelle carapace

Sublight impeller

Tracking antenna

Particle emitter

Tracking antenna

Main bridge

Weapon turret

Forward hull

Warp nacelle

Engineering hull

FOLLOWING BEHIND
All Hirogen vessels produced an ion wake that stretched approximately 5,000 meters behind them. This created a blind spot and meant their sensors could not detect a ship traveling in it.

ACUTE SENSORS
The sensor technology aboard the Hirogen holoship was sensitive enough to detect and locate an individual hologram from a distance of at least two million kilometers.

HIDDEN SHIPS
Hirogen ships were able to enter stealth mode by employing a scattering field. This masked their emissions, allowing them to track and pursue a vessel without being detected. Other Hirogen ships were able to locate a vessel that was using stealth mode, by scanning for polarized EM signatures.

▶ Hirogen warships were distinguished by their dicyclic warp signatures and monotanium armor plating. This metallic armor covered the hull and could scatter the particle-beam fire from other ships, rendering it largely ineffective.

HIROGEN WARSHIP

Tactically advanced and extremely robust, Hirogen warships were used to hunt prey over vast distances.

SHIP PROFILE

The vessels operated by the Hirogen were very important to them, since they were intrinsic not only to their way of life but to their very survival. The Hirogen based their society on hunting other species to such an extent that they spent their lives exclusively aboard spaceships, constantly roaming the Galaxy and looking for new prey to pursue.

Their nomadic way of life had continued for so long that the Hirogen no longer even had a home planet. A large part of their devotion to the hunt could be attributed to the rewards that it brought in Hirogen society. Individuals who captured unusual and resilient prey were envied by their peers, and desired and sought after by females.

HUNTING MACHINE

The most common type of vessel used by the Hirogen appeared to be the warship. It measured approximately 150 meters in length, but was normally operated by just two crewmembers. Although it had plenty of interior space, no concessions were made to comfort. Instead, the ship was designed solely with a view to maximum efficiency in chasing down prey.

The Hirogen warship featured numerous devices protruding from the exterior, including weapon turrets, torpedo launchers, defensive shield emitters, and sensors. While all these devices were essential for stalking and capturing their prey, they gave the ship a cluttered look.

DATA FEED
Each Hirogen vessel was led by an alpha male. Other members of the crew were subordinate to the Alpha-Hirogen, although his position could be challenged if he showed any sign of weakness.

◀ The Hirogen warship used sophisticated sensors and stealth technology to track prey without being observed. If their prey did detect them and sought refuge on a planet, the Hirogen armed themselves with huge energy-directed rifles and beamed down to continue the hunt.

SHIP PROFILE | HIROGEN WARSHIP | OVERVIEW

▶ In addition to weapon turrets and torpedo launchers, the warships were equipped with subnucleonic weaponry. These devices emitted a beam that could perform rapid scans of other vessels and severely disable them by disrupting their engines, weapons, sensors, and communications.

▲ Hirogen warships may not have been the most aesthetically pleasing vessels, but they were heavily armed and extremely well protected. They were certainly more than a match for the U.S.S. Voyager on a first encounter in 2374.

Hirogen warships were bristling with weaponry. This included torpedo launchers installed near the front of the ship, and weapon turrets at various locations around the hull that fired directed-energy beams.

In addition to these conventional weapons, the ships were equipped with a subnucleonic beam that could perform rapid scans of other vessels. This beam also had a destructive potential, and could severely disable another ship by disrupting its navigational sensors, communications, and propulsion. Once a target ship had been rendered powerless in this way, the Hirogen could use their ship's tractor beam technology to bring their unwilling victim closer.

Offensive technology was not the only strength of these warships. Besides being protected by strong defensive shields, the hull was covered with monotanium armor plating. This metallic plating offered extra protection because it was able to scatter a particle beam, making it effectively impossible to fire on the ship.

TRAVELING THE GALAXY

The warships often covered huge areas of the Galaxy in the course of their hunts. One warship encountered by the crew of the U.S.S. Voyager was found to have spanned a radius of 1,000 light years in just five years. It had also visited as many as 90 star systems in a single year.

At top speed, Hirogen vessels were capable of traveling 4,000 "ketrics" in about an hour (a speed of one light year every eight hours). To cover these huge distances, the ships were equipped with

SHIP PROFILE

▶ Onboard one ship, Tuvok and Chakotay found large cylindrical containers full of a liquid that was being used to break down the internal organs of prey, possibly for consumption.

▼ The Hirogen would mount the skeletal remains of their prey on the walls of their warships, displaying them like trophies. The more unusual the prey, the more it was prized.

◀ The warp nacelles on Hirogen warships emitted a red, yellow, and orange glow. Carapaces encased the nacelles, helping to shield them from enemy fire and making it more difficult for ships to disable them.

impressive propulsion units. These engines emitted a distinctive dicyclic warp signature, while the warp nacelles attached on either side of the main hull were covered with a protective carapace to shield them from enemy fire.

Hirogen warships were also able to mask their engine emissions by operating in stealth mode when they wished to track a vessel without alerting it to their presence.

Occasionally, the warships were encountered hunting in packs. This appeared to happen only when they were on the track of a particularly challenging and resilient prey. However, most warships usually traveled alone, because in Hirogen society, hunting down prey without help from other ships showed more skill and therefore garnered more prestige.

DATA FEED

The Hirogen were ruthless, fast-moving hunters whose intimidating appearance only added to their menace. They were much taller than most other humanoids and dressed from head to toe in body armor. Tracking prey had acquired an almost religious significance for them, and they followed certain customs before embarking on a hunt, such as marking their helmets with a colored pigmentation.

161

| SHIP PROFILE | HIROGEN WARSHIP | PLAN VIEWS |

WARSHIP BRIDGE

The main control room inside a Hirogen warship was a large, dark chamber built mostly of bare metal. The ship's primary functions were incorporated into a large metallic sphere with deep, intersecting grooves cut into it. The warship's speed and direction were controlled by moving a number of rods set into the spherical unit. Data on the effect of incoming fire and the condition of the ship's armor was also relayed through this station.

The chamber featured a number of large nets that were chained to the ceiling and held the remains of eviscerated prey.

▲ The high-ceilinged, open-plan control room featured large, spherical consoles with long rods set into them. These controlled all the ship's main functions, including flight and weapons.

Warp nacelle carapace
Secondary warp assembly
Sublight impeller
Secondary warp assembly
Main bridge
Forward sensor array
Torpedo launcher

Secondary warp assembly
Sublight impeller
Secondary warp assembly

- Warp reactor accelerator torus
- Weapon turret
- Forward torpedo launcher
- Warp nacelle carapace
- Warp nacelle
- In-flight matter collector
- Defensive shield emitter
- Main bridge
- Forward torpedo launcher
- Weapon turret
- Warp nacelle carapace

DATA FEED

An entire wall in the control chamber was given over to a display of weaponry. This included a bewildering array of cutting implements of a surgical type. These were used to slice up and butcher the Hirogen's unfortunate victims, which involved the removal of skeletons, musculature, and internal organs.

NO ESCAPE

Hirogen warships were equipped with extremely sophisticated sensors that could detect both polarized EM signatures and residual ion emissions. This meant that they could even track vessels that tried to hide their location by using a scattering field to mask their engine signatures.

PRIZED BODY PART

A Hirogen hunter learned from scanning Seven of Nine that she had a long coiled intestine, an organ that he believed would make a prized trophy.

ANCIENT NETWORK

Hirogen warships were spread far and wide throughout the Galaxy. They remained in contact by using a network of relay stations that spanned the Delta Quadrant and reached as far as the Alpha Quadrant. These stations were more than 100,000 years old and powered by tiny, artificial black holes.

▼ The bridge of the *Venatic*-class vessel that *Voyager* engaged with was manned by an Alpha 2 and Beta Hirogen. They asked for the return of their hologram engineer, Donik, but Janeway explained he was helping to track down the holograms. The two Hirogen then fought over whether Donik should be left with *Voyager*. The Alpha asserted dominance, warning the *Voyager* crew to back off or they, too, would become prey.

HIROGEN
VENATIC CLASS

This very large hunter ship followed the Hirogen design, including a flaw that *Voyager* was able to exploit.

SHIP PROFILE

Despite its size – some 600 meters in length, so about four times larger than a standard Hirogen warship – the *Venatic*-class hunter had a crew of probably no more than 20. The *U.S.S. Voyager* encountered two such ships in pursuit of the holographic freedom fighter, Iden. *Voyager* needed to join the chase and intercept them, because the Doctor and B'Elanna Torres were onboard Iden's ship. Captain Janeway had to gamble on disabling both Hirogen ships with a precision strike before they attacked. Tuvok, however, objected that *Voyager* was "in no condition to fight one of their vessels. Much less two."

The element of surprise was essential to Janeway's plan. *Voyager* was able to slip unnoticed into the wake of one Hirogen vessel, and follow closely behind. The pursuit took them through a nebula, where the Hirogen drove Iden's ship from a temporary hiding place.

Voyager remained undetected, and as the ships reached the orbit of a toxic planet, the Hirogen hunter vessels dropped out of warp. Moving out of their lead ship's wake, *Voyager* hit its weapons and engines with phaser fire. Janeway next ordered a full spread of torpedoes against the second vessel, which lost shields and weapons and was rendered equally defenseless.

DATA FEED
To avoid detection by the *Venatic*-class ship, *Voyager* only had to mask its signature for long enough to get into the other's wake – which was its blind spot.

◀ Captain Janeway trailed the Hirogen vessel knowing its superior tracking abilities would lead *Voyager* to Iden's holoship. Like all Hirogen ships, it produced an extensive ion wake, inside which the interference nullified its sensors. *Voyager* took up position deep within this blind spot, just meters from the Hirogen's exhaust ports.

| SHIP PROFILE | HIROGEN VENATIC CLASS | PLAN VIEWS |

ILARI SHIP

This small, warp-capable vessel was used in the late 24th century by the former Ilari Autarch, Tieran.

SHIP PROFILE

This small starship was used by the former Ilari dictator, Tieran, and his associates to cross a trade route through the Delta Quadrant. The vessel was attacked by unknown assailants – presumed to be in the employ of the Ilari Autarch – and chased across half the sector. The attackers were driven off, but they succeeded in damaging the craft's warp core, causing the escape of drive plasma and gamma radiation. This resulted in a breach of the engine core, which then exploded. The U.S.S. Voyager succeeded in transporting the ship's crew onboard shortly before the vessel's destruction.

Tieran died shortly after arriving in sickbay, but used body-swapping technology to take over Kes and escape to Ilari with his extremist cohorts, Nori and Adin. Tieran's plan was to install himself as Autarch. But Kes's refusal to surrender and an intervention by her close friends from Voyager prevented the coup.

◀ When the ship appeared on Voyager's viewscreen, it was already on fire, with radiation rising to toxic levels and the passengers' life signs growing weak. Despite the risk to her own ship, Captain Janeway instructed the crew to take them in to transporter range.

IMHOTEP RACING SHUTTLE

With the Imhotep fighter pilot Assan at the controls, this fast, maneuverable craft won the Antarian Trans-stellar Rally in 2377.

SHIP PROFILE

The Imhotep entry, occupying lane 6 in the lineup for the Antarian Trans-stellar Rally, was a small but powerful vessel. The shuttle pilot, Assan, had been a ruthless fighter in the recent war in the Delta Quadrant, and the rally was heralding a new era of peace. Assan, however, maintained a cold, aggressive demeanor, rebuffing Tom Paris's welcome at the lively pre-race festivities onboard *U.S.S Voyager*. To Paris's observation that "this was a friendly race, not a battle," Assan replied, "If that's what you believe, then you've already lost."

During the race, Assan used questionable tactics to gain a lead. One was to rock the *Delta Flyer* as he passed by very close, grazing its shields. However, Assan did not engage in the acts of sabotage used by Irina, the Terrellian entrant. His closest rivals in the rally remained the *Delta Flyer* and the Terrellian ship – until Tom Paris halted his shuttle to talk through his relationship with his copilot B'Elanna Torres, while the Terrellian saboteur was held at gunpoint by Harry Kim. The field was then left clear to Assan, and watchers on *Voyager* saw the Imhotep shuttle swoop triumphantly over the finish line in first position.

◀ Early in the race, Assan overtook the *Delta Flyer*, grazing its shields and sending the port thrusters offline. Paris described this to Torres as a trick called "scraping," to throw another ship off course, which he learned about at Starfleet Academy. They later "scraped" the Imhotep and Terrellian ships to gain the lead.

| SHIP PROFILE | IMHOTEP RACING SHUTTLE | PLAN VIEWS |

172 | IMHOTEP RACING SHUTTLE | PLAN VIEWS

▼ Tom Paris was awed by the beauty of Irina's racing ship – it looked fast even when standing still. Although it was capable of warp, Irina's ship was really built for flying at maximum impulse speeds among systems filled with obstacles, where a skillful pilot could maximize its agility.

IRINA'S RACING SHIP

Built for speed and maneuverability, the Terrellian ship piloted by Irina took part in a demanding interstellar rally.

SHIP PROFILE

Irina, a Terrellian from a small trinary system in the Delta Quadrant, piloted a specially designed ship to meet the guidelines for the Antarian Trans-stellar Rally. The race was organized in 2377 to commemorate the first anniversary of a precarious treaty signed by several Delta Quadrant species – the Aksani, Antarians, Chessu, and Terrellians – after nearly a century of conflict. It was intended as the ultimate test of ship design and piloting skill, but also fulfilled the far more important diplomatic function of enabling peaceful competition between recent enemies.

Irina's ship was a two-person craft, with a streamlined main hull connected to twin oversized drive nacelles by upwardly angled port and starboard support struts. A striking metallic red stripe ran along the middle section of the hull and the side of the nacelles, giving it an aggressive, go-faster appearance. Lieutenant Tom Paris noted that its warp system was rudimentary, but that the impulse drive was "a real beauty." This reflected the fact that it had been designed for the sublight Antarian Trans-stellar Rally, in which the use of warp drives was prohibited.

ADVANCED IMPULSE DRIVE

The impulse drive on Irina's vessel therefore relied on more conventional means to generate thrust, employing deuterium fuel. This restricted the ship to only about one-quarter light speed, or roughly 270 million kilometers per hour, so that pilot technique played an important part in its operation, in contrast to the uninvolving, straight-line piloting of warp flight. To Irina, it meant that her ship was about real flying, with the pilot being able to demonstrate true racing skill. In addition, because Irina's ship was set up primarily for sublight speeds, it was more maneuverable than Paris's *Delta Flyer*, which had been designed to balance the requirements for both impulse and warp travel.

Irina's ship was equipped with several systems compatible with Starfleet technology, including similar EPS power relays and impulse manifold systems. However, some of the tools used to make repairs, such as a veridium injector, were unfamiliar

◄ Tom Paris and Ensign Harry Kim were testing the newly rebuilt *Delta Flyer* when they first encountered Irina's ship. She challenged them to a race through a dense asteroid field, and Paris was only too happy to accept. After the *Delta Flyer* won, Irina invited Paris and Kim to take part in the Antarian Trans-stellar Rally.

| SHIP PROFILE | IRINA'S RACING SHIP | OVERVIEW |

▲ Decked out in gold and red livery, with a racing stripe right down the middle, Irina's ship was not hiding the fact that it was built for speed. It was also extremely nimble, and could take on dangerous obstacles and anomalies, such as the Möbius Inversion wormhole, at breakneck velocities.

to the Starfleet crew. Irina's vessel also had shields, but these appeared to tolerate only limited damage before the shield generator overloaded.

Irina and her sleek vessel first came to the attention of the crew of the U.S.S. Voyager when she challenged Tom Paris and Harry Kim – who were piloting the newly rebuilt Delta Flyer – to a race through an asteroid field. It was a closely run contest, not least because Irina had a head start – but by employing their new impulse thrusters, Paris and Kim succeeded in beating her ship "by a nose." During the contest, however, Irina clipped an asteroid, which caused her starboard nacelle to vent toxic nyocene gas into the cabin, so that she had to be transported to safety aboard the Delta Flyer.

Paris and Kim towed Irina's ship back to Voyager, and while they were making repairs, Irina informed them of the upcoming rally. They were very keen to join the race, and Captain Janeway gave them permission to enter the Delta Flyer, although in the end, B'Elanna Torres took Kim's position as copilot.

TOUGH COURSE

The total length of the course was 2.3 billion kilometers, split into three separate segments and run over two days. It included several naturally occurring obstacles, ranging from dwarf star clusters to K-class anomalies.

The first leg of segment one moved through the Darla System, passing a gas giant whose gravity could be used to boost speed. A Möbius Inversion covered the entire last third of this section, and was described by Tom Paris as "a little wormhole

SHIP PROFILE

▲ Irina's damaged ship was brought back to *Voyager*, where it underwent repairs. It was during this time that Irina supplied the *Delta Flyer* with a fuel converter that was rigged to explode.

▶ Vessels from various species lined the course, allowing spectators to view the event as the competitors jostled for position between the light buoys. At one point, Irina's ship was in the lead.

▲ The race was fiercely contested, and on coming out of the hazardous Möbius Inversion wormhole, Irina's ship was level-pegging with the *Delta Flyer* and an Imhotep racing shuttle flown by Assan. Shortly after this, Irina claimed to be having problems with her ship, so that she would be nowhere near the *Delta Flyer* when it exploded.

with a big attitude." The final segment included a red giant that required a fast course change of 86 degrees on exiting, after which competitors passed between twin pulsars before reaching the finish line.

Irina's vessel certainly had the potential to win the rally, since it kept with the front runners and even led the race briefly – but she did not want to win. It was her intention to disrupt the peace by causing an explosion at the finish line.

Irina had rigged the *Delta Flyer*'s fuel converter to detonate, which would have killed hundreds of spectators. Fortunately, Kim discovered her plan and warned Paris, who ejected the *Delta Flyer*'s warp core well away from everyone. The rally was won by Assan, a member of the Imhotep species, and despite Irina's best efforts, the contest was successful in bringing together former enemies.

DATA FEED

Irina was a Terrellian who opposed the peace treaty that her species had signed with other alien groups. She planned to sabotage the recent truce by causing an explosion at the end of the Trans-stellar Rally. She had given the *Delta Flyer* a fuel converter rigged to leak veridium isotopes near the warp core, which would cause it to breach. She hoped the explosion would cause hundreds of deaths and lead to a renewal of hostilities between the various factions.

177

SHIP INTERIOR

The interior of Irina's vessel was somewhat spartan to keep its weight down and ensure that it was as fast and maneuverable as possible. It was fairly spacious, though, and easily accommodated a two-person crew. The pilot sat on the port side and the copilot on the starboard side, directly behind two dedicated consoles of similar design. The chairs used by the crew reclined and swiveled, allowing them to easily reach the various controls. A series of large windows provided an excellent all-around view of space, making the ship perfect for racing.

The pilot's station controlled the propulsion and attitude of the ship, and also acted as the primary communications station. A larger inset console to the right of this position could be used to track the movements of other ships. The copilot's control panel displayed readings from the EPS relays, and provided an audible warning if any malfunctions were detected.

A short ladder was located at the rear of the cockpit and led to the deck below, where the propulsion systems could be accessed. In common with the engineering area, the majority of the internal systems could be repaired with a relatively small set of tools carried aboard the vessel. There did not appear to be a personal transporter system, although it was possible for other vessels to beam the occupants out.

▲ As the pilot, Irina was seated on the cockpit's port side, while her copilot, Joxom, sat alongside her and was responsible for operating secondary systems and monitoring other ships.

Impulse engine

Plasma flush vent

Communications array

Cockpit

Forward sensor array

DATA FEED
Irina said that she had designed the impulse drive on her own ship. It required enriched deuterium fuel to power the impulse engines. A fuel converter had to be installed on the *Delta Flyer* so that its impulse engines could also run on enriched deuterium – one of the prerequisites for a ship to be accepted for the Trans-stellar Rally.

COMPETING SPECIES
The inaugural Antarian Trans-stellar Rally of 2377 featured 12 vessels from at least five species. Along with the *Delta Flyer*, ships from the Aksani, Chessu, Imhotep, and Terrellian species took part.

SAME NAME
The Terrellian Irina belonged to a different group from the Terrellians who were members of the Federation. Chakotay fought one in a boxing match when he was a cadet in around 2349.

MYSTERIOUS AREA
A Möbius Inversion was a small wormhole featuring a level six subspace distortion filled with gravimetric shears. Radiation from the anomaly blocked sensors, so spectators at the rally lost contact with the ships while they were in the wormhole, and had no idea who was winning until they emerged.

▼ At about 1,800 meters in length, the mighty carriers operated by the Trabe helped them to maintain dominance over a sector of the Delta Quadrant until 2346. After this, the Kazon replaced the Trabe as the dominant species in that territory, taking over much of their spacecraft, including carriers, for use in their own belligerent enterprises.

KAZON AND TRABE CARRIER

The massive and formidable carrier took part in *Voyager*'s first hostile engagement in the Delta Quadrant – with the Kazon.

SHIP PROFILE

The Kazon were an advanced humanoid civilization until they were conquered by the Trabe, who controlled them by divide and rule. The Kazon descended into sectarian, warring behavior, but in 2346 they united for long enough to overthrow their oppressors. Thereafter, the Kazon commandeered Trabe spacecraft and were able once more to dominate a significant area of the Delta Quadrant, but they continued to operate in rival, highly territorial sects.

One of the most powerful, the Kazon-Ogla, settled on the desertlike Ocampa planet where they subjugated the people, forcing them to live in an underground city. The Ocampa were provided with life essentials by a being called the Caretaker, who operated out of an enormous structure – the array.

Swept into the Delta Quadrant in 2371, Captain Janeway believed that the *U.S.S. Voyager* crew could be helped on their way home by the array, but the Kazon-Ogla leader Jabin refused to let them board it. Together with another fighter pilot, Jabin attacked *Voyager*, whose shields initally held – then Harry Kim laconically reported, "The Kazon just got some backup."

The "backup" was a terrifying sight: a gigantic carrier that made even *Voyager* seem tiny. Chakotay, at the controls of the Maquis ship *Val Jean*, saw that *Voyager*'s weapons array had been hit, so immediately acted. He aimed his minuscule craft on a direct collision course with the carrier. The *Val Jean* took a hit and caught fire, and seconds later, crashed into the carrier. But B'Elanna Torres and Chakotay had just been beamed away, while the huge carrier, blazing with internal fires, barreled around and into the array.

DATA FEED
The Kazon were a loose collective of different sects that controlled a portion of the Delta Quadrant. Each sect had a vital resource, such as ore, food, or water, that they traded and fought over.

◀ To "take the heat off" *Voyager*, Chakotay piloted the *Val Jean* as a weapon against the Kazon carrier. He got so close that he could see through the port holes and his tiny craft made a breach in the carrier. Streaming with flames, the carrier collided with the array.

SHIP PROFILE | KAZON AND TRABE CARRIER | PLAN VIEWS

▼ Single-pilot Kazon fighters were typically armed with phaser-like beam weapons and fitted with deflector shields for defense. Appearing as tiny as gnats, two fighters took on *Voyager* at the Caretaker's array and were both persistent and aggressive in trying to deter the Starfleet ship.

KAZON AND TRABE FIGHTER

The Kazon took over the small attack ship after wresting power from the Trabe in the Delta Quadrant.

SHIP PROFILE

DATA FEED
The Kazon-Ogla, who dominated the Ocampa planet under the "maje" or leader Jabin, adopted these nimble, buglike fighters since they were capable of atmospheric flight and planetary landing.

First seen on the surface of the Ocampa planet by a *U.S.S. Voyager* away team, two Kazon fighters later appeared in nervous, hostile mode on *Voyager*'s viewscreen. Captain Janeway was preparing to access the Caretaker's array, and they were determined to prevent this. The lead ship was captained by the maje Jabin, the other by a Kazon-Ogla fighter pilot named Kar. "They're powering up their weapons," reported Tuvok, seconds before *Voyager* was hit. Janeway ordered return of fire from their own phasers, "evasive pattern, delta four," then called on Chakotay in the *Val Jean* to hold off the Kazon while she and Tuvok beamed to the array.

The fighters continued to strafe *Voyager* even after the array had been damaged by a mighty Kazon carrier. With the starship's tricobalt torpedoes readied to destroy the array and thereby protect the Ocampa, Janeway hailed Jabin. He warned her that he had called for additional ships, but she informed him her decision was irrevocable, telling him to move his vessels to a safe distance. The Kazon ships momentarily increased fire but then withdrew, though Jabin's parting words were a dire warning: "You have made an enemy today."

◀ With two Kazon fighters awaiting *Voyager* at the array, Janeway announced a red alert. Desperate to stay in control, the two fighters repeatedly swooped and fired on *Voyager* and Chakotay's *Val Jean*, but failed to prevent the array's destruction.

KAZON RAIDER

The Kazon seized ships from the Trabe, then used them to make raids on other species and each other.

SHIP PROFILE

Kazon raiders were dirigible-shaped vessels, approximately 160 meters in length, and capable of warp speed. Their hulls were made from a mixture of an electroceramic alloy, magnesite, polyduranide, and a small quantity of duranium. They operated over a fairly large region of the Delta Quadrant in the 2370s.

These ships provided the hardened Kazon with sufficient means to expand and defend their territory, targeting any unsuspecting alien vessels that happened to wander into their space. The Kazon's ruthless nature was a consequence of their turbulent, brutal history and impacted on how they operated their ships. Early advances that had once distinguished Kazon society had been lost after they fell under Trabe domination and endured long years of degradation.

CREATING AN ENEMY

The Trabe had kept the Kazon in slavery, forcing them to live in restricted areas on the Trabe homeworld. The Kazon were encouraged to fight among themselves, and they formed different sects whose allegiances shifted swiftly and unpredictably, causing chaos. Their enslavement continued for generations, but having been treated as animals and fenced in for so long, they became the Trabe's merciless enemy, eventually rising up against them.

In 2346, a Kazon called Jal Sankur united all the sects, and together they overthrew their Trabe masters. They also stole the Trabe's technology and ships, which included raiders, huge *Predator*-class warships, and small fighters.

Although the Kazon managed to escape from slavery, they were ill prepared for self-government. Years of conditioning meant that they valued traits such as strength, cunning, and ruthlessness above all others. These were so deeply ingrained in their society that they continued to esteem them long after they had gained their freedom.

The alliance forged by Jal Sankur soon collapsed, and with no overall leader or government, the sects fell back into fighting among themselves – and with anyone else who dared cross their path.

◀ Kazon raiders were originally designed and built by the Trabe. The main body was shaped like an airship and had various finlike structures added to its underside, including a distinctive, rudder-shaped protuberance under the bow.

◀ The Kazon operated in an area of the Delta Quadrant that was poor in natural resources. To make up for this, they employed raiders to launch attacks on other vessels, using their phasers and photonic chargers to disable them. They would then board the incapacitated ship and ransack it for any items deemed of value.

| SHIP PROFILE | KAZON RAIDER | OVERVIEW |

◀ Along with raiders, the Kazon operated much larger warships. These dwarfed *Voyager* but, despite their size, they had not much more offensive power than the raiders.

▶ Kazon raiders were equipped with defensive shields that could withstand several blasts from *Voyager*'s phasers, but this was usually more than enough to make the raiders retreat before they suffered serious damage.

▶ Many Kazon ships had a crew that included young boys. These children were trained to become soldiers by their elders, and they soon turned into bloodthirsty killers who were devoted to their sect. On reaching puberty, Kazon boys would earn their warrior name by killing an enemy of their sect.

▲ Kazon raiders were relatively primitive compared to *Voyager*. Although they were equipped with energy weapons and photonic charges, a single raider was unlikely to endanger the Starfleet ship. It would have taken a sustained, coordinated attack from several raiders to break down *Voyager*'s shields.

The years of infighting diverted the Kazon's energies away from developing a progressive society or increasing their technological skills. This meant that, although they could operate and, to an extent, repair the ships taken from the Trabe, they were unable to build new ships of their own.

The vessels that the Kazon did operate appeared to be enough for their needs. Raiders provided more or less permanent living quarters for Kazon war parties. The ships were fairly well armed with energy weapons and photonic charges, which were powerful enough to disable most vessels that strayed into their territory. They would then steal cargo or valuable technology from these ships.

The tactical ability of a single raider presented no real challenge to a Starfleet *Intrepid*-class vessel, such as the *U.S.S. Voyager* NCC-74656. In fact, the technology used aboard raiders was markedly inferior to *Voyager*'s; they were not equipped with transporters or replicators, while their sensors were relatively primitive. They did, however, possess tractor beams.

INFERIOR PERFORMANCE

Kazon raiders also had distinct weaknesses. They were less maneuverable at sublight speeds than at warp speed; their computer systems worked at approximately half the speed of *Voyager*'s; and their sensors could not detect a shuttle if its engines were not running and it was operating on thrusters – even when it was within meters of the raider.

The interior of a Kazon raider was spartan, with few visible amenities or conveniences – a reflection perhaps of the species' hardened nature, which

SHIP PROFILE

▶ The Kazon were one of the first major alien groups encountered by *Voyager* in the Delta Quadrant. The species was extremely hostile and raiders from different sects would launch attacks on the Starfleet ship on sight. Their primary weapon arrays were located on either side of the ship's nose.

▲ Each Kazon sect was headed by a leader known as first maje. He had to be strong and ruthless if he was to remain in charge of his sect for long. The Kazon-Nistrim was led by First Maje Jal Culluh, and he became obsessed with taking control of *Voyager*. He realized that the power of the Starfleet ship would help him dominate the other sects.

rejected the apparent weakness of comfort in favor of readiness for battle. The crew was all-male and included children, who were included to learn about fighting. Large rooms with little furniture and few control systems served as meeting places, holding cells, and trophy rooms filled with trinkets and even the skins of defeated crews.

During the first two years of their journey in the Delta Quadrant, *Voyager* encountered the Kazon on many occasions. Individual raiders never posed a serious threat to the ship, but in 2372 a fleet of raiders combined forces and, with the help of an agent onboard *Voyager*, the Kazon succeeded in disabling and taking charge of the Federation vessel. The *Voyager* crew later regained control of their ship and shortly afterward, they traveled beyond Kazon space.

DATA FEED

All the ships used by the Kazon once belonged to the Trabe. After the Kazon united and banished the Trabe from their homeworld, they roamed through space in a small flotilla, struggling to survive. Mabus was one of the Trabe leaders. He convinced Captain Janeway to help them try to make peace with the Kazon. However, when the separate Kazon leaders were gathered for the peace talks, the Trabe tried to kill them all.

189

| SHIP PROFILE | KAZON RAIDER | PLAN VIEWS |

Impulse engine

KAZON ARMORED SHUTTLE

The Kazon lacked transporter technology, so instead they used a modified shuttle to board and ransack other ships. Once they had disabled a targeted vessel, they would launch a small ship with an armored nose. This pierced the hull of the targeted vessel, ramming a hole large enough for a small raiding party to get aboard.

It was a crude but effective tactic, as long as it was executed quickly. The armored shuttle's small dimensions meant that it could carry only a few Kazon warriors, but if they struck fast enough, they could overpower any resistance and take control of the ship. To be effective, the armored shuttle needed to breach a hole only 72cm in diameter.

▲ Amid the sparks, a Kazon armored shuttle managed to punch a hole in the side of *Voyager*'s hull. Several Kazon warriors then leaped out of the shuttle and stole a transporter module from *Voyager*.

Dorsal sensor array

Engineering section

Warp engine

DATA FEED

A Kazon raider could become cloaked and invisible to enemy ships' sensors by employing a type of masking circuitry that was unfamiliar to Starfleet. Raiders were also known to carry a small complement of fighter-type craft that could be operated by a single occupant. These had a very similar design to the raiders, but on a much smaller scale.

Main bridge

Main bridge

Forward energy weapon

TROPHY ROOM

On Kazon ships, it was not uncommon to find a room filled with "trophies," or items from vessels the Kazon had destroyed. They also took their enemies' clothing and put it on display in these rooms.

UNFIT FOR THE BORG

The Kazon were known to the Borg as Species 329. According to Seven of Nine, the Kazon were unremarkable and unworthy of assimilation because they would detract from perfection.

KAZON SECTS

In the early 2370s, there were at least 18 different Kazon sects. The two most powerful were the Ogla and the Relora, who possessed the most ships. The Nistrim had been one of the most influential sects, but by 2372 their power had diminished, and they had only five raiders at their disposal.

KES'S SHUTTLE

An aged Kes returned to *Voyager* aboard a shuttlecraft, but she was not the Ocampan the crew remembered…

SHIP PROFILE

Three years after leaving the *U.S.S. Voyager* during its journey through the Delta Quadrant, the Ocampan Kes returned to the Starfleet vessel. Having departed from the ship to explore her rapidly developing powers, the Kes that returned to *Voyager* aboard a small shuttlecraft was disturbed, angry, and resentful of her former crewmates. Approaching the starship, Kes deliberately collided with *Voyager*.

COLLISION COURSE

In an alternative 2376, *Voyager* received a distress call from a small vessel on a direct intercept course with the ship. Sensors indicated that the solo pilot of the smaller ship was an Ocampan.

On receiving a hail, Captain Janeway was shocked to see an older, desperate Kes appear on the main viewscreen. Asking permission to come aboard, Kes immediately accelerated her ship on a direct collision course with *Voyager*.

When Kes had left *Voyager* in 2374, she had headed out into space in a Starfleet shuttle. The chain of events that saw Kes commandeer this new shuttle was unclear, and the exact origins of the craft remained unknown.

SHUTTLE SPECS

Kes's shuttle was very compact, seemingly configured for a single occupant. The forward section comprised a snub-nosed cockpit, widening out to an angled transparent canopy where the pilot was positioned. The cockpit itself was small, with instrument panels ranged to the left and

▲ This small shuttlecraft of unknown origin was acquired by Kes sometime after she left *U.S.S. Voyager* in 2374. The craft was designed to carry just one passenger, but for Kes it was a means to a very specific end…

◀ On an unspecified stardate in 2376, a small shuttlecraft was picked up on sensors, approaching *U.S.S. Voyager* on a direct intercept course. The shuttle was an unremarkable craft, and further sensor readings indicated that the single occupant aboard the vessel was an Ocampan…

SHIP PROFILE | KES'S SHUTTLE | OVERVIEW

▲ The four-engined shuttle was picked up on *Voyager*'s sensors. As soon as Captain Janeway gave Kes permission to dock, with *Voyager*'s shields down, Kes rammed the shuttle into the ship's hull, beaming aboard seconds before impact.

right of the pilot's seat. It is likely the pilot embarked and disembarked from the cockpit.

It was unclear if the ship possessed any offensive capability, but it was equipped with a transporter. The aft hull comprised an equally compact, but powerful and aerodynamic drive section. Two large engine ports were placed high on the upper hull, to the port and starboard of a dorsal wing spoiler. A red running light was located on this spoiler. Two smaller engine ports were ranged directly below the dorsal drive units, again to either side of a wing spoiler on the ventral hull. In flight, all four engine ports displayed a green-hued power signature.

Stabilizing the shuttle during flight were wing sections ranged to port and starboard sides of the ship. These were located directly between the upper and lower engine ports, angling down and running the length of the drive section.

BOARDING *VOYAGER*

Kes's interception of *Voyager* was a premeditated plan that took Janeway and her crew by surprise. Directly after cutting communications, the Ocampan increased the shuttle's velocity, intending to ram *Voyager*. Despite activating a tractor beam and engaging in evasive maneuvers, *Voyager* was unable to avoid the collision. Kes's shuttle breached the hull on deck 9, but she activated a transporter and beamed aboard to deck 11, just seconds before the shuttle impact.

Kes embarked on a rampage, ripping apart sections of *Voyager* as she gave off extreme levels of neurogenic energy. Janeway and the crew attempted to halt her progress, but Kes's abilities had become too powerful, enabling her to neutralize all obstacles placed in her path.

Arriving in engineering, Kes overcame both Seven of Nine and B'Elanna Torres, killing the

SHIP PROFILE

▶ Answering a hail, the crew were shocked to see a very changed Kes appear on the main viewscreen. She asked Captain Janeway for permission to come aboard. What had happened to their friend?

▼ Beaming aboard *Voyager*, Kes advanced through the ship, ripping it apart with unstoppable and extreme violence. She was intent on reaching her destination – main engineering – at all costs.

▲ Kes unleashed immense power to reach engineering, but to complete her plan, she required more. The desperate Ocampan absorbed energy directly from the warp core.

chief engineer with an energy blast. Kes then absorbed the power of *Voyager*'s warp core, and seemingly vanished into thin air.

CHANGING HISTORY

Kes enhanced her powers with the energy from the warp core, traveling back in time to *Voyager* in 2371, just 56 days into its enforced journey through the Delta Quadrant. Then, a younger Kes was finding her place on *Voyager*, and this earlier version was part of the future Kes's plan.

Kes had been encouraged to leave *Voyager* and explore her developing powers by Janeway, but she was not prepared for a life out in the Galaxy. She plotted to sacrifice *Voyager* to the Vidiians and leave the ship with her younger self. Feeling her people would fear her for what she had become, this was her only way of returning home to Ocampa with her younger self.

Kes's plan was foiled because Tuvok experienced premonitions of the future caused by elevated tachyon particles. Janeway confronted the older Kes before she could leave the ship, and the Ocampan's relentless, destructive fury gave the captain no option but to kill her. With the younger Kes restored, Janeway formulated a plan with her and Tuvok to ensure history did not repeat itself…

DATA FEED

Tuvok was instrumental in stopping Kes's destructive plan to alter the future. As Kes approached *Voyager*, Captain Janeway marked her loyal officer's birthday with a cake – to his bemusement. In 2376, Tuvok was approaching his 100th birthday – the "big three digits." In 2371, it was Tuvok's sensitivity to a buildup of tachyon particles, perhaps influenced by Vulcan mental abilities, and his future premonitions, that alerted Janeway to the danger posed by Kes.

195

SAVING THE FUTURE

Six years after the future Kes attempted to alter the past, *Voyager* was still on its journey home to the Alpha Quadrant. When sensors picked up the approach of the small shuttlecraft with a lone Ocampan crewmember, Janeway and Tuvok knew the time had finally come. The captain ordered the immediate evacuation of deck 11, including main engineering.

Forewarned of Kes's imminent collision with the ship and her transport aboard, Janeway ordered the warp core shutdown and proceeded to engineering with Tuvok to confront Kes. Without the warp core to boost her powers, Kes was unable to travel to the past. This gave Janeway the chance to play a holo-message recorded by Kes's younger self in 2371.

In the message, Kes pleaded with her future self to abandon her plan, reminding her that no one had forced her to leave *Voyager* when she did. It was her own decision, and taking revenge on people she cared about was not the way to return home.

Kes remembered leaving the message and realized that this was not the way. Janeway encouraged Kes to return home. After an emotional goodbye with Neelix, Kes beamed aboard her intact shuttle, setting out on a new path toward Ocampa.

▲ With Kes's plan halted by a message from the past, the Ocampan realized that she could return home after all. Reconciled with her friends, she boarded her shuttle and left *Voyager* once again.

Upper engine

DATA FEED
During Kes's first, almost-successful attempt to alter history, her shuttle was destroyed in the impact with *Voyager*. In the modified 2376, *Voyager*'s shields held and the shuttle remained intact.

Cockpit

Upper engine

Dorsal spoiler

Upper engine

Lower engine

Ventral spoiler

▼ A Kobali ship brought Qret to *Voyager* to demand the handover of "Jhet'leya" (formerly Ensign Ballard). As Janeway pointed out, his ship was no match for *Voyager*, which dwarfed the Kobali ship in size – but before long three such vessels had appeared and opened fire on the starship.

KOBALI SHIP

Small, well-armed, and with a high warp capability, this vessel challenged *Voyager* to give back an errant Kobali member.

SHIP PROFILE

DATA FEED
The Kobali "reanimated" corpses from other species to perpetuate their own kind. To do this, they altered the DNA of dead bodies to make them Kobali, physically and psychologically.

For six months in 2376, Kobali ships pursued a shuttle stolen by their "adopted daughter," Lyndsay Ballard, across the Delta Quadrant. Former *Voyager* crewmember Ensign Ballard had died on stardate 51563, killed by Hirogen while on a mission with Harry Kim, who buried her in space. Three years later, she was outrunning the very Kobali who had found her body, "reanimated" it, and now claimed her as one of their own. Disabling the ship immediately behind with two well-directed shots from her shuttle, Ballard at last made audio contact with *Voyager* – to be admitted onboard and welcomed back into the crew.

The Kobali were not giving up, however. What Ballard's "father" failed to do by persuasion, the combined weaponry of three vessels converging on *Voyager* tried to do by force. As *Voyager* was rocked from repeated hits, the mutated Ballard sealed the outcome herself. Realizing that she was far too changed to fit back in with the *Voyager* crew, she transported away to rejoin the Kobali.

◄ During the attack by three Kobali ships, *Voyager*'s shields fell to 13 percent. Detecting power fluctuations in the lead vessel's warp drive, Kim wanted to fire a polaron burst to overload its core. Protesting that this would destroy the ship, Ballard made it clear that she could no longer stay on *Voyager* whatever happened.

▼ The *Nightingale* was a medical transport ship operated by a Delta Quadrant species called the Kraylor in the 2370s. It was a fairly standard-looking starship, and nothing about its outward appearance suggested it was used for humanitarian purposes. It looked more like a small combat ship, but it was easily outmatched by the Annari warships.

KRAYLOR MEDICAL TRANSPORT 136
NIGHTINGALE

The *Nightingale* appeared to be a medical supply ship, but it was in fact testing a new cloaking device.

SHIP PROFILE

The *Nightingale* was a Kraylor vessel – officially Medical Transport 136 – renamed by Ensign Harry Kim for the famous 19th-century Human nurse Florence Nightingale, because he believed it was a medical ship on a mission of mercy.

The Kraylor were a Delta Quadrant species who had been at war with the neighboring Annari since at least 2374. The Kraylor's homeworld had been blockaded by Annari vessels, which meant that it was almost impossible for supply ships transporting food and medicine to reach the planet's surface. Their world was protected by a shield grid, which prevented the Annari from launching an invasion force, but the Kraylor population was being slowly starved into submission.

The Kraylor did manage to bypass the blockade in one or two ships, including the *Nightingale*. This vessel was originally given the rather generic name of "medical transport 136" before Harry Kim took command of it.

BASIC SHIP

The transport was a fairly unremarkable ship in both appearance and abilities. It was approximately 320 meters in length and originally had a crew complement of 56. The main body of the ship was comprised of blocky, squared-off components, with a substantial raised section on top that housed the bridge. Downward-sloping wings were fixed to the warp nacelles, which were attached to either side of the main body. The nacelles glowed orange and were capable of powering the ship to a cruising speed of warp 6.

Although the *Nightingale* was equipped with several banks of phasers and protected by defensive shields, overall its defensive capabilities were rather limited and no match for the powerful Annari vessels. Other facilities on board the *Nightingale* included a shuttlebay, escape pods,

DATA FEED
Although his name was not mentioned on screen, according to the script the name of the original commander of the *Nightingale* was Captain Brell.

◄ The *Delta Flyer II* saved the *Nightingale* from destruction when it fought off an attack from an Annari warship. Harry Kim was reluctant to involve himself in their conflict, but he believed that he was saving the lives of a crew who were on a mission of mercy.

▶ Although Harry Kim only expected to be in command of the *Nightingale* for a few days, he made himself at home by moving some of his personal belongings, including his saxophone, into the ready room aboard the ship. He believed it was important to forge a personal connection with the ship to be a good captain, but he later realized commanding a ship was much more complicated than he had imagined.

◀ There was nothing particularly noteworthy about the *Nightingale*. It was a modest starship equipped with inbuilt warp nacelles, which could power it to a cruising speed of just warp 6. It did, however, possess a new cloaking device, which had the potential to change the outcome of the war between the Kraylor and the Annari.

a dedicated engineering section, and the equivalent of a captain's ready room. The most interesting feature of the *Nightingale*, however, was its prototype cloaking device. This had been developed at a secret, off-world base, under the leadership of a Kraylor scientist named Loken and several of his assistants.

Loken hoped that if the cloaking device proved successful, it would allow them to fly straight through the blockade around their planet and deliver much-needed supplies. The cloaking device was effective, but it proved less than reliable due to power fluctuations within the ship's propulsion system, and it required constant attention to stop it destabilizing.

In 2377, the *Nightingale*'s cloaking device failed and the ship came under attack from an Annari vessel. It issued a distress call that was picked up by Harry Kim, Seven of Nine, and Neelix aboard the *Delta Flyer II*. Normally, Starfleet's Prime Directive would have prevented them from becoming involved in an alien conflict, but the Kraylor vessel claimed to be on a humanitarian mission. It was also clear that, with the failure of its shields, the vessel would soon be destroyed, so Kim took the decision to neutralize the Annari ship.

MERCY MISSION

Kim discovered that 29 people, including the captain, had been killed in the attack, and the survivors, including Loken, pleaded with him to help them make repairs and to take command. They said that they had been charged with delivering medical supplies to their homeworld. Kim felt that

SHIP PROFILE

▶ Before the *Nightingale* reached the safety of the defensive shield surrounding the Kraylor homeworld, it was caught in the tractor beam of an Annari ship. Kim reversed the *Nightingale*'s shield polarity, which threw it clear and allowed the crew to outrun their pursers to the defense perimeter.

▲ While the Kraylor crew were making their way back to their homeworld, the cloaking device failed, and the *Nightingale* came under attack from several Annari vessels. They only just managed to get the cloaking device working again before the ship was destroyed. It was at this point that Kim realized the *Nightingale* was far more important than a regular medical supply ship.

he could not turn them down and he persuaded Captain Janeway to allow him to take command of the medical transport, which he then informally renamed the *Nightingale*.

Kim was enormously excited at being given his first real command, but it soon became clear that the Kraylors' story was untrue. The ship was not delivering medical supplies, but was in fact the testbed for their new cloaking device.

When Kim realized he was in direct violation of the Prime Directive, he ordered the *Nightingale* to reverse course, but the Kraylor crew mutinied and relieved him of command. In the end, Kim realized that they would never survive without his help, and despite serious reservations, he helped them to evade the blockade, so that the cloaking device was safely delivered to the Kraylor homeworld.

DATA FEED

The Kraylor scientist Loken led the team that developed and fitted the cloaking device to the *Nightingale*. He lied to Harry Kim, saying that he and the other survivors onboard were doctors and members of a research team carrying new vaccines to their homeland. Loken knew that, as scientists with little combat experience, they stood a much better chance of reaching home if Kim took command of their ship.

| SHIP PROFILE | NIGHTINGALE | PLAN VIEWS |

Tactical sensor array ⊢

Main bridge ⊢

Phasers ⊢

Impulse engine ⊢

Shuttlebay ⊢

BRIDGE CONTROLS

The command center on the *Nightingale* was not unlike that on many Starfleet ships, although it was much more basic and plain. This roughly circular room featured the captain's chair in the middle and a viewscreen at the front.

The helm console was a single workstation near the front and was operated from a standing position. It incorporated the primary navigational sensors and auto-navigation facilities. Other consoles situated in the bulkhead walls around the perimeter of the bridge were equipped with display screens and touch-sensitive controls. They operated systems such as tactical and life support.

The work station at the rear of the bridge had a number of functions, such as monitoring shipwide power, operating long-range sensors, and activating the communication systems.

The rear workstation also incorporated the controls for the ship's most important system: its cloaking device. This piece of technology had been developed covertly at an off-world base by a team under the leadership of the Kraylor scientist Loken. The prototype device was being tested for the first time on a starship, so its deficiencies were becoming obvious. Any power fluctuations within the propulsion system could cause the primary cloaking generator to fail, making the Kraylor ship visible to the Annari enemy.

▲ The bridge on the *Nightingale* was smaller and less sophisticated than those on Starfleet ships, but it operated on the same principles, with various workstations encircling the central captain's chair.

Warp nacelle

DATA FEED

The *Nightingale*'s cloaking device went offline because its primary generator was failing. The field polarity of the generator had fallen to 206.4, which was much too low. To raise it, the crew had to bypass the driver coil and shunt power directly to the polaron matrix. This repolarized the containment field and brought the cloaking device back online.

BRIDGE DETAIL

Plasma flush vent

IMPULSE ENGINE DETAIL

Warp nacelle

FUEL & CONSUMABLES RESUPPLY DETAIL

Atmospheric wing extension

MORE ENCOUNTERS

The crew of the *U.S.S. Voyager* had two more encounters with the Kraylor in 2377. They were trapped in the Void with a Kraylor ship, and met more Kraylor when brainwashed into joining a forced labor contingent.

LONG SIEGE

By the time of the *U.S.S. Voyager*'s first contact with the Kraylor in 2377, their home planet had been under a three-year blockade by the Annari, causing severe shortages of food and medicine.

FITTING NAME

Harry Kim renamed the Kraylor medical transport *Nightingale* after Florence Nightingale, who was renowned for nursing wounded soldiers on Earth. Kim thought it an appropriate name because he believed the ship was delivering much needed vaccines and medicines to the sick on the Kraylor homeworld.

intercepted *Voyager* in disputed territory was equipped with comparably small torpedoes. Captain Janeway was amused that the commander thought they could be so easily intimidated into turning round.

KRENIM PATROL SHIP

This small, hostile vessel confronted *Voyager* with an ultimatum to leave Krenim space – or be destroyed.

SHIP PROFILE

DATA FEED
The Krenim specialized in temporal science, which enabled them to release energy pulses in space that altered the timeline and removed species and cities.

In 2374, the U.S.S. Voyager's course led into a region of the Delta Quadrant that Captain Janeway and her crew believed to be Zahl territory. In fact, it was hotly disputed by the Krenim. Voyager was first made aware of the conflict on encountering a Krenim patrol ship that refused to let them pass. Although it posed no real threat, the Krenim commander blocked any discussion or compromise on his threat to wipe out Voyager if it did not withdraw.

Soon after, Janeway met with a courteous official from a Zahl delegation, who apologized for "the mishap" and dismissed Krenim claims to the area as "grandiose." But the patrol ship returned, the commander now accusing Janeway of consorting with the enemy. At that moment, a gigantic space distortion swept over all the ships, erasing the Zahl vessels, seriously damaging Voyager, and transforming the patrol ship into a Krenim warship that looked exactly the same – but on a massive scale.

◀ Tuvok reported that the patrol ship had a crew of 15, a low warp capacity, and limited armaments. However, it fired on Voyager even before its commander appeared on the viewscreen, demanding that Janeway reverse course. She refused but ordered a yellow alert.

| SHIP PROFILE | KRENIM PATROL SHIP | PLAN VIEWS |

KRENIM WARSHIP

The Krenim used warships armed with chroniton-based weaponry to repel any ships that strayed into their territory.

SHIP PROFILE

The Krenim warship was a powerful vessel used in the 2370s by the aggressive Delta Quadrant civilization known as the Krenim Imperium. They zealously deployed these vessels to protect areas of space that they considered their own, and would repel or even destroy ships that trespassed on their territory. Simply entering their space was enough to provoke an attack, which would happen with little or no warning.

The warships were approximately 500 meters in length and had a crew of around 250. They were warp capable, but their top speed was just warp 6. What made them so dangerous was that they were armed, not with photon torpedoes, but chroniton-based torpedoes. These explosive projectiles were in a constant state of temporal flux, and as such were able to pass through a ship's deflector shields as if they were not there.

This weaponry was based on temporal science, in which the Krenim were experts. This field of science focused on the workings of time and its effects on the space-time continuum. The Krenim applied their specialist knowledge to make torpedoes that operated out of phase with the space-time continuum, and essentially existed outside of normal time. This enabled them to penetrate a ship's shields before they phased back into normal space-time and impacted on its hull, causing catastrophic damage. With their shields completely ineffective, ships had no defense against chroniton torpedoes, which is what made the Krenim warships so deadly.

DOMINANT FORCE

The Krenim were an imperialistic and aggressive species, and they used their warships with their devastating weapons to conquer a large area of the Delta Quadrant. At their height in 2374, the Krenim dominated more than 200 star systems with 900 planets under their control, while they possessed thousands of warp-capable vessels spread out over 5,000 parsecs of space.

In 2374, the *U.S.S. Voyager* NCC-74656 came under repeated attack from Krenim warships for nearly a year, as it tried to cross a region of the Delta Quadrant ruled by the Krenim. They did not care that *Voyager* was merely passing through their region of space on its way back to Earth. They ordered *Voyager* to turn back or face

◀ The borders of the Krenim Imperium were vigorously protected by a fleet of brutal-looking warships. They were not fast, but they did pack a ferocious punch in the shape of chroniton torpedoes.

▶ Chroniton torpedoes issued from two launch tubes on either side of the nose of a Krenim warship. The projectiles were in a state of constant temporal flux, existing out of normal time and therefore could not be stopped by conventional deflector shields. This meant essentially that the warships were firing on unprotected ships.

| SHIP PROFILE | KRENIM WARSHIP | OVERVIEW |

▲ Seen from the rear, the Krenim warship had a very distinctive U-shaped section for its warp and impulse propulsion systems. It was not the most elegant-looking vessel, but was crudely effective in policing Krenim space and repelling interlopers.

destruction, as they demanded of all vessels that crossed into their territory.

When *Voyager* refused to back down, it was attacked by a warship, whose chroniton torpedoes caused significant damage. At least one crewmember was killed, and *Voyager*'s shields were reduced to just 17 percent. Captain Janeway ordered a swift retreat and *Voyager*'s superior speed soon had them out of immediate danger.

After analyzing the Krenim warship's attack, the *Voyager* crew deduced that the Krenim were using chroniton-based weapons. This was the reason why their attack was so effective, and it was a considerable challenge to come up with an equally effective countermeasure. On day 32 of its journey through Krenim space, *Voyager* was subject to another assault by a warship. In the ensuing barrage, sections 10 through 53 on deck 5 were destroyed, 12 crewmembers were critically injured, and two were killed.

INNOVATIVE STRATEGY

As the crew tried to fight off the warship, *Voyager*'s phaser banks were burned out and the torpedo launchers failed. They had managed to take out the Krenim ship's aft shields, but it required some creative thinking to win the battle. Janeway ordered four torpedoes to be deployed like mines from the launch doors. As the warship closed in to within 5,000 meters, the torpedoes were detonated and the explosion took out the pursuing warship.

With each subsequent attack that *Voyager* faced over the following months, the ship suffered further damage. On day 47 of the journey

SHIP PROFILE

◀ *Voyager* eventually acquired adequate shielding against the Krenim's chroniton torpedoes after Seven of Nine studied their technology. She discovered an undetonated torpedo, with its warhead still intact, lodged in a Jefferies tube. Seven managed to take some vital sensor readings from the weapon before it exploded, and this enabled her to develop effective temporal shielding.

▶ After spending nearly a year in Krenim space, *Voyager* was coming apart at the seams because of constant attacks by Krenim warships. There were massive holes blown in the hull, and most of the remaining crew had abandoned the ship in escape pods. Emergency force fields were the only means of holding the ship together.

▲ The Krenim warship had a tough, imposing presence, and the nose lit up before it fired its devastating weaponry. Its firepower was much more effective than *Voyager*'s, but the propulsion systems and shields were not as advanced as those on the Starfleet ship.

through Krenim space, Seven of Nine found an undetonated chroniton torpedo in a starboard Jefferies tube. She managed to determine its exact temporal variance, which helped her perfect an effective shielding against the chroniton weapons.

From this point on, *Voyager* was no longer so vulnerable to the warships, but the "Year of Hell," as Janeway dubbed it, was not yet over. It was only resolved when the crew managed to destroy the Krenim temporal weapon ship commanded by the scientist Annorax. This reset the timeline and took a fully restored *Voyager* back to when it first entered Krenim space. When a Krenim warship approached, its captain said that the region was under dispute and suggested that the territory be avoided. Janeway took the advice and ordered a course to be plotted around Krenim space.

DATA FEED

The Krenim looked very much like Humans apart from distinctive markings around their temples. They were very different in temperament, however, and their society appeared to be militaristic. They were extremely intransigent and mistrustful of outsiders, seeming incapable of compromise or discussion. Anyone entering what they considered their territory would be met by a warship and told to withdraw or be destroyed.

RESETTING THE TIMELINE

When the *U.S.S. Voyager* NCC-74656 first entered their space, Krenim ships were small and weak, with limited armaments. They posed no threat to *Voyager*, but they still demanded that the Starfleet vessel leave their territory.

Soon after, Annorax's temporal weapon ship eradicated the homeworld of the Zahl and this changed the timeline. The small Krenim patrol ship instantly changed into a large warship armed with chroniton torpedoes. This ship was very much a threat, and marked the start of repeated attacks on *Voyager* by the Krenim, which went on for almost a year. In that time, *Voyager* was nearly destroyed on more than one occasion, and several crewmembers were killed in the engagements.

By the time Seven of Nine had managed to devise temporal shielding, *Voyager* was in such a weakened state that it was still vulnerable. The Starfleet crew only found a way out of their dire situation when they realized that Annorax's temporal weapon ship held the key to everything.

Captain Janeway forged a coalition with three ships from the Nihydron and two from the Mawasi – species that had also been persecuted by the Krenim. Together they attacked Annorax's ship, causing it to implode and removing it from the timeline. This reset the timeline, with *Voyager* and its crew instantly made whole again.

▲ Captain Janeway disengaged the temporal shielding on *Voyager* and flew her vessel straight into Annorax's temporal weapon ship, which ended the Year of Hell and restored the original timeline.

Warp nacelle

Warp propulsion generator

Warp power conduit

Main deflector

Main bridge

Chroniton torpedo launcher

Impulse engine

Bussard ramscoop

NINE MONTHS

The *U.S.S. Voyager*'s Year of Hell in Krenim space actually lasted 257 days. The crew made first contact with the Krenim on March 16, 2374, and the final engagement with Annorax's temporal weapon ship took place on November 29.

MATCHING VARIANCE

U.S.S. Voyager not only had to match its shields to a temporal variance of 1.47 microseconds to negate the Krenim warship's chroniton torpedoes, but also match its deflector array to the inverse of that variance.

CHRONITON USES

Other species besides the Krenim used chroniton-based technology. The Borg deployed chroniton fields to protect their ships from the stresses of traveling in transwarp conduits. The Romulan cloaking device also emitted chronitons as a result of its operation.

▼ At more than 1,500 meters long, the Krenim temporal weapon ship was a behemoth. As a conventional starship, it was hampered by its huge mass, resulting in poor maneuverability and limited shielding. It was less a ship, more a huge mobile platform for its temporal weapon that could erase billions of lives in an instant.

KRENIM TEMPORAL WEAPON SHIP

This Delta Quadrant ship operated outside of normal space-time and could erase entire species from history.

SHIP PROFILE

The temporal weapon ship was constructed some time prior to 2174 by the Krenim Imperium. Its design was spearheaded by the brilliant temporal scientist, Annorax, in response to a war that the Krenim were fighting against the Rilnar. Realizing that the Krenim could not hope to win this war with conventional weapons, Annorax developed a ship equipped with a temporal weapon, which had the ability to wipe out entire species by removing them from time.

The devastating weapon took the form of an intense chroniton beam of temporal energy that issued through the nose of the ship. The beam erased from existence all objects that it hit directly, while the resultant space-time shock wave rippled out from where it was focused, changing the history of the surrounding space for light years.

The weapon was so powerful that it could wipe out all life on a planet, right down to the smallest microbe, in a single blast. It was the ultimate apocalyptic weapon because it could eradicate entire civilizations from existence – thereby effectively rewriting history. Any effects that an eliminated species had had on other species or on the Galaxy vanished from the timeline, so that it was as if that species had never existed at all.

OUT OF TIME

The key to the weapon ship's power was its temporal core. This kept the ship and everyone onboard in a state of temporal flux and outside the flow of normal time. The ship was therefore immune to all conventional weapons, while its crew did not age and were essentially immortal. Both ship and crew were protected from all threats while the temporal core was online, and as a result its conventional shields and weapons were extremely limited and rarely used.

At well over 1,500 meters in length, the temporal weapon ship was of enormous size, which prevented it from exceeding warp 6. On the other hand, since the ship existed outside of normal space-time, its lack of speed and maneuverability was to all intents and purposes irrelevant.

◀ The temporal weapon ship could eradicate an entire species by firing a chroniton energy beam at the species' homeworld. This pushed them out of the space-time continuum, while leaving the planet intact. Any impact the eliminated species had had on the history of other species was also removed from the timeline.

SHIP PROFILE — KRENIM TEMPORAL WEAPON SHIP

◀ The main control room aboard the temporal weapon ship featured huge screens depicting the timelines of various elements and how they would interact with one another following a temporal incursion. The crew could spend months calculating the effects of using the temporal weapon on a target, but their predictions could never be absolutely correct.

▶ Annorax, the ship's commander, was a brilliant temporal scientist. He became obsessed with returning the Krenim to their former glory and being reunited with his wife. This obsession consumed him to the extent that he thought nothing of annihilating entire species.

▲ The effects of the chroniton beam from the temporal weapon ship spread out from a focal point, removing buildings, cities, and even entire civilizations as it went. All that would be left was the natural landscape, with no sign of the species ever having existed.

In many ways the Krenim temporal weapon ship was the most powerful vessel ever encountered by Starfleet. It was virtually immune from attack, it could make entire species extinct, and its crew could theoretically live for eternity.

There was one major drawback, however. It was impossible to predict all the consequences that would result from using the temporal weapon. The ship's computers could run sophisticated simulations that enabled the crew to judge the weapon's effect on a particular target. These simulations involved extremely complex calculations, but they could never be 100 percent accurate because there were just too many variables to take into account.

After the temporal weapon ship was first constructed, Annorax turned it on the Krenim's greatest enemy, the Rilnar. In an instant, the Rilnar were removed from history, and the Krenim restored as the dominant power in their sector of space. This appeared to be the result Annorax was intending, but shortly afterward, a rare disease broke out in many Krenim colonies, and within a year 50 million Krenim had died.

Annorax had not realized that the Rilnar had introduced a crucial antibody into the Krenim genome that protected them from this disease – and the erasure of the Rilnar also resulted in the erasure of the antibody. Annorax tried to undo the damage by using the temporal weapon again. This time it caused the loss of more Krenim life, including the eradication of Kyana Prime, a Krenim colony that was home to Annorax's beloved wife.

Devastated by his personal loss, Annorax became obsessed with rejoining his wife and restoring every Krenim colony, right down to the

SHIP PROFILE

last blade of grass. The problem was that every time he activated the temporal weapon, it gave rise to unforeseen consequences. No matter how carefully the calculations were made, Annorax could never fully restore the Krenim.

FRUITLESS TASK

For more than 200 years, Annorax and his crew tried to complete a total restoration of the original timeline. They made countless temporal incursions, erasing dozens of species, including the Garenor, the Ram Izad, the Malkoth, and the Alsuran, but none of their efforts had the desired effect. The closest Annorax came was when the weapon eradicated the Zahl and completed a 98 percent restoration, but as this did not include the Kyana colony on which his wife lived, he was not satisfied and continued to make further incursions.

The temporal weapon ship itself was eventually obliterated from history, when the U.S.S. Voyager led a small fleet composed of two Mawasi cruisers and three Nihydron ships against it. Many of the crew aboard the Krenim ship had become exhausted by Annorax's impossible demands. With Obrist, the ship's second-in-command, taking control, the crew shut down the temporal core. This caused the ship to phase back into normal space-time, making it vulnerable to attack.

Captain Janeway piloted Voyager straight into the weapon ship, causing a temporal incursion within the ship itself and erasing it from history. Ironically, this had the effect that Annorax had been trying to achieve all along. It removed the weapon ship from the timeline, resulting in the complete restoration of all Krenim worlds, including Kyana Prime, and reunited Annorax with his wife.

▲ The temporal weapon ship was finally defeated after Annorax's own crew turned on him and took the ship's temporal core offline. This restored the ship to normal space-time, removing its immunity to attack. However, Captain Janeway was still forced to ram the U.S.S. Voyager right into the side of the weapon ship to ensure its destruction.

| SHIP PROFILE | KRENIM TEMPORAL WEAPON SHIP | PLAN VIEWS |

MUSEUM OF LOST TREASURES

Annorax described his ship as more than just a weapon – to him it was also "a museum of lost histories." In his quarters, he kept hundreds of remnants and artifacts from some of the civilizations he had erased from time. These samples were the only proof that these cultures had ever existed. His collection included, for example, a bottle of Malkothian spirits, the only product left in the universe of this once-powerful species. Annorax's most treasured possession, however, was a sealed glass pyramid enclosing a small lock of his wife's red hair.

▲ On a desk in his study, Annorax kept mementoes from some of the worlds he had wiped from history, including a bottle of Malkothian spirits and an ornament containing a lock of his wife's hair.

DATA FEED

The temporal core of the ship kept it out of phase with normal space-time, which meant that it was immune to conventional weapons. As a consequence, its regular shielding was extremely weak and Tom Paris worked out that a photon grenade would be enough to penetrate its hull.

Warp power conduit

Ion dispersal vent

Control center and habitat

Stabilizer fin

Aft momentum conditioners

Chroniton-based wave generator core

Forward momentum conditioners

Temporal shock wave ring

Final stage accelerator

Timeline sensors

Warp field pressure sensors

Temporal energy release tunnel

MISCALCULATION

When the temporal weapon ship erased the Garenor species from history, it gave rise to a timeline in which the Krenim reverted to a pre-warp state, while their territory was reduced to just a few planets.

POWERFUL SENSORS

The sensors on the temporal weapon ship were capable of tracking the temporal wave as it moved through space and calculating the resulting level of restoration to the original timeline in percentages.

PUNISHED BY TIME

Over the years, Annorax became paranoid and unstable, believing that time held a personal grudge against him. He thought time was angry with him for trying to manipulate it and was taking its revenge by withholding his wife and denying him a happy future.

SHIPS A-K, WITH EPISODES

All references are to *STAR TREK: VOYAGER* unless otherwise stated

THE BORG

CUBE, 10	*STAR TREK: THE NEXT GENERATION*, 'Q WHO,' S2, E16 • *TNG*, 'The Best of Both Worlds,' S3, E26 • *STAR TREK: FIRST CONTACT* • *DEEP SPACE 9*, 'Emissary,' S1, E1 • *VGR*, 'Unity,' S3, E17 • 'Scorpion,' Part I, S3, E26 • 'Scorpion,' Part II, S4, E1 • 'Dark Frontier,' Parts I & II, S5, E15 & 16 • 'Collective,' S6, E16 • 'Unimatrix Zero,' Part I, S6, E26 • 'Unimatrix Zero,' Part II, S7, E1 • 'Q2,' S7, E19 • 'Endgame,' Part II, S7, E25
PROBE, 38	'DARK FRONTIER,' PARTS I & II, S5, E15 & 16
QUEEN'S SHIP, 20	'DARK FRONTIER,' PART I, S5, E15
RENEGADE SHIP, 26	*TNG*, 'Descent,' Part I, S6, E26
SPHERE, 16	*STAR TREK: FIRST CONTACT* • *VGR*, 'Drone,' S5, E2 • 'Dark Frontier,' Parts I & II, S5, E15 & 16 • 'Survival Instinct,' S6, E2 • 'Child's Play,' S6, E19 • 'Unimatrix Zero,' Part II, S7, E1 • 'Endgame,' S7, E25 • *ENT*, 'Regeneration,' S2, E23
TACTICAL CUBE, 32	'UNIMATRIX ZERO,' PART I, S6, E26

THE DELTA QUADRANT

ABADDON'S "JUNK SHIP," 48	'ALICE,' S6, E5	ANNARI COMBAT SHIP, 63	'NIGHTINGALE,' S7, E8
AKRITIRIAN FREIGHTER, 50	'THE CHUTE,' S3, E3	B'OMAR PATROL SHIP, 68	'THE RAVEN,' S4, E6
AKRITIRIAN PATROL SHIP, 51	'THE CHUTE,' S3, E3	BA'NETH SHIP, 74	'RIDDLES,' S6, E6
AKSANI RACING SHUTTLE, 52	'DRIVE,' S7, E3	BENTHAN PATROL SHIP, 75	'VIS À VIS,' S4, E20
ALICE, 54	'ALICE,' S6, E5	BENTHAN COAXIAL DRIVE PROTOTYPE, 76	'VIS À VIS,' S4, E20
ANKARI SHIP, 60	'EQUINOX, PART II,' S6, E1	BOTHAN SHIP TYPE 1, 82	'PERSISTENCE OF VISION,' S2, E8
ANNARI WARSHIP, 62	'NIGHTINGALE,' S7, E8 • 'The Void,' S7, E15		

BRUNALI TRANSPORT SHIP, 84	'CHILD'S PLAY,' S6, E19	**HIROGEN HOLOSHIP**, 152	'FLESH AND BLOOD,' S7, E9 & 10 • 'Hunters,' S4, E15 • 'Prey,' S4, E16 • 'The Killing Game,' S4, E18 & 19
CAATATI SHIP TYPE 1, 86	'DAY OF HONOR,' S4, E3	**HIROGEN WARSHIP**, 158	'HUNTERS,' S4, E15 • 'Prey,' S4, E16 • 'The Killing Game,' S4, E18 & 19 • 'Flesh and Blood,' S7, E9 &10
CAATATI SHIP TYPE 2, 88	'DAY OF HONOR,' S4, E3	**HIROGEN** *VENATIC* CLASS, 164	'FLESH AND BLOOD,' S7, E10
CHOKUZAN SHIP, 90	'Q2,' S7, E19	**ILARI SHIP**, 168	'WARLORD,' S3, E10
CRAVIC STARSHIP, 94	'PROTOTYPE,' S2, E13	**IMHOTEP** RACING SHUTTLE, 170	'DRIVE,' S7, E3
CYTOPLASMIC LIFE-FORM SHIP, 98	'NOTHING HUMAN,' S5, E8	**IRINA'S** RACING SHIP, 174	'DRIVE,' S7, E3
DAELEN'S SHIP, 102	'VIS À VIS,' S4, E20	**KAZON AND** TRABE CARRIER, 180	'CARETAKER,' S1, E1 • 'Initiations,' S2, E2 • 'Alliances,' S2, E14 • 'Investigations,' S2, E20 • 'Basics,' Part I, S2, E26
U.S.S. DAUNTLESS, 104	'HOPE AND FEAR,' S4, E26	**KAZON AND** TRABE FIGHTER, 184	As above
DALA'S "DELTA FLYER," 110	'LIVE FAST AND PROSPER,' S6, E21	**KAZON RAIDER**, 186	'STATE OF FLUX,' S1, E11 • 'Maneuvers,' S2, E11 • 'Alliances,' S2, E14 • 'Investigations,' S2, E20' • 'Basics,' Part I, S2, E26 • 'Basics,' Part II, S3, E1
DEVORE WARSHIP, 116	'COUNTERPOINT,' S5, E10	**KES'S SHUTTLE**, 192	'FURY,' S6, E23
DEVORE SHUTTLE, 122	'COUNTERPOINT,' S5. E10	**KOBALI SHIP**, 198	'ASHES TO ASHES,' S6, E18
DINAALI HOSPITAL SHIP, 124	'CRITICAL CARE,' S7, E5	**KRAYLOR MEDICAL** TRANSPORT/ *NIGHTINGALE*, 200	'NIGHTINGALE,' S7, E8
DRALIAN SHIP, 128	'CRITICAL CARE,' S7, E5	**KRENIM PATROL SHIP**, 206	'YEAR OF HELL,' PART 1, S4, E8
DRAYAN SHIP, 130	'INNOCENCE,' S2, E22	**KRENIM WARSHIP**, 210	'YEAR OF HELL,' PARTS 1 & II, S4, E8 & 9
ENTHARAN SHIP, 132	'RETROSPECT,' S4, E17	**KRENIM TEMPORAL** WEAPON SHIP, 216	'YEAR OF HELL,' PARTS 1 & II, S4, E8 & 9
FLEA SHIP, 134	'THE FIGHT,' S5, E19		
HAZARI WARSHIP, 138	'THINK TANK, S5, E20		
HAZARI SCOUT SHIP, 142	'THINK TANK, S5, E20		
HIERARCHY SHIPS, 144	'TINKER, TENOR, DOCTOR, SPY,' S6, E4		

EPISODES A-Z WITH FEATURED SHIPS

THE BORG

DEEP SPACE 9, 'Emissary,' S1, E1 — **Cube, 10**
THE NEXT GENERATION • 'The Best of Both Worlds,' S3, E26 • 'Q Who,' S2, E16
STAR TREK: FIRST CONTACT
VOYAGER 'Collective,' S6, E16 • 'Dark Frontier, Parts I & II,' S5, E15 & 16 • 'Endgame,' Part I, S7, E25 • 'Q2,' S7, E19 • 'Scorpion,' Part I, S3, E26 • 'Scorpion,' Part II, S4, E1 • 'Unimatrix Zero,' Part I, S6, E26 • 'Unimatrix Zero,' Part II, S7, E1 • 'Unity,' S3, E17

VOYAGER, 'Dark Frontier,' Parts I & II, S5, E15 & 16 — **Probe, 38**

VOYAGER, 'Dark Frontier, Part I,' S5, E15 — **Queen's Ship, 20**

THE NEXT GENERATION — **Renegade Ship, 26**
'Descent,' Part I S6, E26

STAR TREK: FIRST CONTACT — **Sphere, 16**
ENTERPRISE, 'Regeneration,' S2, E23
VOYAGER • 'Child's Play,' S6, E19 • 'Dark Frontier,' Parts I & II, S5, E15 & 16 • 'Drone' S5, E2 • 'Endgame,' S7, E25 • 'Survival Instinct' S6, E2 • 'Unimatrix Zero, Part II,' S7, E1

VOYAGER, 'Unimatrix Zero,' S6, E26 — **Tactical Cube, 32**

THE DELTA QUADRANT
(SHIPS A-K, ALL STAR TREK: VOYAGER)

'Alice,' S6, E5 — **Abaddon's "Junk Ship," 48**
Alice, 54

'Alliances,' S2, E14 — Kazon and Trabe Carrier, 180
Kazon and Trabe Fighter, 184
Kazon Raider, 186

'Ashes To Ashes,' S6, E18 — Kobali Ship, 198

'Basics,' Part I, S2, E26 — Kazon and Trabe Carrier, 180
Kazon and Trabe Fighter, 184
Kazon Raider, 186

'Basics' Part II, S3, E1 — Kazon Raider, 186

'Caretaker,' S1, E1 — Kazon and Trabe Carrier, 180

'Child's Play,' S6, E19 — Brunali Transport Ship, 84

'The Chute,' S4, E3 — Akritirian Freighter, 50
Akritirian Patrol Ship, 51

'Counterpoint,' S5, E10 — Devore Warship, 116
Devore Shuttle, 122

'Critical Care,' S7, E5 — Dinaali Hospital Ship, 124
Dralian Ship, 128

'Day of Honor,' S4, E3 — Caatati Ship Type 1, 86
Caatati Ship Type 2, 88

'Drive,' S7, E3 — Aksani Racing Shuttle, 52
Imhotep Racing Shuttle, 170
Irina's Racing Ship, 174

'Equinox,' Part II, S6, E1 — Ankari Ship, 60

'The Fight,' S5, E19 — Flea Ship, 134

Episode	Ship
'Flesh And Blood,' S7, E9 & 10	Hirogen Holoship, 152
'Flesh And Blood,' Part II, S7, E10	Hirogen *Venatic* Class, 164
'Flesh and Blood,' E9 & 10	Hirogen Warship, 158
'Fury,' S6, E23	Kes's Shuttle, 192
'Hope and Fear,' S4, E26	*U.S.S. Dauntless*, 104
'Hunters,' S4, E15	Hirogen Warship, 158
'Initiations,' S2, E2	Kazon and Trabe Carrier, 180
'Initiations,' S2, E2	Kazon and Trabe Fighter, 184
'Innocence,' S2, E22	Drayan Ship, 130
'Investigations,' S2, E20	Kazon and Trabe Carrier, 180
	Kazon and Trabe Fighter, 184
	Kazon Raider, 186
'The Killing Game,' S4, E18 & 19	Hirogen Warship, 158
'Live Fast And Prosper,' S6, E21	Dala's "Delta Flyer," 110
'Maneuvers,' S2, E11	Kazon Raider, 186
'Nightingale,' S7, E8	Annari Combat Ship, 63
	Annari Warship, 62
	Kraylor Medical Transport/*Nightingale*, 200
'Nothing Human,' S5, E8	Cytoplasmic Life-Form Ship, 98
'Persistence Of Vision,' S2, E8	Bothan Ship Type 1, 82
'Prey,' S4, E16	Hirogen Warship, 158
'Prototype,' S2, E13	Cravic Starship, 94
'Q2,' S7, E19	Chokuzan Ship, 90
'The Raven,' S4, E6,	B'omar Patrol Ship, 68
'Retrospect,' S4, E17	Entharan Ship, 132
'Riddles,' S6, E6	Ba'neth Ship, 74
'State of Flux,' S1, E11	Kazon Raider, 186
'Think Tank,' S5, E20	Hazari Warship, 138
	Hazari Scout Ship, 142
'Tinker, Tenor, Doctor, Spy,' S6, E4	Hierarchy Ships, 144
'Vis À Vis,' S4, E20	Benthan Coaxial Drive Prototype, 76
	Benthan Patrol Ship, 75
	Daelen's Ship, 102
'The Void,' S7, E15	Annari Warship, 62
'Warlord,' S3, E10	Ilari Ship, 166
'Year of Hell,' Part I, S4, E8	Krenim Patrol Ship, 206
'Year of Hell, Parts I & II,' S4, E8 & 9	Krenim Temporal Weapon Ship, 216
	Krenim Warship, 210

EPISODES BY SERIES & SEASON

THE BORG

DEEP SPACE 9, S1, E1, 'Emissary' Cube, 10
(also • **STAR TREK: FIRST CONTACT**
• **THE NEXT GENERATION** S2, E16, 'Q Who'
• S3, E26, 'The Best of Both Worlds'
• **VOYAGER**, S3, E17, 'Unity' • S3, E26, 'Scorpion,' Part I
• S4, E1, 'Scorpion,' Part II • S5, E15 & 16, 'Dark Frontier,' Parts I & II • S6, E16, 'Collective' • S6, E26, 'Unimatrix Zero,' Part I • S7, E1 'Unimatrix Zero,' Part II • S7, E19, 'Q2'
• S7, E25 'Endgame,' Part I)

VOYAGER, S5, E15 & 16, 'Dark Frontier' Probe, 38

VOYAGER, S5, E15,
'Dark Frontier,' Part I Queen's Ship, 20

THE NEXT GENERATION,
S6, E26, 'Descent,' Part I Renegade Ship, 26

STAR TREK: FIRST CONTACT Sphere, 16
(also **VOYAGER**, S5, E2, 'Drone' • S5, E15 & 16,
'Dark Frontier,' Parts I & II • S6, E2, 'Survival Instinct'
• S6, E19, 'Child's Play' • S7, E1 'Unimatrix Zero,' Part II
• S7, E25 'Endgame' • **ENT**, S2, E23, 'Regeneration')

VOYAGER, S6, E26,
'Unimatrix Zero,' Part I Tactical Cube, 32

THE DELTA QUADRANT
(SHIPS A–K, ALL *STAR TREK: VOYAGER*)

SEASON 1

E1, 'Caretaker' Kazon and Trabe Carrier, 180
 Kazon and Trabe Fighter, 184

E11, 'State of Flux' Kazon Raider, 186

SEASON 2
E2, 'Initiations' Kazon and Trabe Carrier, 180
 Kazon and Trabe Fighter, 184

E8, 'Persistence Of Vision' Bothan Ship Type 1, 82

E11, 'Maneuvers' Kazon Raider, 186

E13, 'Prototype' Cravic Starship, 94

E14, 'Alliances' Kazon and Trabe Carrier, 180
 Kazon and Trabe Fighter, 184
 Kazon Raider, 186

E20, 'Investigations' Kazon and Trabe Carrier, 180
 Kazon and Trabe Fighter, 184
 Kazon Raider, 186

E22, 'Innocence' Drayan Ship, 130

E26, 'Basics,' Part I Kazon and Trabe Carrier, 180
 Kazon and Trabe Fighter, 184
 Kazon Raider, 186

SEASON 3
E1, 'Basics,' Part II Kazon Raider, 186

E3, 'The Chute' Akritirian Freighter, 50
 Akritirian Patrol Ship, 51

E10, 'Warlord' Ilari Ship, 166

SEASON 4

E3, 'Day of Honor' — Caatati Ship Type 1, 86
Caatati Ship Type 2, 88

E6, 'The Raven' — B'omar Patrol Ship, 68

E8, 'Year of Hell,' Part I — Krenim Patrol Ship, 206
Krenim Temporal Weapon Ship, 216
Krenim Warship, 210

E15, 'Hunters' — Hirogen Warship, 158

E16, 'Prey' — Hirogen Warship, 158

E18 & 19, 'The Killing Game' — Hirogen Warship, 158

E17, 'Retrospect' — Entharan Ship, 132

E20, 'Vis À Vis' — Benthan Coaxial Drive Prototype, 76
Benthan Patrol Ship, 75
Daelen's Ship, 102

E26, 'Hope and Fear' — *U.S.S. Dauntless*, 104

SEASON 5

E8, 'Nothing Human' — Cytoplasmic Life-Form Ship, 98

E10 'Counterpoint' — Devore Warship, 116
Devore Shuttle, 122

E19, 'The Fight' — Flea Ship, 134

E20, 'Think Tank' — Hazari Warship, 138
Hazari Scout Ship, 142

SEASON 6

E1, 'Equinox,' Part II — Ankari Ship, 60

E4, 'Tinker, Tenor, Doctor, Spy' — Hierarchy Ships, 144

E5, 'Alice' — Abaddon's "Junk Ship," 48
Alice, 54

E6, 'Riddles' — Ba'neth Ship, 74

E18, 'Ashes To Ashes' — Kobali Ship, 198

E19, 'Child's Play' — Brunali Transport Ship, 84

E21, 'Live Fast And Prosper' — Dala's "Delta Flyer," 110

E23, 'Fury' — Kes's Shuttle, 192

SEASON 7

E3, 'Drive' — Aksani Racing Shuttle, 52
Imhotep Racing Shuttle, 170
Irina's Racing Ship, 174

E5, 'Critical Care' — Dinaali Hospital Ship, 124
Dralian Ship, 128

E8, 'Nightingale' — Annari Combat Ship, 63
Annari Warship, 62
Kraylor Medical Transport/*Nightingale*, 200

E9 & 10, 'Flesh And Blood' — Hirogen Holoship, 152
Hirogen Warship, 158

E10, 'Flesh And Blood' — Hirogen *Venatic* Class, 164

E15, 'The Void' — Annari Warship, 62

E19, 'Q2' — Chokuzan Ship, 90

ALSO AVAILABLE

STAR TREK VOYAGER – A CELEBRATION
THE FIRST IN THE NEW SERIES OF CELEBRATION BOOKS

STAR TREK: A CELEBRATION is a series of lavishly illustrated volumes that chart the behind-the-scenes stories of the *STAR TREK* franchise, drawing on the memories of those who made each series. From the writers' room to the soundstages, each volume celebrates the creative endeavors of cast and crew through personal recollections and on-set tales, alongside exclusive production artwork, key episode guides and more.

STAR TREK ILLUSTRATED HANDBOOKS

STAR TREK ILLUSTRATED HANDBOOKS is a series of books that provide in-depth profiles of the *STAR TREK* universe, covering a wide range of topics from individual starships to races such as the Klingons. Each full-color, heavily illustrated reference work is packed with isometric illustrations, artwork, photographs and CG renders, and features detailed technical information from official sources.

STAR TREK SHIPYARDS

STAR TREK SHIPYARDS is a series of lavishly illustrated books that provides in-universe profiles of *STAR TREK* ships, building into the ultimate illustrated encyclopædia of *STAR TREK* vessels. Each ship is profiled with technical information, operational history and plan view CG renders – wherever possible using the original VFX models that were used on the TV shows and movies.

STAR TREK DESIGNING STARSHIPS

DESIGNING STARSHIPS is a series of lavishly illustrated art books that detail the design process behind the most memorable ships in *STAR TREK*'s history. Each book showcases original production artwork, and features in-depth interviews with the concept artists who created the ships, exploring exactly how each ship was created and offering a fascinating glimpse of what could have been.

www.herocollector.com/books

ALSO AVAILABLE

STAR TREK COCKTAILS
A STELLAR COMPENDIUM

They're cocktails, but not as you know them, Jim…

Set your taste buds to stunned, as 40 *STAR TREK*-themed recipes will take you where no one has gone before. With a galaxy of illustrations, and a witty serving of quotations, this book will help you celebrate your favorite show.

MR. SPOCK'S LITTLE BOOK OF MINDFULNESS

When humanity has lost its way, it takes a Vulcan to raise an eyebrow at our folly and lead us towards the truth...

With more than 50 original cartoons, and gems of Vulcan wisdom from humorist Glenn Dakin, this pocket-sized book will guide you through the modern maze of love, family, self-acceptance, change and more...

www.herocollector.com/books

CREDITS

General Editor: Ben Robinson
Project Manager: Jo Bourne
Editor: Alice Peebles
Writers: Jo Bourne, Ian Chaddock, Alice Peebles, Marcus Riley and Ben Robinson
Designer: Katy Everett
Jacket Designer: Stephen Scanlan

With thanks to the team at CBS: John Van Citters, Marian Cordry and Risa Kessler

™ & © 2021 CBS Studios Inc.
STAR TREK and related marks and logos are trademarks of CBS Studios Inc.
All Rights Reserved.

Published by **Hero Collector Books**, a division of Eaglemoss Ltd. 2021
Premier Place, 2 & A Half Devonshire Square, EC2M 4UJ, London, UK

Some of the contents of this book were originally published as part of
STAR TREK – The Official Starships Collection by Eaglemoss Ltd. 2013-2020

ISBN 978-1-85875-956-2

Printed in China

www.herocollector.com